BBRRRRRRR

RRRRRAAAAKKAAAA

THE ESSENTIAL GUIDE TO
COMIC BOOK
LETTERING™

By NATE PIEKOS

Foreword by
TOM ORZECHOWSKI

THE ESSENTIAL GUIDE TO COMIC BOOK LETTERING. Second printing. February 2022. Published by Image Comics, Inc. Office of publication: PO BOX 14457, Portland, OR 97293. Copyright © 2022 Nathan Piekos. All rights reserved. "The Essential Guide to Comic Book lettering," its logos, and the likenesses of all characters herein are trademarks of Nathan Piekos, unless otherwise noted. "Image" and the Image Comics logos are registered trademarks of Image Comics, Inc. No part of this publication may be reproduced or transmitted, in any form or by any means (except for short excerpts for journalistic or review purposes), without the express written permission of Nathan Piekos or Image Comics, Inc. All names, characters, events, and locales in this publication are entirely fictional. Any resemblance to actual persons (living or dead), events, or places, without satirical intent, is coincidental. Printed in Canada. For international rights, contact: foreignlicensing@imagecomics.com.

ISBN 978-1-5343-1995-0

Design and Production by Nate Piekos and Deanna Phelps. Copy Editing by Melissa Gifford.

IMAGE COMICS, INC. · **Robert Kirkman:** Chief Operating Officer · **Erik Larsen:** Chief Financial Officer · **Todd McFarlane:** President · **Marc Silvestri:** Chief Executive Officer · **Jim Valentino:** Vice President · **Eric Stephenson:** Publisher / Chief Creative Officer · **Nicole Lapalme:** Controller · **Leanna Caunter:** Accounting Analyst · **Sue Korpela:** Accounting & HR Manager · **Marla Eizik:** Talent Liaison · **Jeff Boison:** Director of Sales & Publishing Planning · **Lorelei Bunjes:** Director of Digital Services · **Dirk Wood:** Director of International Sales & Licensing · **Alex Cox:** Director of Direct Market Sales · **Chloe Ramos:** Book Market & Library Sales Manager · **Emilio Bautista:** Digital Sales Coordinator · **Jon Schlaffman:** Specialty Sales Coordinator · **Kat Salazar:** Director of PR & Marketing · **Drew Fitzgerald:** Marketing Content Associate · **Heather Doornink:** Production Director · **Drew Gill:** Art Director · **Hilary DiLoreto:** Print Manager · **Tricia Ramos:** Traffic Manager · **Melissa Gifford:** Content Manager · **Erika Schnatz:** Senior Production Artist · **Ryan Brewer:** Production Artist · **Deanna Phelps:** Production Artist · IMAGECOMICS.COM

FOR **CONCETTA,** WHO ALWAYS BELIEVES IN ME, EVEN WHEN I DON'T.

Informational asides are separated from the main text in light blue fields throughout the book.

FOREWORD
By Tom Orzechowski

When you letter a comic, your name is on it. But, before Marvel's second year, this would not have been the case. It was only with *Fantastic Four* #9 (September - 1962) that I saw the name Art Simek. This credit, for me, was a revelation: not only was this work done by a person, but—the boss felt that this person deserved a mention. For the first time in my comics-reading life—which then totaled four years, beginning when I was five—the books had a deeper context. People had thought them up! It was suddenly a thing for me to look at them critically, including—and I promise this is true—the story title designs. The designs at DC seemed like minor addenda to every splash page's introductory paragraph. Marvel's story titles, by contrast, stood alone. They seemed to fill a quarter of the page, just by themselves. They were bold, emotive, and silly. Irresistible. Inspirational.

I began working at the Marvel office a bit over a decade later. It was the spring of 1973, and I was nineteen. I'd graduated from touching up book reprints to lettering the books which, a few months earlier, I would have bought. A lot of the scripts and pencils that came my way were by people whose comics I'd consumed—inhaled!—in my recent memory. It was terrifying! I didn't want to diminish the look of those incredible penciled pages. The trick, of course, was to get better, and fast. I looked with newly informed eyes at the lettering that'd inspired me to pick up my pens in the first place. Artie Simek showed an almost draftsman-like approach: a regular look to his body copy, a no-nonsense feel to his titles and logos. Sam Rosen's letterforms were bouncier, likely influenced by the brush-drawn movie posters and lobby cards of the 1940s, the days of his youth. DC's *Justice League*-related books, lettered by Gaspar Saladino, showed his design school background. His titles flipped confidently and appropriately between Art Deco, and moody penwork. My own early 1970s titles showed the quirky angularity of *Star Trek,* the freeform funk of underground comix, and the Art Nouveau homage in hippie music posters. So it was that I became part of the tradition of doing my own versions of things for which I had personal context. The roots of that context, eventually ranging much further, have been an ongoing pursuit for nearly five decades. I think it's a safe bet that anyone in this field today whose work shows any flair is likewise playing off something that caught their eye.

It was more exciting than I can say to have lettered story titles and dialogue, in ink, on the penciled artwork. Every setup suggested a different treatment. My reference shelves groan under type design and poster sample books spanning a century. Also, these days, my Pinterest collections grow with each new logo job. Recently, it has been images of graffiti on freeway underpasses.

Ours is an odd and rarified little field, building with pixels on the penwork of the past. Skilled pen-and-ink pros had the eye to make real-time modifications—narrower here, wider there—when faced with an awkward space in the standard page grid. Wiggle room was where you found it. Preposterous hyphenations (unforgivable now) would preserve an outstretched finger or horse's snout. Around 1967, though, Neal Adams and Jim Steranko, two of very few new artists hired in a decade, made themselves noteworthy for taking liberties with that infernal grid. They chose instead to treat each page as a cohesive unit, thereby amplifying the exaggerated reality of the scripts. The placement of the captions, dialogue, and sound effects was suddenly much more in concert with the flow of the figure-work, capes and exploding spaceships.

Through the 1980s, the pages gained a dynamism not seen since the anything-goes days of the early 1940s. The letterer's job, increasingly, became one of flattering the script and artwork equally. That is to say, we had become contributors to the visual appeal of the page, rather than script copyists, relegated to the tops of the panels. We had become designers.

The shift from pen-and-ink to typography eased the deadline problems brought on by the work of designing these complicated pages. At the same time, unfortunately, the software learning curve, combined with the inflexibility of type, threatened the reasoned, informed look of our craft. The newer letterers could not count on guidance from the inexperienced newer editors. New publishers, operating on a shoestring while selling to niche markets, were

popping up rapidly. This continues to be the case.

Poor budgets call for quick results. If we can save the boss some trouble by approaching the job with confidence, we're one up on the game. A solid understanding of technique means that the possibilities for lettering treatments are wide open.

While we're working on a book, we've been trusted to own those pages, to meld the elements appropriately and attractively. Dialogue fonts number in the hundreds. Once a choice is made, there are ways to work with it that will add some personality. Variations on dialogue balloons are not all that difficult. The pen could do it. So can vectors and brush effects. An important bit of eye candy is the bold sound effect. Edgy fonts, applied flatly, regardless of their stylistic touches, aren't sufficient to convey that energy. Sound effects fonts can express a lot more power with a bit of effort, and a willingness to work with the rhythm of the page. Likewise, when using them for logos, some distinctive touches will help a book jump off of the shelves.

Nate Piekos has been bridging the skill of penmanship with the craft of font design for two decades. He'd have been welcome around the inkwell when that was the way of things. Given the weight of his shelf of professional awards, and the impressive range of his client list, he's the person you'll learn a lot from today. I know I will.

PREFACE

My cellphone rang as I stood in the copy room of one of New England's largest sign manufacturers. On the other end was an editor from Marvel Comics offering me my first professional lettering gig. It was 2002, and Mike Allred, legendary creator of *Madman,* and then artist on Marvel's *X-Force,* wanted me to fill in on some issues as letterer. Mike and I already had some history together—the year before, he had discovered my website, Blambot.com, and asked me to create some custom typefaces.

I'd never lettered a professional comic before, much less a Marvel comic, but there I was, at my dreary corporate design job, being offered freelance work from the publisher whose comics I'd been reading for most of my life. It was that moment you dream about, that chance you wait seemingly forever for, but think will never happen.

Of course, I said yes. I only realized after the call that even though I was a trained graphic designer, I had almost no idea about what was expected of a professional comic book letterer. Surely it was going to be drastically different than designing signs for restaurants and pharmacies all day.

In 2002, the internet was still relatively "new." There were very few online communities where obscure topics like comic book lettering were discussed in any detail, and digital lettering itself was still in its fledgling stages. Most pro letterers were originally hand letterers before going digital. I was not.

I reached out to Pat Brosseau for some tips. Pat is a letterer whose work I admired (and still do), and a veteran letterer of virtually every publisher. He gave me some initial instruction over the phone, but there was an ocean of technical and grammatical traditions of comic book lettering that I was clueless about.

I had gone to college for graphic design, and I'd always been a fan of lettering in comics, but now I was neck-deep in it. I studied the masters like Saladino, Klein, Orzechowski, Chiang, Workman, and others. Over the next few months, I worked at my corporate job during the day, and at night I lettered some issues of *X-Force* . . . which became *X-Statix.* Soon, I was lettering every issue of the series.

I look back on my early work and cringe a little. It was an uphill battle to learn such a nuanced art without serving some kind of apprenticeship, and it showed. I worked to get better as fast as I could, and within a year I was lettering books for almost all the major publishers.

In 2003, I quit that day job. I was twenty-eight. Blambot.com was taking off, and lettering work was coming in steadily. It was a huge gamble, but it paid off. I'm forty-five now, and still a successful freelancer.

I'd had the idea for this book many years ago, but I put it off, thinking that it just wouldn't be possible. My schedule was always packed. In lieu of a book, I'd been sharing design tips piecemeal on social media, but I just couldn't escape the question, "when are you going to write a book?" One morning in October of 2019, I was asked again, and I finally decided to make it happen. I figured I could set aside an hour at the end of every day after my lettering duties were finished . . . little did I know, it would turn into a second full-time job for two years!

Understand that every letterer's process is a little different from their fellow letterer's preferences. This book is based on *my* approach, and I've constructed each chapter to build upon the techniques of the chapter before it. As you move along, your skill set will grow. You'll move from fundamentals to the more advanced techniques that will be the building blocks upon which you can formulate *your own* process.

What you're about to read is not a magic shortcut to success—it's the *foundation* for success. There is no way around having to put in a lot of practice. If there's any "big secret" to learn, it's this: graphic design sense is what separates a mediocre comic book letterer from a great one. The truly great letterers are primarily graphic designers, whether they know it or not—whether they have been formally trained or are just inherently talented. *That's* how you stand out from the crowd.

I wish I had a book like this when I was preparing for my chance to work in comics.

Now you have it in preparation for yours.

CHAPTER ONE
THE LETTERER

WHAT IS A LETTERER?

A letterer uses the writer's script to create virtually all the text components you see in a comic book. We're responsible for dialogue balloons, sound effects, captions, titles, logos, and sometimes even road signs, newspaper headlines, and cellphone texts. We guide the reader's eye from one element to the next, so they're never confused or taken out of the story. Our goal is to create engaging graphic design that complements the style of underlying artwork and the genre of the comic book.

For instance, let's say a comic book has a science fiction theme, and the writer or artist wants that reflected in the lettering. The letterer needs the talent, creativity, and experience to design robotic dialogue for a cyborg sidekick, laser beam sound effects that invoke crackling energy weapons, or weird balloons for the gurgling voices of aliens. Another project might be a medieval fantasy adventure . . . captions could look like torn banners, and an army of orcs might need dialogue balloons that look boisterous and scary. To make matters more complicated, a letterer is going to have to jump back and forth between all these different styles, sometimes multiple times a day, as various projects demand.

Every letterer must have a working knowledge of computers, graphics programs, word processing, pre-press, and printing. Lettering is a digital art these days, which helps speed up our turnaround times. Our job happens at the end of the comic creation process, and our page rates are the lowest of the creative team. To make a living, we have to juggle more projects simultaneously than other comic freelancers. We shift gears quickly, do our best work right up against a deadline, and sometimes even save the day for our beleaguered editors.

Finally, the letterer, like any freelancer, needs social savvy to establish and maintain a career and interact with professionals and fans on a regular basis. In an increasingly digital world, it's becoming more common for letterers to be included in social media events with the rest of the creative team—interviews, live-streaming broadcasts, and project pitches as well. Social savvy also comes into play more directly in our interpersonal work relationships. There are high-stress moments when it seems like everything is going wrong. Editors will remember when their freelancers have a meltdown and blow a deadline, and when they handle the chaos with poise. When we deliver the work on or before deadlines, editors seek us out for more work.

THE LIFE OF A LETTERER

Most American comics are between 20-24 pages long, and a professional letterer can be expected to letter at least half a comic a day. Most letterers can complete more than that, depending on how intensive a given project is. At top speed, completing a whole book in a day is possible, but as they say, "you can have it good, or you can have it fast." Remember, when that book hits shelves, it's your name in the credits. You'll want to be happy with the finished work.

Most letterers are freelancers who work-for-hire out of their own home studios, so they set their own schedules. Great right? It's tougher than it sounds. You need to buckle down and produce good work amidst the distraction of working from home. Keeping a rigid schedule, and treating the job with respect, is key. You must try your best to get up at a regular time, get dressed, start work on schedule, take breaks at designated times throughout the day, and end the workday on time. Freelancers make jokes about working in our pajamas (we've all done it . . .) but

I find that choices like that set you up for the wrong "headspace." We have a fun job, but it's still a job . . . and too much of it can affect your health. It's easy to forget about your personal relationships, sleep schedule, and health when deadlines are looming.

While the freelancer is in command of which hours in the day they work, there's always the danger of life's duties and distractions getting in the way: catching the flu, exhibiting at conventions, being the only person who can drive a loved one to an important appointment, etc. There's no calling the boss to get a day off. If you're not working, you're not getting paid, and there is the potential to blow deadlines and not be asked back for future work. It's all part of the deal you're making if you want this job.

To make matters even more stressful, the industry is growing more crowded. Getting your foot in the door is hard, and staying in the industry is even harder. Going from amateur, to part-timer, to having a full-fledged career is a sustained effort.

A career in any field in this industry is hard work. There are no shortcuts to success. You have to love this with all your heart, put in the hours, and be prepared to make sacrifices without any guarantees. That may sound pretty discouraging, but I'm being honest. I'm trying to paint a realistic picture of freelance life. Comics is not a career for the timid.

That said, the rewards for your hard work *can* be many. You'll be getting paid to do something you presumably love. Every day you'll have the chance to hone your design skills and see your work get better and better. You'll develop life-long bonds of friendship with other creators—people just as passionate as you are. You'll be contributing to the comic book characters you read about and obsessed over as a kid—lending your talent to the next generation of stories. You'll be helping to create new fantasy realms for the next crop of readers . . . inspiring kids to follow their passion just as you did! You may even get to work with the legendary creators that shaped *your* love for the medium. You'll walk into comic book shops every month, pick up comics off the shelf, and see your work presented to the world . . . with *your* name in the credits.

NOT RULES, BUT CONVENTIONS

Throughout this book, you'll see asides like this one, separated from the main text with a pale blue background. These consist of advice, helpful tips, standard practice, or the aesthetic and grammatical traditions that are unique to lettering in the comic book industry. It's important to note that while these standards have become commonplace over the history of American comic book lettering, they are not absolutes. Some are more strictly adhered to than others. For instance, use of a barred-I for personal pronouns, and a slash-I in all other dialogue is almost always used by mainstream American publishers.

Other conventions are more malleable, or even region-specific. For instance, the use of a double dash instead of a semi-colon is standard practice in America, while in the UK, an Em dash is typically used.

While the majority of these ideas have been established by the largest publishers over time, opinions vary slightly from publisher to publisher, or even from editor to editor within the same company. I'm sometimes asked to bend or break these rules based on what "feels" best, or more likely, the space constraints within a panel.

As a letterer, it's your job to learn which standards are practiced by the publishers with whom you work, and apply them even when the script misses some of them. You're going to see scripts that may not have been proofread, or are from writers who don't know these practices or don't apply them while writing. It's in your best interest to recognize and correct any of these issues as you letter—because odds are, your editor or proofreader will have you change them during corrections anyway. You'll save yourself some time later if you can catch these things on the fly.

MY TYPICAL WORKDAY

I work Monday through Friday, from approximately 9am to 6pm. Having a very rigid schedule is a priority for me—it keeps me at peak productivity, well-rested . . . and *sane*. I thrive on structure. When I first started out, I eagerly worked nights and weekends—whatever was asked of me—and I worked that way for many years until I realized that my life was too chaotic, my health was suffering, and I was burned out all the time. If I wanted to play the long game, I had to set my schedule in stone, take the risk that my incoming work wouldn't decline, and believe that my editors would understand. I'm pleased to report that this schedule worked like a charm for me. Your mileage may vary, so do what feels right for you. Some freelancers like to work late at night. Some have no problem working weekends.

On social media, I post nearly every day about what I'm working on during my "first shift" or "second shift," and I'm often asked what my daily schedule is actually like . . . well, here it is!

9:00 · I start my first shift. I get into the studio, get a music playlist going (I can't work in silence), and check email. I reply to questions from customers of Blambot.com and see what work came in overnight. I also check the Blambot social media accounts and schedule any events for the day . . . then I start lettering. Any corrections or final files get priority, and then I move on to lettering new/ongoing projects.

1:00 · I take my midday break. I leave the studio, eat lunch, stretch, exercise, and run any quick errands.

2:00 · I'm back in the studio for my second shift. If I'm all caught up on lettering, I use most of this time for designing new typefaces or working on logo projects. I listen to more music or play movies I've already seen as background noise.

6:00 · My workday is done. I stop checking email, make sure that everything that was due that day is done, and I close up the studio.

Note that since letterers have a very sedentary job, I step away from my desk for five or ten minutes every hour or so to stretch and just move around.

YOUR CAREER IN COMICS

One of the questions I'm frequently asked is, "How do I get a job lettering comics?" In my opinion, there are five factors involved: talent, skill, determination, reliability, and luck.

Talent is your raw ability and passion for this job. It's something that can't be taught. It's innate. If you don't know how deep your natural aptitude for design is, don't worry. This is not a make-or-break factor . . . it is however, what raises you above the crowd of other letterers.

Skill is something I'm covering pretty extensively with this book. This is the knowledge of how to do the job. Skill takes the raw iron ingot of talent and turns it into a sharp steel blade. Skill is developed with constant practice.

The third factor is something I *can't* teach you . . . determination. This is not an overnight process, so you need the tenacity to keep trying even when you feel like you're failing and the future seems uncertain. Determination is the promise you make to keep practicing.

Reliability is next, and it is arguably the most important factor, particularly when we talk about *staying* employed. There are lots of letterers who may not be the most talented or skilled, but who are completely reliable . . . and editors love reliability. An editor is more likely to hire you again and again if you turn in work on time, every time.

Finally, we have luck. I'm not sure if I believe in luck, but there are times when we seem to be in the right place at the right time. If you asked most freelancers in the comics industry how they got in, their stories often feature some moment of "being in the right place at the right time." Even I have one of those stories: Mike Allred emailed me out of the blue and asked if I'd like to work with him on some typeface designs. For days I thought the email was fake. It wasn't. However, I think we can influence luck—by the time Mike called me, I had already been posting some work online. That's how he found me. Luck didn't start Blambot.com, I did.

So what can you do to improve your chances of getting into the industry? Everyone's path is a little different. The days of taking your portfolio to the publisher's offices and pitching yourself to an editor are over. Most publishers don't accept submissions anymore, and certainly not in-person at their offices. Some editors will schedule critiques during a convention, and those are a great way to learn, but they are not necessarily job interviews.

I recommend you take full advantage of the internet, and begin networking amongst other comic creators. A social media presence is essential. Get to know the folks who are writing, drawing, coloring, lettering, and editing comics in both amateur and professional circles. Seek out small press/indie projects to hone your craft. Often, the people you've worked with in the past may want to continue working with you when they finally find work with a publisher and their careers begin to take off.

Once you've got some work under your belt, create your own online presence. Purchase a domain name and some web space. An online portfolio of your best work is necessary. Make sure it looks professional, and has all the pertinent contact info that prospective clients will need to get in touch with you. Reply to them promptly and courteously. With time and hard work, opportunity will present itself.

If you're concerned about your own signature "style" amongst the field of other letterers, know that this is not something you're going to decide upon one morning, and forever hence be known for. Recognizable, personal style is largely involuntary. Your own small habits and preferences begin to add up in your design work until, in time, astute fans may recognize your work simply by viewing it.

Also remember that being completely satisfied with your work is nearly impossible—and that's okay! If your lettering is the best it can ever be, you're doomed to stagnation. The pursuit of betterment never ends.

Expect to have days when it seems like everything is going wrong, and nothing you've designed is any good. We all have those days. It just means there's more to learn and an opportunity to be even better tomorrow than you were today. Step away, immerse yourself in design and lettering that inspires you, and give it another try. You'll get it.

Most people focus solely on getting *into* the industry—and that's not easy—but *staying in* is even harder. This comes down to building relationships, being reliable, and not being a jerk. Seriously. Everyone gets grumpy once in a while, but if you consistently burn bridges and overreact, you won't get more work. Your teammates want someone who can deliver a great product under pressure, and do it without having a meltdown. As far as building relationships and reliability, these things are developed and fostered over time.

Alternatively, there are people to *avoid* in the comics industry. Comics are like any other community—some people are wonderful, and some aren't. You'll have to try to spot those people early, but unfortunately it usually means working with them long enough to realize you don't want to work with them anymore. So goes life.

Well, I hope I've given you a broad, honest look into this crazy career.

Are you still with me? Good . . . let's get to work.

A NOTE ABOUT NOTATION

As you progress through this book you'll notice shorthand for some processes using Illustrator, Photoshop, etc. For instance, (Window > Actions) means you should click on Window first, to bring up a menu where you should then click on Actions.

A note that says, (Command + A), means press the Command key *and* the A key together.

Finally, when you encounter something like **(Fig. 3.9)**, this is a reference to a particular image that will help clarify some instructions. The first digit is the chapter number, and the second digit denotes the particular image.

Speaking of images, most of the graphic examples presented in this book are larger than they would appear in a standard comic book in order to more clearly show details.

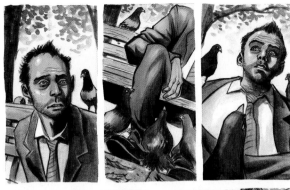
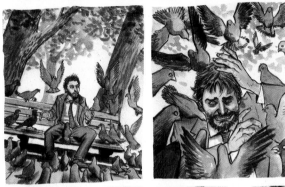
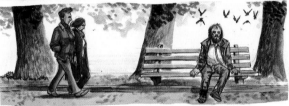

Fig. 1.1

In the digital era, artwork is typically turned in without lettering (**Fig. 1.1**), and it's up to the letterer to design the text elements. (**Fig. 1.2**)

BEFORE AND AFTER LETTERING

In this page from *Colder: Toss the Bones* #1, a character's descent into madness is made apparent through use of a cacophany of perstering pigeons.

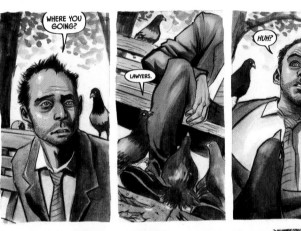
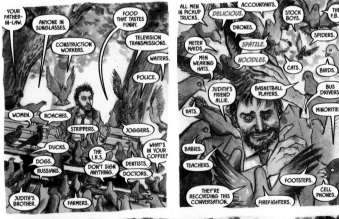
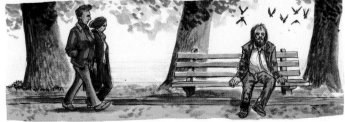

Colder: Toss the Bones #1 Courtesy of Paul Tobin and Juan Ferreyra. **Fig. 1.2**

CHAPTER TWO
TOOLS OF THE TRADE

Until the mid-to-late '90s, comics were predominantly lettered by hand. Since then, letterers have traded Ames guides and calligraphy pens for computers and comic book typefaces. Hand lettering versus digital lettering is still a huge debate among long-time fans and pros alike. Everyone loves the organic feel of touching pen to paper, but publishing is a business like any other, and digital lettering is an inevitable and effective way to save time.

Should you learn to hand letter? Absolutely. There's a whole skill set to explore that will deepen your appreciation and understanding of how lettering works. It's also a fantastic way to learn the fundamentals that can be applied to the digital realm.

Understand that if you want a career lettering comics professionally in the modern age, you will be doing it digitally, and that's the focus of this book. Publishers want to send you materials via FTP, they want the option to make corrections after the lettering is proofed, and they want the final files transferred via FTP back to them as soon as a letterer can get those corrections finalized.

I like to remind people that the "magic" is not in the tools, but the artist using them. We're still lettering with our hands, it's just that the crow quill pen is now a stylus. Amazingly organic typography can be accomplished digitally these days. Many letterers are using custom digital brushes to make sound effects, in addition to typefaces. The typefaces themselves are becoming more organic with the options offered by OpenType contextual alternates and ligatures. (We'll talk more about those later!) It's important to think of advancements in technology as another set of tools in your toolbox, not the extermination or obsolescence of everything that came before.

YOUR LETTERING WORKSPACE

When you get a bunch of comic creators in a room, inevitably the subject of "gear" comes up. What mobile options are best for lettering on the road during a convention? What's the cool new Japanese brush pen? Did So-and-So use a tablet to draw those weird balloons in last month's comic?

I've broken this section into two categories: *The Essentials,* and *The Non-Essentials.* Let's take a look at the things you're going to need . . . and the things that are just great to have at your disposal!

THE ESSENTIALS

Workspace

If you're going to do this job with any regularity, you'll need a dedicated desk with plenty of room for your hardware, and a comfortable, ergonomic chair. Don't skimp; you'll spend eight or more hours a day at this desk. It's important to make the most health-conscious decisions about your work environment that you can afford. Your workspace should be a place away from distraction, with good sunlight, and have space for reference materials. Create a positive environment for yourself: action figures, framed original art, and an awesome sound system for music! Surround yourself with whatever inspires you, makes you happy, and keeps you motivated.

A Computer

While Apple computers are generally preferred in the design industry, it doesn't really matter whether you prefer Mac or Windows anymore. (But note that the keystroke shorthand in this book is for Mac keyboards.) The apps you need are available for both platforms, and both are available in configurations powerful enough to run graphics software. Whether you work on a laptop or a desktop is up to you. Plenty of letterers use both. The advantage to a desktop computer is the bigger screen, but laptops are obviously more mobile.

Adobe® Illustrator® Graphics Creation Software

I've covered this a bit already, it's the industry standard not just in comics but in the world of commercial graphic design. It's a vector-based program with impressive tools. The tips in this book are tailored specifically for Illustrator, but this is *not* a *Beginner's Guide to Illustrator* textbook. It's in your best interest to already have some familiarity with the program.

Adobe Acrobat® Software

Letterers are expected to send and receive PDF proofs of the books they are working on. Editors might send placements in PDF format, and if you're doing pre-press on the project, the client might even ask for print files in PDF format.

Microsoft® Word

Word is a part of the Microsoft Office suite of apps, and Word's default *.docx* format is standard for comic book scripts. Even if the writer is using some other program, once the script gets to editorial and the letterer, it always ends up as a Word document. As letterers, we need specific formatting, and the ability to copy and paste text from a script into Illustrator.

Comic Book Typefaces

You'll need professionally made comic book typefaces designed by typographers who actually work in the industry. There are grammatical traditions and specific style requirements in lettering that you'll be expected to adhere to. Type designed by experienced letterers contains features such as a dedicated barred-I for pronouns and a slash-I for everything else, breath marks for non-language vocalizations, and more. Typographers who have no experience in the comics industry don't tailor their typefaces this way.

Typefaces come in different formats. Opentype is preferred in almost every case. Opentype, or "OT," is cross-platform for either Mac or Windows, and can have interesting features programmed into it by savvy typographers like ligatures and contextual alternates.

Non-Comic Book Typefaces

Having an arsenal of typefaces beyond those styled specifically for comics is also required. These are used for logos, titles, signage, and more. For instance, a script might call for a panel that shows a cellphone receiving a text. You'll need a nice sans-serif body copy font that looks convincingly like it's displayed on a smart phone. Another script might describe a handwritten letter being read by a character. In lieu of actually hand lettering it, you'll need an organic typeface that mimics penmanship.

Adobe Photoshop® Image Editing Software

In most cases, you won't have to modify art—if a problem with the art arises, you can kick it back to the publisher for correction. However, if you're being paid extra to do the final pre-press and deliver printable files, it's your responsibility to make sure the art is properly formatted. Most of the problems that arise with art are related to size or proportion.

American comics are reduced down to a full-bleed size of 6.875" x 10.4375", and we letter at print size. The inker or colorist sometimes delivers art to the publisher/letterer at the wrong dimensions. If you need Photoshop, it'll primarily be to resize art, not modify colors or linework, which is not typically your purview.

If you letter manga, you may use Photoshop more than a letterer working with English comics. Since manga letterers are re-lettering Japanese comics, they have to work with existing balloons that once had Japanese text running vertically inside them. They have to erase that lettering. They're also expected to edit out Japanese sound effects to make room for new English versions, which may require retouching the artwork. Photoshop is designed for working with pixel-based graphics, and is perfect for this.

File Transfer

The larger publishers have private browser-based servers for the upload and download of materials, but it's handy to have an FTP app. Another option is a web service. For a subscription price you'll get private space to store and share files with anyone you choose.

Backup Storage

Most computers offer automated backups of your computer content, but it will only take one catastrophic hard drive failure to convince you that regularly duplicating all your work files somewhere *outside* of your computer is a good idea. Imagine the nightmarish scenario of losing everything and having to re-letter every book you were working on. Some people use web-based backup services, but external hard drives are another good option. They're very affordable, and much smaller than they used to be.

THE NON-ESSENTIALS

An Extra Monitor

Working with additional screen space can be very handy. Almost all computers allow you to add a secondary monitor via HDMI cable to increase the scope of your desktop. It's a convenient time saver to have Illustrator open on your primary monitor, and your script and balloon placements on the secondary monitor. Time is money, and it's important to prevent every extraneous click or drag. Shuffling back and forth between three or four open programs layered on top of each other on one monitor can be tedious. Positioning apps across your field of vision on one massively wide desktop area gives you access to everything at a glance.

The extra monitor doesn't have to be ridiculously expensive, but should have high resolution, and it's important for it to have good color accuracy. On-screen colors and physically printed colors can vary widely.

A NOTE ABOUT TYPEFACE LICENSES

Assuming you haven't been hired into a lettering studio, you are responsible for purchasing your own typefaces. Be sure to purchase them from reputable foundries. Pay attention to license details—when you buy a font, you don't own it, you're purchasing a license to use it in specific commercial situations. Some licenses are just for print or flattened into rasterized graphics. These are commonly referred to as "Desktop Licenses." Most of the time, this is what you'll be looking for. Other licenses are just for dynamic use on websites (Webfont licenses) or embedding in apps (Embedding licenses). Some of these can be divided into price tiers by the number of users (or "seats,") you require. Most people are surprised at how complex this can be, but this is essential learning for letterers.

Also note that sending your font files to a publisher is generally frowned upon by the typographers who created and own the rights to those fonts. Unless your publisher or print bureau has licenses of their own for the fonts you used, you should convert all live text to outlines before delivering your work files so that you don't have to transfer your fonts. We'll cover how to Create Outlines in Illustrator in a later chapter.

Printer/Scanner

I recommend having a large-format printer/scanner in your studio—particularly if you'd like to delve into hand lettering or logo design. The price of these all-in-one printer/scanners has come down considerably, and you can get an excellent model for around $300 to $400. If you're going to invest in one of these, you might as well pick one that scans and prints 11" x 17". Be forewarned, they take up a lot of space in your office, so make sure you have an appropriate place for it.

A Tablet

A tablet is a surface that you "draw on" using a stylus. They're pressure sensitive, and take some getting used to, but may be more intuitive for artists used to drawing with marker, pen, or brush. The learning curve you'll experience has to do with looking up at a screen while you use the stylus on the tablet lying on your desk.

A Tablet/Screen Hybrid

Imagine a computer monitor set at an angle like a drafting board, that you can "draw" on with a stylus. They're amazing for drawing digitally, but they're much more expensive than a basic tablet.

Adobe InDesign® Desktop Publishing Software Application

This app is intended for publishing and is really useful for compiling your .ai lettering files into a multi-page PDF proof, and for delivering final, printable files if you're hired to provide that service. It doesn't feature all the powerful graphic design tools Illustrator contains, but it has many of Illustrator's basic text manipulation functions. It's more suited to working on elements across multiple pages simultaneously.

InDesign is the program of choice for manga letterers who generally aren't expected to design original balloons, but fill the existing Japanese balloons with English text.

Typeface Management Software

Most letterers eventually end up with hundreds if not thousands of fonts. Having them all active on your computer isn't really necessary, and could actually be hogging your hard drive space. The solution is to find a management app that you're comfortable with to make fonts active or inactive with a single click. You can even group typefaces by project, style, or however is convenient for you.

NATE'S WORKSPACE

My current workspace in the Blambot studio is a 6' x 6' L-shaped desk with a sit/stand desk conversion on one side. I switch from sitting to standing throughout the day. On top of the sit/stand conversion is my "workhorse" computer, a 27" iMac, with an attached 27" secondary monitor for an approximate desktop spread of 54". I prefer a lot of desktop space so I can spread app windows around instead of constantly flipping overlaid windows back and forth. This is especially handy when lettering as I can have a script and balloon placements open on my secondary monitor, while I do the actual lettering in Illustrator on the iMac's monitor.

Even though I have one attached, I infrequently use a mouse. Instead, I prefer to use a stylus and tablet for the majority of my day. To make my styli more ergonomic, and give them just a bit more heft, I slip tattoo machine rubber grips over them!

Sitting on the other end of my L-shaped desk is an older, backup 24" iMac, which mostly gets used for streaming music to my stereo or playing movies and TV shows for background noise while I work.

A Sit/Stand Desk

Comic creators have a sedentary job. We sit too long without breaks and tend to hunch our shoulders. These problems have a cumulative negative impact over time. Having the option to alternate between sitting and standing at a desk takes some getting used to, but can benefit a sore back or neck.

Art Supplies

While it's not required for letterers to be handy with analog tools anymore, having these skills can only improve your craft and set you apart. To be honest, getting away from the computer and getting a little ink under your fingernails can be a refreshing change of pace. The time and effort involved in learning to use conventional art supplies can always be applied to your digital work, giving you other options for logo designs, typography, and more.

Reference Materials

The answer to any question or image search is just a click away, but an extensive library, both digital *and* conventional, can be important. Sometimes physically immersing yourself in reference is more inspirational than web-surfing. Whether you start your own library of reference materials or you take advantage of your local library, physical books offer you another outlet of possibilities for inspiration.

MATERIALS PROVIDED BY A PUBLISHER

Once you've landed a job from a publisher, the editor will provide you with what you need to work your magic: properly sized art, a script, and sometimes what we call, "balloon placements." Let's go through these three things in more detail.

PROPERLY SIZED ART

Original comic art is drawn on sheets of 11" x 17" bristol board, or digitally drawn to the proportionate measurements. Letterers often encounter a problem dealing with artwork that doesn't reduce down to the standard print dimensions, because it wasn't drawn at the proper proportions. Adhering to universal measurements is important. Letterers work within a standardized lettering template and the art needs to fit that template. American comics have the following dimensions, and these should be committed to memory by everyone working in the industry:

Full Bleed: 6.875" x 10.4375"
This is the outermost area of the art, and will probably be trimmed off during the printing/binding process. It exists as insurance in case the pages are cut incorrectly. You never letter anything in the full bleed area unless you intend to have it run right off the page.

Trim Line: 6.625" x 10.1875"
This line is where the page is supposed to be trimmed. Anything you letter outside this line will probably get cut off.

Safe Area: 6.125" x 9.6875"
Most of the panel borders drawn by the artist fall within this area. It's safe to put all your balloons and sound effects here.

If you get art at the wrong size, alert your editor. They can provide resized art. If you're working without an editor, ask the artist or colorist, but the job may fall on you to resize the art—know that this is part of the *production* process, and since it is not considered a part of the letterer's usual job, you should charge an additional fee.

STANDARD AMERICAN COMIC BOOK
PAGE DIMENSIONS AT PRINT SIZE

Shown at actual size

Original comic book art is typically drawn on sheets of 11" x 17" bristol board
(or the digital equivalent) that are ruled to a drawing area of roughly 10" x 15"
or 10" x 15.375", and then reduced down to the sizes listed below for print.

Full Bleed
6.875" x 10.4375" or
17.4625 cm x 26.5113 cm
*Anything drawn or lettered to
this edge will most likely be
trimmed away.*

Trim Line
6.625" x 10.1875" or
16.8275 cm x 25.8762 cm
*The physical page will be trimmed
here during the print process.*

Safe Area
6.125" x 9.6875" or
15.5575 cm x 24.6063 cm
*Panel borders typically end up
within this area, and all lettering
placed here will be safely printed.*

Fig. 2.1

COMIC BOOK SCRIPTS

Letterers don't re-type dialogue, we copy and paste "live" text from Word to Illustrator, so it's important to get scripts in a format we can open and edit in-app like .docx or .rtf. Getting a non-editable format like a .pdf is useless.

You should expect that by the time you get the script, it's been edited for grammar and plot, and is final. There will be some edits, but sweeping changes should be avoided at all costs. Nothing will gobble up your time—and therefore your page rate—faster than an editor or writer treating the lettering stage as a "first pass."

There is no standardized formatting for comic book scripting (unfortunately), but there are accepted commonalities. Simplicity and specificity are what make the best form, as you see in **Fig. 2.2**. Note the numbered breakdown explained on the following pages . . .

1 SECRET AGENT SPECTER#1 / by John Smith

2 THIRTEEN

PANEL 1 **3**

Wide shot of the inside of the warehouse. It's dark, with dust-speckled light shining in through high windows. Groggy, Steve realizes he's tied to the nuclear warhead, which is clearly big enough to wipe out the entire city. Before him stands an army of ninja warriors with all different weapons. (See **4**

5 *www.totallynotrealwebaddress.com/ninjaweapons.jpg* for references.) One of the ninjas is clearly in charge here, he's wearing a red ninja gi, and a demon mask.

6
1. STEVE CAPTION (INTERNAL) - Oh, my head. Feels like I got hit pretty hard...
2. NINJA LEADER - Good morning, Secret Agent Specter.
3. STEVE CAPTION (INTERNAL) - Can't really see what I'm strapped to, but I have a ***pretty*** good idea...

PANEL 2

Close up on the the Ninja Leader and a cluster of black-clad ninjas around him. The Ninja Leader is clearly enjoying the culmination of his plans.

7
4. NINJA LEADER - As you may have figured out, this game is almost over, *gaijin*.
5. STEVE CAPTION (INTERNAL) - They've done a good job restraining me. I think they even found the mini-blade hidden in my wristwatch.

PANEL 3

Close-up as the Ninja Leader grabs Steve by the chin, and tilts his head up to look in his eyes. In the Ninja Leader's other hand is the detonation device for the warhead.

8
6. NINJA LEADER - We've found all your ***gadgets*** and ***gizmos***, Secret Agent.
7. NINJA LEADER (cont.) - ***All*** of them. You're ***done.***
9
8. STEVE CAPTION (INTERNAL) - He may be right...

PANEL 4

Ninja Leader clicks the warhead remote, and the warhead hums to life and begins to tick. We can't see it because of his mask, but the Ninja Leader is grinning ear to ear under there.

10. SFX (remote) - CLICK **10** **12**
11. SFX (warhead) - BZEEEP - BZEEEP - BZEEEP
9. NINJA LEADER - There's a helicopter waiting for ***us*** on the roof, Specter. But ***you*** and this whole ***city***
11 will be wiped off the map.

Fig. 2.2

1 — A page header with the book title, issue number, revision number, and writer's name is handy on every page, but should be featured in the header of the first page.

2 — Each new script page should begin on a new document page, and the page number should be clearly distinguishable.

3 — Panel numbers should be called out as clearly as page numbers.

4 — Panel descriptions feature the actions of characters, "camera" angles, and set direction. Sometimes an editor will remove the panel descriptions before giving the script to the letterer, but leaving them in can be helpful in instances when the art might be confusing.

5 — Links to reference photos can be included in the panel description. This is a handy way for a writer to show an artist exactly what they envisioned while writing.

6 — Under each panel description is the lettering area. Everything that needs to be lettered goes here.

7 — Each item in the lettering area should be numbered. If the editor is doing lettering placements, these numbers correspond to the placements sent to the letterer.

8 — The call-out of each item to be lettered and any descriptors. It's important for the writer to be specific with these. Take particular note of the extra information between the parentheses in these examples. You'll need to come up with designs for all of these variations when you're planning the style guide of each new project.

CHARACTER — The most common descriptor you'll see in a comic script is the name of the character speaking with a dash, followed by their dialogue.

CHARACTER (THINKING) — While thought balloons have mostly fallen out of fashion in modern comics, you may still encounter them. The text included can be set in your Regular or Italic font, as long as you are consistent.

CHARACTER (OFF) - The character is speaking from off-panel, and the letterer should have the balloon tail starting at the balloon, and ending at the panel border that is "closest" to the character off-panel.

CHARACTER (WHISPER) — Letterers usually add a dashed line to a whisper balloon, or scale the text down to about 75% and add extra negative space in the balloon.

CHARACTER (BURST/SHOUT) — The character is shouting and the balloon should reflect this. Jagged "burst" balloons and over the top treatment of the dialogue is acceptable—have fun with these!

CHARACTER (WEAK) — Someone may be sick or dying, and their voice should reflect this. A wobbly balloon and wavy tail with smaller than average text can convey this.

CHARACTER (SINGING) — Sung dialogue should be italic, and have a few musical notes around it.

CHARACTER (IN JAPANESE) or (IN ITALIAN) etc. — A character speaking a language other than English in a western comic is traditionally shown as italic text surrounded by < and > symbols. Usually, the first time the dialogue switches from English to the other language an asterisk is used, which references an editor's caption somewhere on the page to clarify exactly what language is being spoken.

9 — Like dialogue, captions have their own descriptors:

CHARACTER CAPTION, (SPOKEN) or (VOICE-OVER) - This person is speaking out loud, but is not shown in the panel art. The text should begin with double quotation marks, but only have end quotation marks on the last in a series of captions, or if they get interrupted. The color of spoken captions often corresponds to the signature color palette of the character for easier identification.

CHARACTER CAPTION, (INTERNAL) or (NARRATION) - These kinds of captions have largely replaced thought balloons. This person is thinking, and we can "hear" their thoughts. These captions have no quotes, and can be italicized and/or left aligned to further visually separate them from spoken captions.

CAPTION, (TIME/PLACE) or (LOCATOR) - Such as: *New York, 2020*. Styles range widely for these, from italicized dialogue fonts in a caption box, to beefy sans-serif fonts, or something that works with the genre of the comic. For instance, a crime-noir comic could have locator captions that look like they were typed with an old typewriter. These are largely the choice of the letterer, and decided on while designing the style guide for the series.

10 — Sound Effect, or SFX — These are usually some onomatopoeia that the letterer can have some fun with. While it's important to stick to what's written, sound effects can be edited due to space restrictions in the art. If the script says something like, KRAKKKAAAAA-DOOOOOOOOOOOOOOOM, and there isn't enough space for that many letters, you could truncate, but keep the essence of what was in the script . . . perhaps something like: KRAKA-DOOOM. When in doubt, run it by the editor.

11 — In a Word document, dialogue should be separated to its own line, or indented. It should never be tabbed over, or bumped right with a dozen clicks of the space bar. When a writer does this, the letterer has to run find/replace searches on the document to delete them all before lettering. Dialogue should also be written in plain sentence case, not CAPS.

12 — Ideally, dialogue meant to be emphasized should be bold and/or underlined in the script. Some writers will type emphasized dialogue in all-caps, which is acceptable, but less desirable than actually using bold or underlines. Whichever method is used, it should be consistent throughout.

PREPPING A SCRIPT FOR LETTERING

Most letterers "prep" a script before they start lettering. This means we use Edit > Find > Replace in Word to automatically find and replace common errors or comics-specific grammar issues throughout an entire document. As you work repeatedly with certain writers, you'll get to know their habits and know exactly what to find and replace.

Some common errors that I replace are: changing double spaces between words to single spaces, changing a series of periods to the ellipsis glyph with no spaces before or after it, changing Em or En dashes to a double dash with no spaces before or after it, and changing straight quotes to smart quotes.

PLACEMENTS

It's your primary job as a letterer to make sure there is no question about the reading order of all balloons and sound effects on a page. Careful consideration of placement cannot be understated. The moment a reader questions the order of what's happening—having to skip around the page to see if they can make sense out of the context of the dialogue—they fall out of the reading experience, and you've failed as a letterer. Harsh but true.

For English language readers, the cardinal rule is *"left to right, top to bottom."* As easy as that sounds, you have to work hand in hand with the available space in the art. It's a challenge for every new page, but with practice, you'll be able to see the proper course of action in a few seconds.

Some editors will provide you with a set of PDF placements, these are their suggestions for how lettering can be placed on the artwork. Placements are usually digitally marked up, or low-resolution scans of the art with balloons, caption boxes and sound effects quickly sketched in marker. Each one is numbered to match a numbered element in the script. Some letterers prefer no placements sent to them at all—and that's fine if they have plenty of experience.

The biggest discrepancy you'll encounter will be editors indicating placement of a balloon in a space that turns out to be too small to fit the amount of text in the script. You'll have to get creative and rely on your own ability to place lettering elements.

I like to think of editors' placements as a time-saving measure on pages where there are lengthy conversations

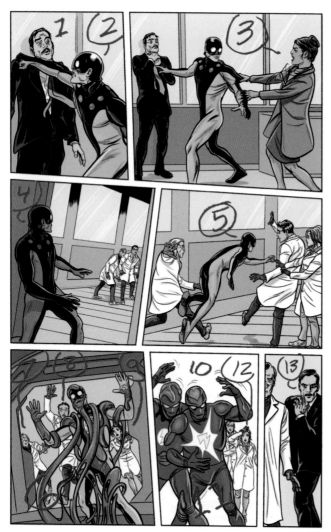

X-Ray Robot #1 Courtesy of Mike Allred.

Fig. 2.3

Fig. 2.4

going on between characters I might not immediately recognize. There are plenty of times when new characters have been introduced in a series that I'm not familiar with yet. It saves me the few minutes it would take to identify and plan the balloon arrangement for each person speaking. Otherwise, I'd have to email the editor to verify my assumptions—and time spent waiting for an answer is time I could have been lettering those pages!

Placements can be figured out by looking at the arrangement of panels and characters, the amount of space available for lettering, and also recognizing where the artist is leading the reader. If you are a comic fan, you've likely been reading comics your whole life, so you're used to the "beats"—the rhythm to a page of comic art. Make an effort to think about where the reader's eye should linger and where it should speed up.

Once you've got the beats in the art figured out, think about where the reader's eye is logically going to sweep across the page. Your balloons are like guide posts on the path through the narrative.

If the artist was thinking about balloon placement when they were drawing, you'll see the negative spaces where they thought lettering would eventually go. Many times they're right, but often the letterer has more experience. We think about lettering placement *constantly*.

The examples of placements shown on these pages are from Mike and Laura Allred's *X-Ray Robot* #1 (**Figs. 2.3** to **2.6**). In each case, the image on the left is the placement suggestion and the image on the right shows the lettered pages as they appeared in print. Can you spot where I made different decisions from the editor's suggestions?

X-Ray Robot #1 Courtesy of Mike Allred. **Fig. 2.5** **Fig. 2.6**

Let's return to the idea of the reader's eye sweeping across the page in the proper reading order. Look at the wavy red lines in **Figs. 2.7** to **2.9.** The lines represent the path of the reader's attention through the panels using the lettering as guideposts. The choice of balloon and sound effects placement should harmoniously reinforce the path set forth by the art.

Properly executed lettering placements (in English), should not break the aforementioned *"left to right, top to bottom"* rule. If there's a smooth, sweeping transition throughout the lettering, the reading experience remains enjoyable.

If you've ever suddenly realized something wasn't right while you were reading a comic book—you seem to have missed some crucial bit of information or the dialogue doesn't make sense—it's probably because the lettering placements weren't well executed.

X-Ray Robot #3 Courtesy of Mike Allred.

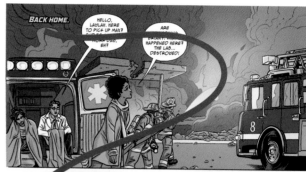

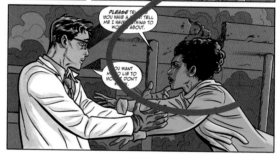

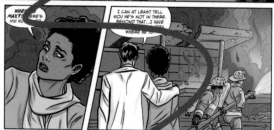

Fig. 2.7

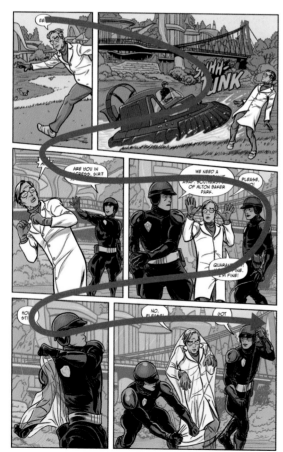

Fig. 2.8

Fig. 2.9

ILLUSTRATOR ACTIONS: THE LETTERER'S BEST FRIEND

When you're lettering, you want to focus on the creativity involved. Flipping through menus and windows isn't part of the process, it's a *hindrance* to the process. Whenever you can save some time by reducing those tedious steps, it means speeding up your workflow and making your page rate more profitable.

Throughout this book, and particularly in the chapters on balloons and sound effects, you're going to read many multi-step processes in Adobe Illustrator that will, by necessity, become a part of your everyday work as a letterer. From masking and trimming objects, to making compound shapes out of tails and balloons. If you had to perform all those steps every single time you trimmed a balloon to a border, or compounded a tail to a balloon, it would add up to hundreds of extra clicks and too much wasted time over the course of your day.

Imagine taking any of the processes that you'd be repeating over and over again and reducing them to the single click of an F-key. That's exactly what we can do with Illustrator's Actions feature; record the steps one time, and play them back on an object any time we want.

Actions are without a doubt the most important workflow tip I'll share with you in this book, and I can't possibly suggest more strongly that you learn to use them. Here's how it works . . .

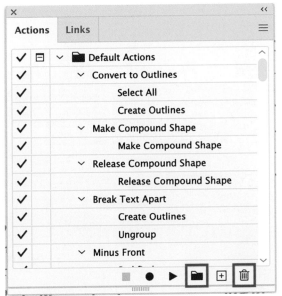

Fig. 2.10

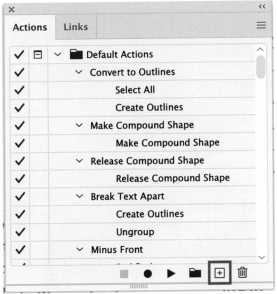

Fig. 2.11

Any time you have a multi-step process you want to turn into an Action, first open the Actions window (Windows > Actions). In this example **(Fig. 2.10),** you can see some of my pre-recorded Actions, but if you're opening this window for the first time, you'll notice that Illustrator already has a bunch of Actions pre-programmed. If there's anything in there you don't think will be useful, you can delete it by selecting it and then clicking the trash can icon in the bottom right corner of the window. You could also create a new folder to keep your Actions in by clicking the folder icon.

Before you perform the steps you're going to record, or one of the many featured in this book, first make sure you know exactly what steps you're about to perform—you don't want to accidentally record a mistake. It can be a bit of a hassle to edit Actions, or worse yet, re-record them. When you're sure, click the plus symbol icon. **(Fig. 2.11)**

This brings up the New Action window **(Fig. 2.12)** where you can name your Action and select which F-key you want to

New Action	
Name:	Action 1
Set:	Default Actions
Function Key:	None ☐ Shift ☐ Command
Color:	None
Cancel	Record

Fig. 2.12

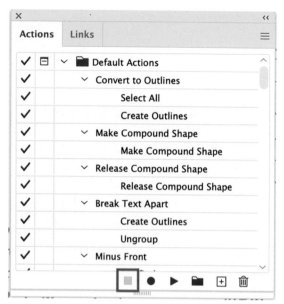

Fig. 2.13

assign it to in the Function Key field. You can also take advantage of using an F-key in conjunction with Shift and Command. (You can change these options later if you change your mind.) When you're ready, click Record.

Perform the process as efficiently as possible, and when you're done, click the Stop Recording icon **(Fig. 2.13)**.

Test it out by clicking the assigned F-key, and if you're happy with the result, that's it! If you messed up somewhere along the way, you can delete the Action with the trash can icon and start again. Once you get the hang of it, you'll be recording new Actions all the time.

As we progress through the following chapters, I'll remind you periodically of which sets of instructions make great Actions. In the meantime, **Fig. 2.14** is a look at a few of the Action keys I use every day.

	F1	F2	F3	F4	F5	F6	F7	F8	F9	F10	F11	F12
		Convert All Text To Outlines	Make Compound Shape	Release Compound Shape	Create Outlines & Ungroup	Unite	Minus Front	Offset Path 1pt	Offset Path 1.5pt	75% Scale Whisper Balloons	Balloon Calligraphic Stroke	Off-panel Tails/ Connector
SHIFT	Clean Up Outside Artboard	Place Art & Align To Zero Point	Offset Path 5pt		Telepathy Balloons	Tech Pen XShort Brush	Tech Pen Short Brush	Drop Caps Effect	Dashed Whisper Balloons	Nudge Art		Final File as EPS
SHIFT +CMD	Delete Layer	Align Horiz. and Vert.	1pt Stroke				Tech Pen Medium Brush				Ghost Balloons	

Fig. 2.14

NUMBERS IN DIALOGUE: WORDS OR NUMERALS?

It's a good rule of thumb that any number over twenty can be expressed in numerals. This is mostly a space-saving measure. "350" in a dialogue balloon takes up much less space than "three-hundred and fifty." Dates, and number designations should use numerals. Roman numerals remain their letter representations.

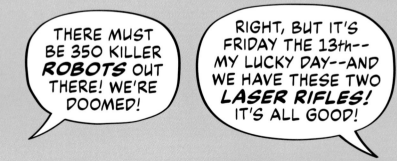

ILLUSTRATOR KEYBOARD SHORTCUTS

Illustrator has some built-in keyboard shortcuts that will save you from selecting tools with your mouse. **Fig. 2.15** shows just a few of the available keyboard shortcuts that I use frequently . . .

Shortcut	Mac / Win
Selection	V
Direct Selection	A
Pen	P
Type	T
Rectangle	M
Ellipse	L
Paintbrush	B
Pencil	N
Rotate	R
Reflect	O
Free Transform	E
Eyedropper	I
Artboard	Shift + O
Hand	H
Zoom	Z
Color	,
Toggle Fill/Stroke	X
Show/Hide Guides	Command + ; / Ctrl + ;
Create a New Document	Command + N / Ctrl + N
Open a Document	Ctrl + O
Place a File in the Document	Shift + Command + P / Shift + Ctrl + P
Print	Command + P / Ctrl + P
Exit the Application	Command + Q / Ctrl + Q
Group the Selected Artwork	Command + G / Ctrl + G
Ungroup the Selected Artwork	Shift + Command + G / Shift + Ctrl + G
Add a Layer	Command + L / Ctrl + L
Make Clipping Mask	Command + 7 / Ctrl + 7
Remove Clipping Mask	Option + Command + 7 / Alt + Ctrl + 7
Hide Selection	Command + 3 / Ctrl + 7
Show All Selections	Option + Command + 3 / Alt + Ctrl + 3
Export	Command + E / Ctrl + E
Save As	Shift + Command + S / Shift + Ctrl + S
Save	Command + S / Ctrl + S

Fig. 2.15

LETTERING TEMPLATES

WHAT ARE LETTERING TEMPLATES?

Unless they're working for a publisher with a dedicated lettering department, most letterers craft their own template for lettering standard-sized pages and for double-page spreads. These are Adobe Illustrator documents that are set up with the proper artboard size, layers, and guides. Frequently used balloons, caption boxes, and typefaces, which I call "assets," are also stored there. Each time we letter a new page, we open a blank copy of our template, complete the lettering, and when we're done, save a copy of it with a new file name based on the book's title, issue number, and page number.

Each letterer's template becomes a very unique and personal thing. They evolve over time, and while they all have similar assets, no two letterers design the same exact kind of balloon or caption box. The aggregation of all these elements can evolve into the recognizable style of a particular letterer.

As an example of what a lettering template looks like, here's my default template as of this writing. **(Fig. 3.1)** It includes years of unusual balloon designs, custom Illustrator brushes, and often-used color swatches that I've saved to incorporate into future projects.

Fig. 3.1

Every time I begin a new series, I open this file, update the title block with the name of the new project, and decide which style of balloons and captions will work best with that particular project. I delete all the other assets that won't be needed before saving the new template with that particular job's file name. In essence, this default template is the raw material to develop other blank templates for new jobs that I'm hired to complete.

THE TWO SCHOOLS OF DIGITAL LETTERING

Before we delve into the steps of template creation, it's important to first explain the primary methods used to create dialogue balloons, since this directly affects how your template will be set up.

There are generally two approaches: the Layer Method and the Stroke Method. Most of us prefer one method or the other, based on how fast we perceive one of the techniques allows us to letter a page. The truth is, neither is superior. It all comes down to which method you're comfortable with.

The Layer Method, created by letterer Albert Deschesne, is generally what's used by Marvel and DC letterers. It uses objects on multiple layers to achieve the illusion of cohesive balloons.

The Stroke Method uses fewer objects and layers to create balloons. I first became aware of the Stroke Method via the work of the most award-winning letterer of all time, Todd Klein. It has become my preferred style, and is the focus of this book.

It's important to note that *both* methods make use of the Layers window in Adobe Illustrator. The Layer Method is so named due to the fact that you're stacking objects like layers of a sandwich to make the white and black parts of balloons. The Stroke Method uses an *actual* stroke for the black line around the white balloons.

It's a bit confusing, I know, but you'll get a better understanding if you see a visual example of what's going on in both versions. I've created an exploded view of how each technique is achieved. (**Fig. 3.2**)

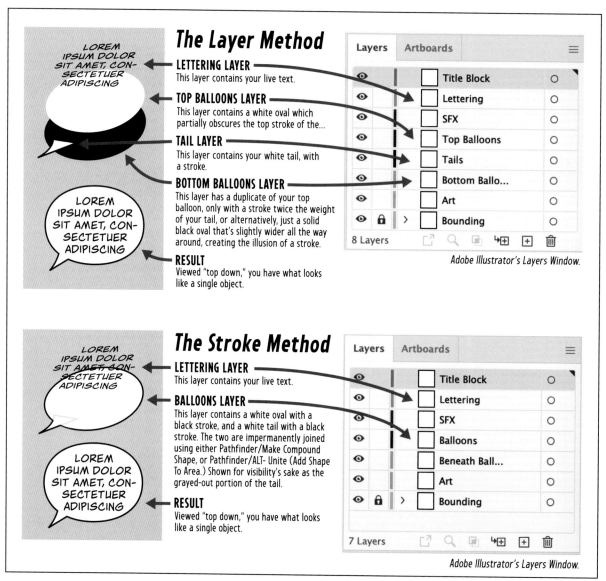

Fig. 3.2

A NOTE ABOUT CREATING AN ILLUSTRATOR WORKSPACE

If you look at the previous example of my lettering template **(Fig. 3.1),** you can see the Illustrator windows stacked up on the right side of my screen that I use most often for lettering (Glyphs, Character Styles, Paragraph, etc.) Having your preferred windows already open and saved as a Workspace means they'll always be open, and in the arrangement you prefer, each time you work. I recommend you open the following windows and place them efficiently around your Illustrator screen:

Window >
Application Frame and Control

 Toolbars >
 Advanced, Align, Appearance, Attributes, Brushes, Color, Gradient, Layers, Pathfinder, Stroke, Swatches, Transform, and Transparency

 Type >
 Character, Character Styles, Glyphs, Opentype, Paragraph, and Paragraph Styles

You'll note that many of them nest together when opened. You can save your custom Workspace by going to Window > Workspace > New Workspace and giving it a name.

BUILDING A LETTERING TEMPLATE

Building a lettering template from scratch takes some effort, but it's something you're going to use every time you work. A letterer's template is an ever-evolving tool. Over time, you'll develop interesting new styles of balloons and caption boxes of your own to use in style guides for different projects.

We're going to create a lettering template that utilizes the Stroke Method of lettering. First, you'll open Illustrator and start a new document (File > New, or Command + N). This will bring up the New Document window **(Fig. 3.3).** You'll need to change the Preset details as shown. Most importantly, make sure the width is 6.875" and the height is 10.4375". These are the full bleed dimensions of a standard American comic book page at print size.

Fig. 3.3

You'll end up with a blank document that looks like **Fig. 3.4**:

Fig. 3.4

Next, we have to create the many layers where your assets will be stored in the Layers window (Window > Layers), so let's start at the bottom and work up. By default, this default layer is called "Layer 1," but that won't do, so double-click the name and rename it "Bounding" **(Fig. 3.5)**.

Create another layer on top of that one by clicking the little button that looks like a plus sign in a box **(Fig. 3.6),** and call that layer "Art." Repeat this process until you have seven layers in total. From the bottom up you should have Bounding, Art, Beneath Balloons, Balloons, SFX, Lettering, and Title Block.

See the multicolored bars to the left of each layer's name? Those indicate what color will be used as a highlight any time you select an object on that layer. **(Fig. 3.6)** You can change them by double-clicking on the layer name. A menu of colors will pop up. I like to use colors that are easily distinguishable from one another, of medium tone.

Let's run down the purpose of each of these layers from the bottom up:

Bounding — You'll put your guidelines here, as well as some tricks to help make pre-press go more smoothly.

Art — You'll place the art here, of course! Once you've created the layer, double-click it to bring up the Layer Options window **(Fig. 3.7),** and make sure to check the box next to Dim Images and give it a value of 30%. This will make any art you place

Fig. 3.5

Fig. 3.6

on this layer look slightly "washed out." This is going to make it easier to see all your lettering and sound effects as you work. If you need to see the page at full color any time during the lettering process, just come back to this window and uncheck Dim Images. I like to toggle Dim Images off to sample colors from the art to use in sound effects, and check that all my caption colors jive with the color palette of the art.

Beneath Balloons — Since this template is designed for the Stroke Method, where all our balloons and tails will be on one layer, this layer is used any time you need to place something *under* your balloons. This is handy for when you need a sound effect to run behind a balloon—you'll design that sound effect here instead of on the SFX layer.

Balloons — All your balloons, tails, and caption boxes will go on this layer. Note that if this was a template geared for the Layer Method of balloon construction, you would need three layers instead of this single layer.

SFX — You'll design the majority of your sound effects here.

Lettering — All of your Area Type objects for dialogue and captions will reside on this layer.

Title Block — Your topmost layer will have an infographic for the title, issue number, page number, your name, or even the name of your studio if you're part of a group. Note that your title block is really only there for reference during the proofing stage. This way, everyone is on the same page (pun intended) if corrections need to be made.

You'll want to delete the Title Block layer from any final files you send to a publisher. Let's leave the design of your infographic aside for now; we'll return to it once the template is complete.

Once your layers are in order, we need to make sure rulers are visible in your template. Go to: View > Rulers > Show Rulers. You'll see them appear along the top and left side of your Illustrator window if they aren't on already.

Make sure the unit of measurement is Inches by right-clicking or Control-clicking on either ruler. You'll see a checkmark next to whatever unit of measurement is being used **(Fig. 3.8)**.

Note that by default, Illustrator sets the "zero point" for all horizontal and vertical measurements at the exact top left corner of your artboard **(Fig. 3.9)**. That's important for the next step.

It's time to create guides based on those standard comic dimensions I mentioned in Chapter Two. The guides will show up above the art (even though we're about to create them on the bottommost layer, trust me . . .) and tell us where it's safe to letter. We do that by first making three rectangles.

Make sure you're on the Bounding layer and select your

Fig. 3.7

Fig. 3.8

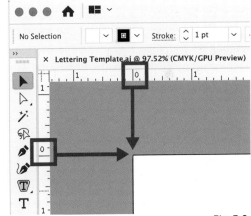

Fig. 3.9

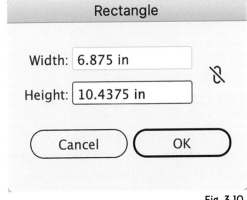

Fig. 3.10

Rectangle Tool (M). Click once anywhere on the Bounding layer to bring up the Rectangle window **(Fig. 3.10)**, and make a rectangle that is 6.875" wide by 10.4375", another rectangle 6.625" wide by 10.1875" tall, and a third at 6.125" by 9.6875". It doesn't matter what their fill or stroke currently is, or where they are in the document.

You should end up with something like this **(Fig. 3.11)**: three increasingly smaller rectangles. (The fourth rectangle in the top left is the artboard itself.)

Fig. 3.11

Once you've got all three, we need to align them to their centers **(Fig. 3.12)**. To do that, select all three rectangles and align them with the Align window (Window > Align) so they are centered horizontally and vertically on each other by clicking on the Horizontal Align Center and Vertical Align Center buttons **(Fig. 3.13)**. It's important that they're perfectly aligned. Don't eyeball any of this.

Fig. 3.12

Fig. 3.13

The rectangles are aligned to each other, but now we need to align these three rectangles to the artboard. Here's where that zero point in the rulers comes into play. Make sure all the rectangles are selected, and in the Transform window (Window > Transform), set the X- and Y-coordinates to zero. **(Fig. 3.14)** Your centered rectangles should now also be centered on the artboard. **(Fig. 3.15)**

Fig. 3.14

Fig. 3.15

We have to make these rectangles into guides. With all three selected, go to View > Guides > Make Guides. You'll see the rectangles go from objects with a fill and stroke to very thin cyan-colored guidelines that will show up above everything else in your template. **(Fig. 3.16)**

Now you'll always be able to see where the full bleed, trim, and safe areas are, and whether the art is properly formatted for print.

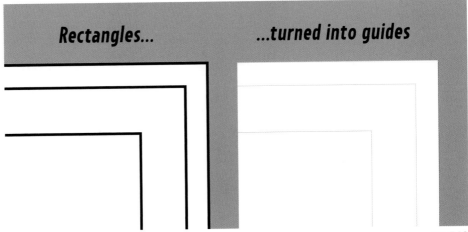

Rectangles... ...turned into guides

Fig. 3.16

You should also double-check that your guides are locked since you don't want to ever accidentally move them. They may even be locked by default. Right-click or Control-click anywhere in the document to bring up the menu shown in **Fig. 3.17,** and check Lock Guides.

Note that guides don't show up in .pdf proofs.

Next, we have to create and place a bounding box in the Bounding layer. This will be an "invisible" rectangle with the exact same full bleed dimensions of our artboard. Its purpose is to quickly and accurately align your lettering to the artwork during the production stage when the lettering is married to the art.

Normally, you delete the Art layer when you're prepping final lettering for a publisher who prefers .eps files. This invisible rectangle (which measures 6.875" x 10.4375"), remains in the .eps file so that when the lettering is dropped on top of the art (which also measures 6.875" x 10.4375") in InDesign, the two match up instantly. There will be no guessing which balloon goes in which panel, or having to manually align any sound effects that were intricately masked around inked elements in the art.

Let's repeat the process of how we made the largest rectangle for the guides. First, make sure you're on the Bounding layer. Switch to the Rectangle Tool and click once, anywhere in the document. When the Rectangle window pops up, change the dimensions to 6.875" wide by 10.4375" tall. The fill and stroke don't currently matter. Once you have a rectangle, align it to the zero point, just as we did for the guides by changing the X- and Y-coordinates to zero in the Transform window (Window > Transform).

At this point, you have two ways to make the rectangle invisible. Some letterers have a preference based on their workflow:

Option 1: Select the rectangle, and in the Swatches window (Window > Swatches), give it *no stroke, and no fill*—essentially making it invisible. **(Fig. 3.18)** Now you can either lock the Bounding Layer **(Fig. 3.19)** so that you don't accidentally move this invisible rectangle, *or* you can lock the invisible rectangle itself by selecting it and using Lock Selection (Command + 2).

Fig. 3.17

Fig. 3.18

Fig. 3.19

Option 2: Select the rectangle, give it no fill in the Swatches window (Window > Swatches) and give it a 1pt black stroke in the Stroke window (Window > Stroke) with the stroke *aligned to the inside of the rectangle.* **(Fig. 3.20)**

Next, up at the top of your Illustrator window, where the rectangle's stroke properties are shown, change the stroke's opacity to 0%. **(Fig. 3.21)** You'll see the stroke disappear.

Finally, you can either lock the Bounding Layer **(Fig. 3.19)** so that you don't accidentally move this invisible rectangle, *or* you can lock the invisible rectangle itself by selecting it and using Lock Selection (Command + 2).

I prefer—and recommend—Option 2 since this method is ideal for almost every method of proofing and making final files.

Your template is nearly done! **(Fig. 3.22)**

Fig. 3.20

Fig. 3.21

Fig. 3.22

YOUR TITLE BLOCK

Now that your single-page template is finished, you can have a little fun designing the infographic for your Title Block layer. A title block is the area where the project's title, issue number, page number, and the name of the letterer will be displayed for proofing purposes. I've found that the top right corner of the artboard is best. You'll want to keep it out of the way of the safe area so as not to obscure any of your work, or any important art, but still be visible in your proofs. Keeping the design about ¼" in height seems to work well.

Here's a close-up of my standard Blambot title block as an example. **(Fig. 3.23)** (I've concealed the guides for an unobstructed view. Otherwise, they would show up over the title block, which is normal.) Note that I've gone with a subdued gray color scheme so that it never competes with the art for focus.

Fig. 3.23

For our new template, I've designed this generic title block, appropriate for any letterer. **(Fig. 3.24)**.

Fig. 3.24

Remember that whatever you design, it should be simple, legible, and not compete for attention with the work you're doing. With that, your standard template is done! You should have something that looks like **Fig. 3.25**.

Fig. 3.25

BUT HOW DOES THIS NEW TEMPLATE ACTUALLY WORK?

In summary . . . you'll start with the blank template. **(Fig. 3.26)**

Place the properly-sized art on the Art layer **(Fig. 3.27)** and lock it. (Note that the art looks washed out because we set the Art layer to 30% "Dim" to better see the lettering as we work.)

You'll complete the lettering (easy for me to say!) by designing the text on the Dialogue layer, balloons on the Balloons layer, etc., and then save a copy of the file in your project folder. **(Fig. 3.28)**

Once you've lettered the whole book, made proofs for the editor, and finished any corrections, you'll deliver final files to the publisher in one of several ways. **(Fig. 3.29)**

We'll cover all these steps in much more detail in Chapter 10, so hang tight!

I Hate Fairyland #10
Courtesy of Skottie Young.

Fig. 3.26

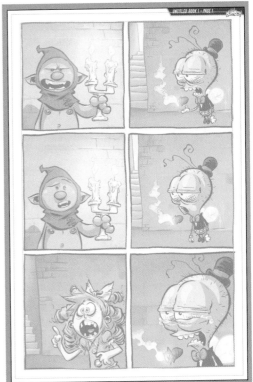

Fig. 3.27

Fig. 3.28

Fig. 3.29

THE TWO VERSIONS OF THE LETTER I IN COMICS

Of all the tips I've posted on social media, this one is by far the most popular. Most people don't even realize there are two versions of the letter I being used. Once it's brought to your attention, you'll spot it in comics both old and new.

Traditionally in mainstream English-language comic book lettering, the "I" with bars is reserved for the personal pronoun, "I." As in, "I like cookies," and the words I'm, I'll, I'd, etc. Some letterers choose to use barred-I in acronyms like C.I.A., or in Roman numerals like WWII. In virtually all other cases, the typical slash-I is used.

Professionally made comic book dialogue fonts usually place the slash-I in the lowercase i key, and the barred-I in the uppercase (or shift + I) key. This is why you should never letter comic books with your caps lock on, or type in all-caps in a script that a letterer will be copying and pasting from. The barred-I will pop up in the wrong places. To a professional editor or letterer, one of the most common signs of a poorly lettered comic book is the incorrect use of the two versions of the letter I.

Correct **Incorrect**

I HAVEN'T BEEN INSIDE THE SECRET ROOM, BUT I INTEND TO FIND OUT WHAT'S IN THERE!

I HAVEN'T BEEN INSIDE THE SECRET ROOM, BUT I INTEND TO FIND OUT WHAT'S IN THERE!

SITTING UP HERE ON THE ROOFTOPS, I'M REMINDED WHY I PROTECT THE CITY...

SITTING UP HERE ON THE ROOFTOPS, I'M REMINDED WHY I PROTECT THE CITY...

In fact, I was never so frightened as when I heard the tires squeal on the pavement.

In fact, I was never so frightened as when I heard the tires squeal on the pavement.

YOU MAY NOT THINK I AM A PERSON, BUT I HAVE FEELINGS JUST LIKE YOU.

YOU MAY NOT THINK I AM A PERSON, BUT I HAVE FEELINGS JUST LIKE YOU.

Like many of our traditions, this one most likely stems from the days of poor print quality. In the event of a misprint, the barred-I was more likely to be legible when used on its own for pronouns than a slash-I.

As a side note, some recently made dialogue typefaces have corrective contextual alternates that resolve this issue as you type. A handy time-saver!

A DOUBLE-PAGE SPREAD TEMPLATE

There will be times when an artist has drawn one enormous piece of art across the facing pages of a comic book. For this, you're going to need a template for double-page spreads. Here's my Blambot version . . . **(Fig. 3.30)**

Fig. 3.30

We're going to create your double-page spread from the standard template you just finished, but with some changes to the artboard measurements and to the guides.

Double-page spreads have a total artboard width of 13.5". The height remains 10.4375", the same as a standard page. The big change to the guides is that there is *no full bleed area between the two facing pages.* The full bleed on a double-page spread exists only on the top, bottom, outer left, and outer right. Take a closer look at the guides in **Fig. 3.30** to see what I mean.

This gets a little complex, so bear with me. Essentially what we're about to do is correct the guides to get rid of the full bleed area that would fall between the pages. Those modified guides will become your guides on the left page. We'll then mirror a copy of those left-side guides over to the right side.

Let's sort it all out, a step at a time...

With your standard template open in Illustrator, before you do anything else, save a copy of it (Command + Shift + S) with a title something like, "Lettering Template Spread.ai." That's what we'll be modifying from here on out. You *don't* want to modify your original single-page template and accidentally save over it!

Switch to the Artboard Tool in the Toolbar (Shift + O), which will show the artboard's editable features at the top of your screen. Make sure the Constrain Width and Height button is toggled off. Change the width to 13.5". That'll change the overall width of your artboard. **(Fig. 3.31)**

Fig. 3.31

We're going to slide all the elements of your title block all the way to their new home on the far right side of your new, wider template. In order to do that accurately, we need to select all the elements of your title block, and then open the Transform window (Window > Transform). First, change the Reference Point (it looks like a grouping of nine little squares), so that the top right square is darkened. Then change the X-coordinate to 13.5" and the Y-coordinate to zero. **(Fig. 3.32)** You should see the Title Block slide over to the exact top right corner of the artboard. **(Fig. 3.33)**

Fig. 3.32

Fig. 3.33

When you're done, *make sure you change the Reference Point in the Transform window back to its default top left corner!* Otherwise, the next time you attempt to use the Transform window, objects will continue to align to the right!

Unlock your Bounding layer, (or if you opted to lock the invisible rectangle itself, right-click on the very edge of the artboard where the rectangle sits to bring up a menu that allows you to Unlock > Rectangle) and move the invisible rectangle that we hid there off the artboard for now. **(Fig. 3.34)** Since it's invisible, just click on the very edge of where it should be, Illustrator will know what you're trying to select. Just remember roughly where you moved it so you can make changes to it later!

Fig. 3.34

With the invisible rectangle put aside, right-click (or Control-click) anywhere on-screen to open up a pop-up menu that lets you Unlock Guides. **(Fig. 3.35)**

Select the full bleed guide (the outermost guide) and change its width to 6.75" in the bar at the top of Illustrator. Make sure that the Constrain Width and Height Proportions button to the right of it is toggled *off.* **(Fig. 3.36)**

Fig. 3.35

Fig. 3.36

Select *only* the two innermost guides—the trim and safe area guides—and group those two together (Command + G). This is important, we want those two inner guides to act like one object when we do the next step...

Grab the two grouped inner guides, and the outer guide, and align them to their right side with the Horizontal Align Right button in the Align window. **(Fig. 3.37)**

You should end up with guides that look like they're aligned like **Fig. 3.38.** The full bleed and trim guides are aligned along their right edge, but the safe area guide is still centered to the trim guide. Here's a close-up. Look at the guides on the left side, and then the right side, and note the different alignment...

Fig. 3.37

Two outermost guides aligned to their right sides

Fig. 3.38

If you did it wrong, you'll know it because the safe area guide will slide all the way to the right, and all *three* guides will look aligned along their right edge.

Notice that the guides aren't aligned to the top left corner of the artboard? Let's fix that. Group all three guides (Command + G). With all three now grouped, select them and align the whole batch to the zero point of your template by changing the X-coordinate in the Transform window to zero. **(Fig. 3.39)** They should slide left and be nice and snug against the top left side of the artboard.

You've just made the guides for the left side of your double-page spread! **(Fig. 3.40)**

Fig. 3.39

Fig. 3.40

MULTI-ARTBOARD TEMPLATES

If you're already very familiar with Adobe Illustrator, you may be asking, why not use multi-artboard templates? The short answer is: you can! There are a few pro letterers who do.

Illustrator supports files that have multi-artboards, so you could have every page of a comic that you're lettering right in the same document, running left to right. This approach is superior for proofing and final filing—you could output .pdf files of a whole book from one document, or save .eps files for every page with a single process. Be aware that there are some minor drawbacks: having to create templates with different page counts, moving all your unused assets along with you as you finish each page, or if a double-page spread comes up, you'll have to edit that particular artboard's dimensions to accommodate.

These are all just quibbles, though. No technique is perfect. That's why we endlessly try to improve them! It's all about what you're comfortable with. If you have the know-how, try working with a multi-artboard version of your template!

We're missing the right page guides, so now we're going to make a copy of the left page guides and mirror them over to the right side.

Select the guides, copy them (Command + C), then paste a copy of them in front (Command + F), directly on top of the original guides. Select the new guides and constrain-drag (hold the Shift key while dragging) them to the right. **(Fig. 3.41)** It doesn't quite matter how far over they are.

Fig. 3.41

Next, we need to flip this new set of guides so they are a mirror image of the originals. To do this, go to: Object > Transform > Reflect to bring up the Reflect window, and flip them vertically. **(Fig. 3.42)**

Now we've got a mirror image of those original guides, and you can see that they would book-match—with no full bleed area between them—if they were aligned to their inside edges. There is currently a space between them, however, and we need to close that up. **(Fig. 3.43)**

Select the right page guides, and in your Transform window, change the X-coordinate to 6.75", and the Y-coordinate to zero. **(Fig. 3.44)** You'll see those right page guides slide into place!

Fig. 3.42

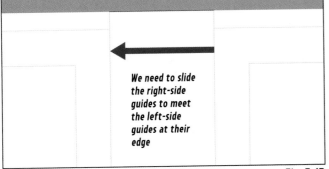

We need to slide the right-side guides to meet the left-side guides at their edge

Fig. 3.43

Fig. 3.44

You should have something that looks like this. **(Fig. 3.45)** See how the two sets of guides are now perfectly book-matched with no full bleed area in between them? That's what we're looking for.

Fig. 3.45

Before we move on, let's lock those guides so we can't accidentally move them. Right-click the mouse, or Control-click anywhere in the document to bring up the menu that will let you Lock Guides. **(Fig. 3.46)**

Now, let's update that invisible rectangle so it's the same width as your spread, and then place it back where it's supposed to be. Do you remember where you placed it in the document for safekeeping? Select it on the Bounding layer, and in the Transform window, change the width to 13.5". **(Fig. 3.47)**

Now we have to make sure it lines up perfectly to our artboard, so set the X- and Y-coordinates to zero. **(Fig. 3.48)**

Fig. 3.46

Fig. 3.47

Fig. 3.48

Now you can lock your Bounding layer in the Layers window (Window > Layers) or lock the invisible rectangle itself by selecting it and using Command + 2. This way it can't be accidentally moved during the lettering process.

Before we finish, let's modify the text of your title block to reflect that this will feature two pages. **(Fig. 3.49)**

ISSUE TITLE 01 › PAGES 02/03 › LETTERER'S NAME

Fig. 3.49

Congratulations! You've finished your double-page spread template! The final file should look something like **Fig. 3.50**.

Fig. 3.50

One important note: save backups of your blank templates. You *will* accidentally save over the original file while working on a comic book page—it's guaranteed. Each of my templates has a backup version. I just add "_bak" to the duplicate's file name.

You might be able to salvage the file from a hard drive backup, but who wants to go through the trouble?

ALTERNATE TEMPLATE SETUP

It's worth noting that there is another style of template that is very common. The big difference is that the artboard is not the exact size of standard art at print size (6.875" x 10.4375"), but is 8.5" x 11". This gives you a gutter area around the guides, and enough room on one side of the guides to place your title block without covering any art at all. Another convenience is that editors who may want to print your proofs for review are already dealing with a universal page size for most printers. The only drawbacks I've found to this method is the exporting of a print-ready .tif may include all that extra artboard space, and exported .eps files placed on art in InDesign may not drop exactly into place.

I worked this way for years until I switched to the style explained in detail in this chapter (because I needed to export .tifs efficiently). As with many lettering techniques, it's all about preference. If you're so inclined, try both approaches and see which one you prefer.

To create your own version, just start out with a default 8.5" x 11" artboard. All the other steps are almost the same except you'll need to create a guide for the outermost 6.875" x 10.4375" full bleed edge. **Fig. 3.51** shows the single-page template I used up until about 2017. **Fig. 3.52** is my old double-page version of this setup which has an artboard size of 11" x 17".

Fig. 3.51

Fig. 3.52

PAGE RATES

Often a taboo subject, I wondered whether to even include a note about page rates. In the interest of my fellow letterers not undercutting one another and being aware of their worth, I decided to address the subject. Rates fluctuate, and if you're reading this far in the future, I'm sure some of these numbers will have changed . . . hopefully to the benefit of the letterers. (Unlikely . . . but we can dream, can't we?)

As I mentioned elsewhere, letterers are considered work-for-hire freelancers—not technically employees of a publisher who are due vacation time, sick days, a guaranteed weekly paycheck, etc. We are paid by the page. A decent, entry-level page rate for a novice being hired by a publisher should span the $10 to $15 range. A seasoned professional should expect $15 to $25 per page. Anything higher than this is generally considered a special perk.

The letterer's page rate includes delivering final lettering as vector files to a publisher—it does *not* include "production" work, e.g., resizing art, marrying lettering to the art, or providing final printable files. Some letterers provide these services as an option at an additional fee—usually $5 or $8 per page.

It's understood that when a publisher promises a project of a certain number of pages, the letterer will invoice for that number of pages regardless of how much or how little lettering is on them.

Sadly, manga letterers translating Japanese comics to English have much lower page rates even though they are doing a massive amount of extra work. They're expected to clean up artwork in Photoshop.

As a freelancer, you will be expected to keep track of the payment status of your projects. It's up to you to send an invoice to the publisher after you've turned in final files.

It's also important to note that undercutting universally accepted rates is frowned upon. While there will always be those freelancers willing to lowball the competition to get work, you must understand that in the long run, this only serves to drive rates down for everyone . . . even the person doing the undercutting. And since we are a community where "everyone knows everyone," word gets around about who's doing this.

CHAPTER FOUR
DIALOGUE

Before we delve into the digital realm, let's take a minute to look at the roots of what it is we do. The defining characteristics of comic book hand lettering began to solidify in the 1940s and 1950s with Ira Schnapp. It continued with letterers like Gaspar Saladino, Ben Oda, Danny Crespi, Artie Simek, and the Rosen brothers. Following in their footsteps were Tom Orzechowski, Todd Klein, John Workman, Bill Oakley, Janice Chiang, Jim Novak, Lois Buhalis, Rick Parker, Clem Robins, Ken Bruzenak, Chris Eliopoulos, Pat Brosseau, and others. These letterers created a wide range of styles that still inspire us today . . . and many have transitioned to digtal lettering!

Hand letterering provided the roots for what we all recognize as comic book lettering, whether we see it in the latest issue of our favorite comic or a window display selling sneakers at the mall. It's no surprise that professionally created comic book dialogue typefaces are inspired by the hand lettered text most commonly associated with those classic comics.

ABOUT HAND LETTERING

I feel as though I'd be remiss if I didn't at least touch on hand lettering. After all, it's at the root of everything we're doing in the digital realm. Know that hand lettering (or even digital hand lettering) is not going to be expected of you by mainstream editors in the modern era of comics. Compared to lettering performed with typefaces, it's more time-consuming, it requires a higher page rate, and for corrective purposes, it is not nearly as editable.

In the heyday of hand lettering, most letterers were either using a wedge-tipped calligraphy nib such as a Hunt 107 "crow quill" with a slightly sanded edge, or a Speedball C6 nib. Calligraphy dip-pens create thin strokes when pulled in one direction, and thick strokes when pulled in the other.

Some letterers used a refillable tech pen. These have a consistent round point and less angular look. Tech pens were always my preferred option, but keeping them clean was a chore. (I admit, these days I use disposable pens or digital brushes that approximate my old tech pens.)

The letterer would receive the original penciled artwork on 11"x17" bristol board before it was inked. (Towards the end of the hand lettering era, letterers might receive 1:1 photocopies of the art, and would tape sheets of translucent vellum over those—then letter on top of that.) The letterer would be responsible for penciling guidelines using a T-square and a plastic Ames guide **(Fig. 4.1)**, before lettering with ink pens. Letterers also usually inked panel borders.

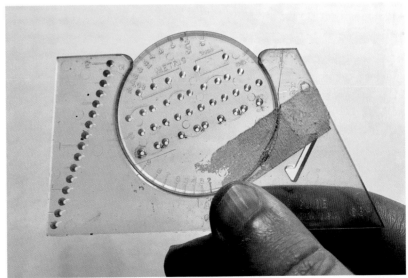

Fig. 4.1

The T-square would be aligned to the edge of the page, with the Ames guide resting on its top edge. The Ames guide, set to 3.5 in most cases, would slide back and forth horizontally by placing a pencil tip in the appropriate holes and drawing lines left and right. (**Fig. 4.2**) These guidelines would allow for a larger space for the letters, and a narrower space for the leading between the lines of lettering.

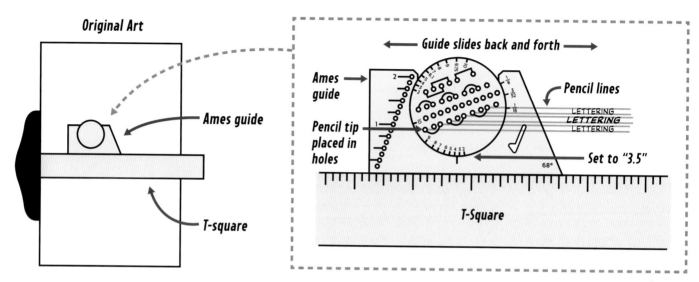

Fig. 4.2

The letterer would complete the dialogue (**Fig. 4.3**) and then ink balloons and panel borders before shipping the art back to the publisher so the art could be inked and colored.

Should you learn to hand letter? In my opinion, yes. Try it with an Ames guide on paper, and digitally in Photoshop with brush tools using a tablet and stylus—it's a valuable learning experience. It's a fantastic way to build your digital skill set on a traditional foundation. Frankly, there are lessons that can't be learned any other way. It'll give you a whole new perspective on the art, and honestly, it's a lot of fun.

Fig. 4.3

Digital typography has carried the traditional look of hand lettering forward with commercially available, specialized comic book typefaces crafted by career letterers.

In general, our typefaces represent the two pen styles most common to hand lettering. (**Fig. 4.4** and **Fig. 4.5**)

Calligraphy Pen Style
Thin vertical strokes, and thick horizontal strokes with a sharper "wedge" point.

AUTUMN LEAVES FLY SWIFTLY ON THE CHILLY BREEZE.

Fig. 4.4

Tech Pen Style
Uniform strokes in both directions, with a rounded point.

AUTUMN LEAVES FLY SWIFTLY ON THE CHILLY BREEZE.

Fig. 4.5

It's best to have a few of each style in your collection. One of your jobs as letterer is to try to make sure your lettering complements the artwork. When I'm deciding on what assets will constitute a style guide on a new series, I start with which dialogue typeface I will use, and I look to the art for inspiration—I also look at the inking tools the artist or inker is using. Beyond that, I consider the genre of the series and the level of realism of the art. Cartoony art can have a much different lettering treatment than a hyper-realistically drawn drama. In the end, experience will provide you with a gut feeling. Trust your design sense.

DIGITAL LETTERING USING AREA TYPE

The default method of typing text in Illustrator is called Point Type—this is used when you select the Type Tool (T), drop the cursor somewhere on a document, and begin typing. Using Point Type, you'll discover that having to hit return after every line of text to make your dialogue fit a balloon shape is a tedious waste of time.

Luckily, Illustrator has a feature called Area Type. You can take any vector object (ellipse, rectangle, star, anything . . .) and turn it into an Area Type object. Think of the Area Type object as a clear plastic bag, and the text as liquid poured into the bag. As you squeeze or stretch the plastic bag, the liquid inside just fills the new shape. No matter what text you paste inside an Area Type object—and as long as the Area Type object is big enough—the words will break into lines of text to fill that shape. **(Fig. 4.6)** Once converted, the shape itself has no fill or stroke, and so is invisible except for whatever text you place inside it. You can enlarge and stretch this Area Type object, and the text inside won't distort, it will just flow to fill the available space.

Fig. 4.6

The goal of using Area Type is that your lines of text will break automatically to fit the shape as you stretch, expand, or contract it. There is no need to manually hit the return key to shape your dialogue line-by-line into an ovoid shape that is small on top, wide in the middle, and small on the bottom to fit inside a balloon. Lettering that way is far more time-consuming and creates hassles when you have to edit during the correction stage.

We can break down the majority of dialogue into three shapes: a balloon shape, a flat-top balloon for butting against panel borders, and a rectangle for captions. You can see the basic shapes more clearly in blue in **Fig. 4.7.**

Fig. 4.7

The majority of letterers use a single rectangular Area Type object for all their text, no matter the intended final shape, be it balloon, butted balloon, or caption. To me, rectangular Area Type objects make sense for captions that are naturally rectangular, but for text meant to fit in balloons, this would means having to manually break a shorter line of

text at the top and bottom of that rectangle using the Return key to make the text stack in a more balloon-friendly shape. This is too much extra work for me . . . especially when you consider that there may be hundreds of balloons in a single issue.

If you create *three* Area Type objects . . . an ellipse, a flat-top ellipse, and a rectangle, all styled with dialogue typefaces that you use frequently, you'll save time in the long run, and only infrequently have to break lines of text with your Return key.

CREATING THREE BASIC AREA TYPE OBJECTS, PART 1

Before we begin, make sure you've got a good comic book dialogue typeface installed on your computer. You'll need it in just a bit . . .

The first step is to create objects in the shapes of the three Area Type objects, so create a brand-new document in Illustrator (Command + N). The size isn't particularly important. The default 8.5"x11" artboard is fine.

Select the Ellipse Tool (L), and draw an ellipse that's slightly wider than it is tall. **(Fig. 4.8)** The exact dimensions don't matter, and neither does the fill or the outline. But for ease of viewing, I'm giving this ellipse a black stroke. This is what we'll turn into your basic Area Type object.

Fig. 4.8

It may surprise you to find out that professional comic book balloons aren't perfect ellipses. They're actually squared off just a tiny bit. It's barely noticeable.

Make sure your new ellipse is *not* selected before switching to the Direct Select Tool (A). Shift + click on each of the four line arcs *between* the anchor points to select them. **(Fig. 4.9)**

Switch to your Scale Tool (S), click and drag just outside of one diagonal corner of the balloon. **(Fig. 4.10** and **Fig. 4.11)** You'll see the lines equally square off. Again, you just want to do this a little bit.

You end up with an ellipse that's just barely squared off, as in **Fig. 4.12.**

Fig. 4.9

Fig. 4.10

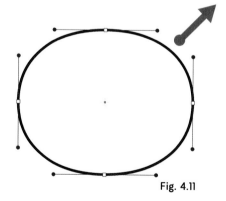

Fig. 4.11

Fig. 4.12

See the slight difference between the shapes? It's subtle, but it's there. **(Fig. 4.13)**

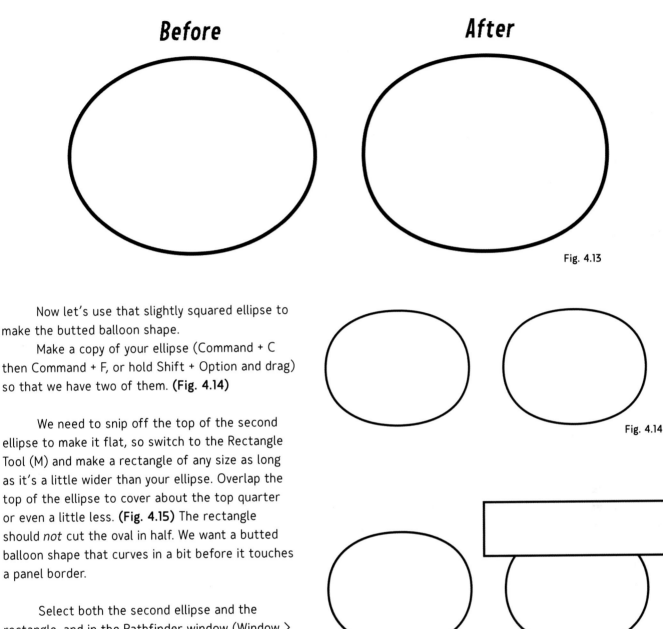

Fig. 4.13

Now let's use that slightly squared ellipse to make the butted balloon shape.

Make a copy of your ellipse (Command + C then Command + F, or hold Shift + Option and drag) so that we have two of them. **(Fig. 4.14)**

Fig. 4.14

We need to snip off the top of the second ellipse to make it flat, so switch to the Rectangle Tool (M) and make a rectangle of any size as long as it's a little wider than your ellipse. Overlap the top of the ellipse to cover about the top quarter or even a little less. **(Fig. 4.15)** The rectangle should *not* cut the oval in half. We want a butted balloon shape that curves in a bit before it touches a panel border.

Select both the second ellipse and the rectangle, and in the Pathfinder window (Window > Pathfinder), use Minus Front **(Fig. 4.16)** to clip off the top. That's two shapes finished. **(Fig. 4.17)**

Fig. 4.15

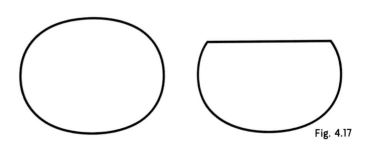

Fig. 4.17

Fig. 4.16

For the caption box Area Type object, all you need to do is go back to your Rectangle Tool (M), and draw a box a little wider than it is tall. (**Fig. 4.18**) Now you have all three shapes!

Fig. 4.18

Now we need to make these three objects into Area Type.

Switch to the Type Tool (T) and mouse-over anywhere on the perimeter of that first ellipse. When you see the cursor change, click once to change the ellipse to an Area Type object. You'll see any fill or outline on the ellipse disappear and get replaced with some lines of random highlighted text. (**Fig. 4.19**)

Fig. 4.19

Repeat this process with the butted balloon object and the rectangular caption object. (**Fig. 4.20**)

Fig. 4.20

Now that we have all three Area Type objects created, let's style the text. With all three Area Type objects selected, go into your Type window (Window > Type) and then to the Paragraph tab. We need to center-justify the text in all three by clicking the Align Center button. (**Fig. 4.21**)

Fig. 4.21

You'll see all the text in the Area Type objects become center-justified. **(Fig. 4.21)**

Lorem ipsum
dolor sit amet, eos
ut error mucius
postulant,

Lorem ipsum
dolor sit amet, eos
ut error mucius
postulant,

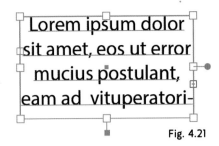

Fig. 4.21

With all three Area Type objects still selected, switch to the Character tab in the Type window. Change the font to the regular weight of the dialogue typeface I asked you to install before we got started. **(Fig. 4.22)** For this example, I'm using my own typeface, Might Makes Right Pro BB. You'll see your Area Type objects change to the new font you selected. **(Fig. 4.23)**

Our text is currently too big for comic lettering. We need to adjust the point size (size of the letters) and leading (space between lines of text). Take another look at **Fig 4.22.** The Point and Leading fields are directly under the typeface Name and Style fields. Point size has a symbol next to it that looks like small and large capital *T*s. Leading has a symbol next to it that looks like two capital *A*s with baselines, separated by a two-headed arrow.

Fig. 4.22

LOREM IPSUM
DOLOR SIT AMET,
EOS UT ERROR
MUCIUS

LOREM IPSUM DOLOR
SIT AMET, EOS UT
ERROR MUCIUS
POSTULANT, EAM AD

Fig. 4.23

But what is the "standard" size for comic book dialogue typefaces? That's a question I get asked *all* the time, and it requires a little explanation . . .

DIALOGUE TYPEFACE POINT SIZE

The truth is, there's no industry-standard point size for comic book dialogue typefaces. The vague answer is: Point size usually lands somewhere between 7.5pt and 9.5pt. This mostly has to do with the fact that a point size in one font might not have the same readability of that point size in another font. This is due to how wide or narrow the characters of a given font design are.

When typographers design typefaces, they have a particular height that all glyphs must fit within, this includes diacritical accent marks. It's logical that the typographer uses up the entirety of this space. Hence very narrow typefaces may look "smaller" at a given point size than those that are very wide.

In the examples in **Fig. 4.24,** imagine that the dashed blue lines represent the maximum height that the typographer can use when programming a font. This space determines the size of the letters at a given point size. Everything has to fit in that height whether the letters are very wide or very narrow. This gives them different "visual weight" even when they're at the same point size.

So how do you know how large to make your dialogue typeface when you letter? To sum up, my recommendation is always, "do some print tests." Fill an Illustrator document with

Fig. 4.24

your chosen dialogue typeface at various sizes, print that out, and compare the samples to other comics. Look at both digitally lettered comics and hand lettered comics. When in doubt, always go a tiny bit *larger*. It's preferable to have text that's just a bit too big than text that's too small to read.

DIALOGUE TYPEFACE LEADING SIZE

Another important tip when sizing typefaces is to think about the leading before you begin. Leading is the space between the lines of text. Leading that is too tight is unreadable, with lines of bold or diacritical characters running into each other. Leading that's too loose is equally unpleasant to the eye, and worse yet, wasteful of space on the page because your balloons will need to be bigger to compensate. **(Fig. 4.25)** You can set a typeface's leading by going to the Character window (Window > Type > Character) and adjusting the Leading coordinates.

My rule of thumb: set several lines of a dialogue typeface in its bold or bold italic fonts and make sure that the lines never collide, then add just a bit of extra room. If the bold lines don't collide, the smaller regular and italic weights won't either.

Leading too tight

LOREM IPSUM DOLOR SIT AMET, EOS UT ERROR MUCIUS POSTULANT, EAM AD VITUPERATORIBUS. SED DETRAXIT VERO PUTANT EX PRO, EI ILLUD MENAND

Leading too loose

LOREM IPSUM DOLOR SIT AMET, EOS UT ERROR MUCIUS POSTULANT, EAM AD VITUPERATORIBUS. SED

Just about right, because...

LOREM IPSUM DOLOR SIT AMET, EOS UT ERROR MUCIUS POSTULANT, EAM AD VITUPERATORIBUS. SED DETRAXIT VERO PUTANT EX PRO, EI ILLUD

...bold italic lines don't collide

LOREM IPSUM DOLOR SIT AMET, EOS UT ERROR MUCIUS POSTULANT, EAM VITUPERATORIBU S. SED AXIT VERO

Fig. 4.25

As with point sizes, you can do print tests of your dialogue typefaces with various leading sizes. You'll often find that the default leading programmed into most typefaces won't be quite right for your usage, and you'll have to adjust them.

Fig 4.26 shows some of my dialogue typefaces *at actual print size,* with my preferred point and leading measurements applied. You can compare print tests of your typefaces to these.

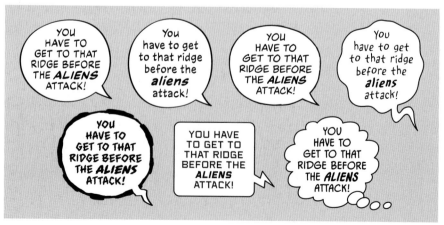

Fig. 4.26

CREATING THREE BASIC AREA TYPE OBJECTS, PART 2

For the example typeface, Might Makes Right Pro BB, I prefer 9.5pt, with 7.5pt leading. **(Fig. 4.27)**

Another important note about kerning—which is the amount of spacial adjustment needed between certain glyphs based on their shape—if the person who designed your typeface did their job well and kerned it properly, you should be able to set the Kerning option to *Auto* in the Character window. If the font is not kerned properly, you may have to set this option to *Optical* and let Illustrator decide on the level of kerning.

With our preferred point and leading size figured out, as well as the kerning option, you should have something that looks similar to **Fig. 4.28**.

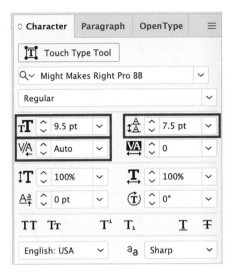

Fig. 4.27

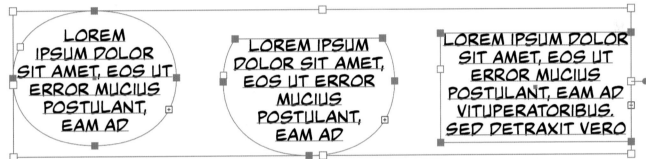

Fig. 4.28

You're also going to want to switch to the Paragraph window (Window > Type > Paragraph) and un-check Hyphenate. **(Fig. 4.29)** You don't want Illustrator deciding to break words in half. If you need to hyphenate, it should always be *your* decision.

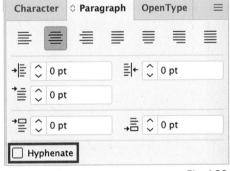

Fig. 4.29

OVERPRINTING K:100 BLACK

Let's make sure our text prints correctly in most situations by default. Select all three of your new Area Type objects and make sure they're filled with a K:100 fill in your Swatches window (Window > Swatches) **(Fig. 4.30)** or the Swatch samples at the bottom of your Toolbar.

"K" is design shorthand for black, as in "CMYK" (Cyan, Magenta, Yellow, blacK), which represents all the potential color combinations in print. The number represents a percentage of each color ink. You want C:0 M:0 Y:0 K:100 for your text. Nearly every time you need to use black in comics lettering, you want to use K:100 and not "rich black," which is a mix of all four colors.

Fig. 4.30

Since the text is K:100 black, it's a safe bet to set it to overprint. Overprinting is a reference to the physical printing process of colored ink on paper. If ink is laid on the page in the wrong order and there is a slight shift during printing, you can end up with weird color halos. Even though you don't have anything to worry about with black text on a white balloon, a good rule of thumb is that your K:100 blacks should be set to overprint just in case you end up designing black text on a color-filled balloon. You'll mitigate overprint errors if the printer prints the black ink *last* on a given page.

Select your new Area Type objects and in the Attributes window (Window > Attributes), make sure Overprint Fill is checked. **(Fig. 4.31)** Now any time you copy and paste duplicates of those Area Type objects, the overprint will already be set.

It's also important to note that if you end up changing the fill of your dialogue to something other than K:100 black, you'll most likely have to un-check Overprint Fill (imagine white text against a red balloon, etc.) You'll have to do this on a case-by-case basis and it's up to you to remember.

Fig. 4.31

All of these rules about overprinting K:100 black also apply to K:100 black strokes—like the black stroke around a balloon—but we'll get to that in the next chapter.

That's it. You've got your first three Area Type objects! Now let's put them into action.

WHY IS COMIC BOOK DIALOGUE IN ALL-CAPS?

Back in the days when comics were printed on newsprint with technology that couldn't even begin to approach the print quality we take for granted now, lettering comics in all-caps was insurance against poor printing. The larger negative spaces in uppercase letters were less likely to close up if ink bled on cheap newsprint paper.

Another reason could be that lettering in all-caps has more uniformity of negative space between lines. Sentence-case lettering (i.e. lettering that includes lowercase letters) has to deal with descenders that dip below the baseline and create wider leading between lines. With all-caps, the space between lines can be more "closed up."

While some letterers will occasionally use sentence-case lettering to show hushed tones or non-language utterances like, "Oof" and "Huh," the majority still use all-caps.

It seems we mainly letter in all-caps due to tradition, although there has been some movement towards sentence-case lettering in the last couple of decades. It's one of those hotly debated topics amongst both industry pros and fans. Most people either love it or hate it.

One pro sentence-case argument is that we now live in the modern age of emails and texting, and all-caps represents shouting. Another pro sentence-case theory is that "you can fit more text in a balloon" . . . but letterers who use sentence-case will usually find that they have to bump up the point size of sentence-case fonts for the sake of legibility in comparison to their all-caps fonts, negating any space that may have been saved.

While I'm not a fan of sentence-case lettering in comics, I have seen it done well, primarily when it's treated more like handwriting than comic book lettering. Plenty of webcomics and projects outside the mainstream have beautiful, sentence-case lettering, complementing artwork that's highly stylized or fantastical. Debates will rage on, but for now, most comics will be lettered with all-caps dialogue fonts.

USING YOUR AREA TYPE OBJECTS WITH YOUR TEMPLATE

You've created these three handy Area Type objects, but how do you put them to use? You can copy/paste them into the Lettering layer of your lettering template, preferably somewhere off the edge of the artboard but within easy reach. Resave the template, or save a copy of the template.

Any time you have a page to letter, with the art in your template and a script ready to go, you can figure out which of these Area Type objects you're going to need in each panel. Using either the editor's placements or your own judgment, copy/paste the elliptical, butted, or caption Area Type objects where they're needed (or better yet, Option-drag duplicates). **(Fig. 4.32)**

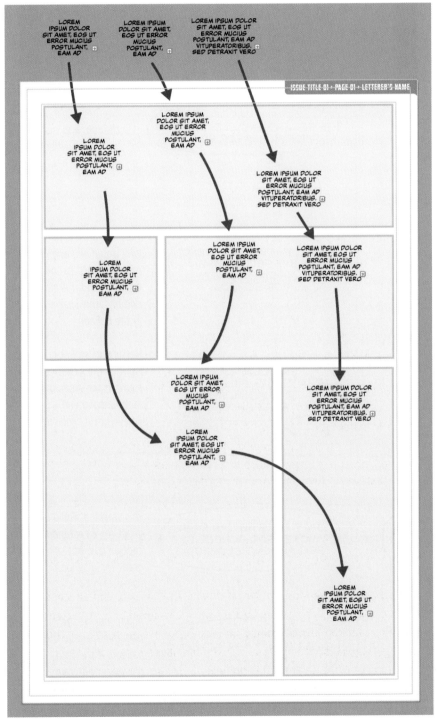

For any butted balloon Area Type objects, you want to place the tops about one text line-height below the actual panel border so there's a space between the panel border and the top of your Area Type object. They need a little room to breathe above the top line later on when you add balloons.

When you've got your various Area Type objects approximately where you think they'll fit over the art, you can go ahead and copy lines from the script (Command + C). Once the text is copied, you can flip back to Illustrator and paste it into the appropriate Area Type objects (Command + P).

It's important to make sure the line breaks and general shape of each Area Type object is the best it can be at this point. **(Fig. 4.33)** You can always change it, but taking some care at this step, will save you time later . . . when you not only will have to change the Area Type object, but its balloon, too.

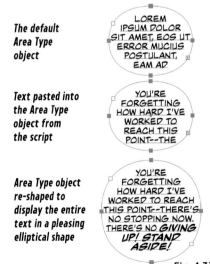

Fig. 4.32

Fig. 4.33

PROPERLY STACKING LINES OF DIALOGUE

Before you can shape a balloon around your dialogue text, you need to make sure the lines are stacked in the most visually pleasing elliptical shape possible. (Or flat-top elliptical shape for butted balloons!) The Area Type objects you created are going to go a long way to help with this, but you should know the right and wrong way to stack lines of dialogue. **(Fig. 4.34)** Poorly broken lines of dialogue text are a dead giveaway of an amateur letterer, particularly when you have a very long word that won't hyphenate well . . .

Text	Correct	Incorrect
Jim is selling encyclopedias to raise money for school.	JIM IS SELLING ENCYCLOPEDIAS TO RAISE MONEY FOR SCHOOL. *The longest word is in the middle. Easy enough! Plenty of options, and no excuse for an oddly stacked balloon!*	JIM IS SELLING ENCYCLOPEDIAS TO RAISE MONEY FOR SCHOOL. — *The middle line is too wide.* JIM IS SELLING ENCYCLOPEDIAS TO RAISE MONEY FOR SCHOOL. — *One tiny word at the top, and too wide everywhere else!*
Encyclopedias aren't a big seller, when raising money for school.	ENCYCLOPEDIAS AREN'T A BIG SELLER WHEN RAISING MONEY FOR SCHOOL. *Here, the longest word is right at the beginning. As long as the middle lines are longer, you're okay! This would also be a great candidate for butting agaist the border at the top of a panel.*	ENCYCLOPEDIAS AREN'T A BIG SELLER WHEN RAISING MONEY FOR SCHOOL. — *The first word is long, why would you add another word to the top line? And it creates odd negative space in the balloon.* ENCYCLOPEDIAS AREN'T A BIG SELLER WHEN RAISING MONEY FOR SCHOOL. — *Better, but still not right. If the negative space in the balloon looks unbalanced, you've got a problem.*
Jim thinks he can raise money for school by selling encyclopedias.	JIM THINKS HE CAN RAISE MONEY FOR SCHOOL BY SELLING ENCYCLOPEDIAS. *Here, the longest word is at the end. Having a long word at the beginning or end is the worst case scenario, but you have to make it work!*	JIM THINKS HE CAN RAISE MONEY FOR SCHOOL BY SELLING ENCYCLOPEDIAS. — *This stacking would be great for a rectangular caption box. Not so great for a balloon.* JIM THINKS HE CAN RAISE MONEY FOR SCHOOL BY SELLING ENCYCLOPEDIAS. — *Again, look at the negative space in the balloon. It's a dead giveaway that your line breaks are wrong.*

Fig. 4.34

SIZING AND SHAPING YOUR AREA TYPE OBJECTS

Once you've pasted some text into your Area Type objects, you need to shape and size them based on two factors: creating a pleasing stack of lines to fit a balloon shape, and using the available negative space in the art to best advantage. These two factors can sometimes be maddening to resolve due to restrictions in the art. Hopefully the artist has left you enough space to fit the amount of text designated by the script so you don't have to cover anything too important in the art. Now that you're using Area Type, you can quickly reflow your text on the fly to check all these factors.

Fig. 4.35

If there's more text than seems to fit in the Area Type object after you've copied the text in there, you'll see a little red warning box with a plus sign in it appear in the lower right quadrant of your Area Type. **(Fig. 4.35)** This indicates that there's an overflow of text that the Area Type object is not big enough to display.

Select your Area Type Object and grab one of the Anchor Points in the four corners of its bounding box. **(Fig. 4.36)**

Drag the handle to resize the Area Type object until you get the right shape to fit the available space in the artwork and the full text revealed in the balloon. You'll see the text flow and create line breaks to fit whatever size and shape you need, and the red warning box will disappear.

Fig. 4.36

Fig. 4.37 features some text in an elliptical Area Type object that has been restacked three different ways by simply grabbing and dragging one of the corner anchor points. These would all be considered acceptably stacked text to fit in a balloon shape given available room on the artwork.

This process is identical for the butted balloon shape and the caption box shape as well.

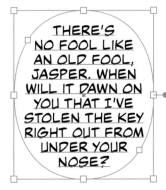

Fig. 4.37

THE GRAWLIX

I know you've seen strings of typographical symbols used in place of swear words . . . but I bet you didn't know that they have a name! They're called grawlixes! Legendary cartoonist Mort Walker coined the term in 1964, and they've since become an instantly recognizable part of our culture.

USE OF FONT STYLES IN DIALOGUE

Now that you can shape an Area Type object and you're acquainted with typefaces, you know that most of them come with different variations like regular, italic, bold, and bold italic. **(Fig. 4.38)** You'll predominantly use three of these variations for different kinds of emphasis (and one for extra emphasis that I'm going to throw in at the end for fun . . .). But professional letterers don't just arbitrarily switch styles on a whim. Let's break down how styles of dialogue fonts are used . . .

REGULAR
ITALIC
BOLD
BOLD ITALIC

EXTRA EMPHASIS

Fig. 4.38

Regular

By far, the regular weight of your dialogue typefaces are going to get the most use. Character dialogue is predominantly set in regular fonts. It represents normal, calm discussion. But using just the regular font by itself can get a little "lifeless." Imagine if a whole comic was set in just the regular weight. **(Fig. 4.39)** Every character would seem to drone on without inflection or interest.

DON'T TAKE THE CHANCE, JIM, YOU'LL NEVER MAKE IT OUT OF THERE ALIVE!

THAT'S FUNNY-- I GET HIRED TO DO ALL THE DIRTY WORK, WHILE YOU GUYS COLLECT ALL THE CASH.

"WHERE DID YOU PUT THE BOMB, YUKIO?! TELL ME RIGHT NOW!"

Fig. 4.39

Italic

The italic style has the most complicated usage in dialogue. **(Fig. 4.40)** Note that any punctuation following an italic word should also be italic.

Book and Movie Titles — As is standard in prose, book and movie titles mentioned in lettering should be italicized.

Internal Monologue or Omniscient Narrator Captions — While italics are not an industry-wide standard here, they are an obvious way to differentiate internal captions from spoken captions, as well as omniscient narration. I prefer to set both of these in italics.

Names of Ships — Whether it's a sea-going vessel or a starship, its name should be italicized.

Non-English Words — Just like you see in novels, non-English words not readily adopted into English should always be italicized.

Non-Word Vocalizations — When a character utters a sound or noise that's not necessarily an actual word—but is not shouting—that sound is often italicized, and can be set on either side with breath marks. Utterances like: *Ugh, huh, oof,* etc. are all non-word vocalizations.

Radio Transmissions — Any sort of dialogue spoken over a radio, telephone, walkie-talkie, speaker, etc. should be italicized.

Song Lyrics — If a character is singing their dialogue, their lyrics should be italicized. (And you'll almost always throw some random musical notes around the balloon as well.)

Thought Balloons - Like internal monologue captions, it's not an industry-wide standard, but you'll sometimes see the text in thought balloons set in italics. In a similar vein, telepathic communication can also be set in italics.

The Exception Reversal — What if the dialogue in question is being broadcast over a radio transmission, but the text mentions the name of a ship? When a situation like this comes up, you'd switch back to the regular weight for the lesser use. In this case, the name of the ship would be switched back to the regular weight. The rest of the radio broadcast would remain italicized.

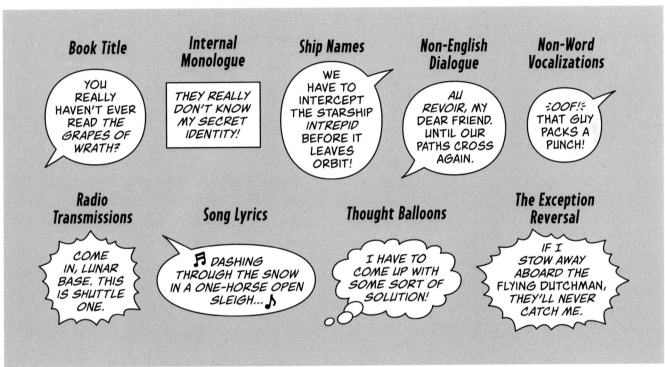

Fig. 4.40

Bold

Oddly, there is almost no plain bold in comics dialogue. **(Fig. 4.41)** Letterer John Workman uses plain bold to indicate emphasis in his hand lettered and digital work, but the majority of the time, bold italic is used to indicate emphasis instead. That said, any punctuation following a bold word should also be bold.

Fig. 4.41

Bold Italic

When a writer indicates a word that needs emphasis in a script, it's set in bold italics in the comic. **(Fig. 4.42)** Bold italic dialogue gives rhythm to otherwise plain dialogue. It lends subconscious beats to the reader, and goes the furthest to providing a realistic speech pattern that we "hear" while reading. Bold italic dialogue can indicate everything from a slight vocal push on a word to an angry shout.

Note that it's not the letterer's job to decide what dialogue is going to be emphasized; the writer will normally have underlined or otherwise indicated emphasized text in the script.

As an exception, I have worked with some writers long enough that we have a somewhat symbiotic relationship regarding emphasis. I know their writing style very well, and what they are trying to get across, and they have no problem with me making some stylistic choices about emphasis. That said, it's not something you'll want to do without permission.

Note that any punctuation following a bold italic word should also be bold italic.

Fig. 4.42

Extra Emphasis

Here's the fourth option that I mentioned earlier, and it's one of my absolute favorite things to letter. Someone is *really* shouting their dialogue, and bold italic just doesn't seem powerful enough. Sometimes you need the dial to go to eleven! It's time to get creative and have some fun. Extra emphasis is often used in conjunction with shout-style balloons. **(Fig. 4.43)**

Tom Orzechowski always did the most beautiful hand lettered treatments in these scenarios, and he's often my inspiration when I need a word or a short sentence to be totally bonkers. I've even designed typefaces just for this kind of use.

Using a beefy font other than your dialogue style (but otherwise complementary and vaguely "shouty" looking) make the desired text bigger, bouncier, and more representative of someone totally losing their cool. I find it helps

HYPHENATION

Hand letterers used to hyphenate words all the time, but by the time digital lettering became the norm, hyphenation fell out of fashion. It's become somewhat of a gray area, frowned on by some publishers and accepted by others.

Personally, I try not to hyphenate if it's possible to shape the lines of text into a decent elliptical shape that will fit comfortably inside a balloon. If I'm forced to choose between torturing lines of text to get them decently stacked or simply hyphenating a word that will easily break in two and not be confusing, I hyphenate.

Here is an example of a particularly awkward sentence to fit into an ovoid shape. It is a perfectly legitimate candidate for hyphenation, particularly because the troublesome word, "commonplace," is easily understood when broken in two.

Text doesn't fit comfortably inside an elliptical shape

Acceptable, but not ideal

Best case scenario with hyphenation

to think of these almost as sound effect treatments from a design standpoint.

I separate the word out of the Area Type text it would normally have been a part of, change the font to something over the top, convert it to outlines (Type > Create Outlines), and adjust individual letters to maximum effect. I usually give it a little extra shear to mimic italicization using the Shear Tool before uniting all the letters back together (Pathfinder > Unite) and making it comfortably sit within the rest of the text in that balloon, if any.

Sometimes you'll see a shout that seems to explode out of the balloon itself. This is done by creating some or all of the shouted dialogue separately from the basic

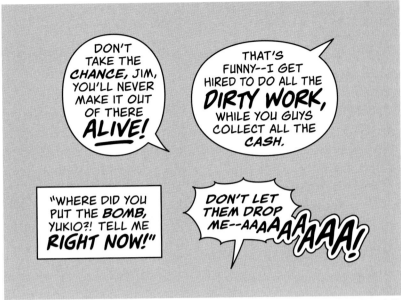

Fig. 4.43

balloon text's Area Type and then using Offset Path to shape what looks like an extension of the balloon around those letters. But we'll talk more about balloons in the next chapter!

DESIGN DECISIONS ABOUT EMPHASIS

One of the many influences that the letterer has on the reading experience of a comic book is their interpretation of *how much* emphasis should be placed on dialogue. Most of the time, a script will indicate a stressed word or scream like this . . .

Lee: AAAIIIEEE!

. . . without much else in the way of indication of intensity (though sometimes a writer *will* add a note indicating an above-average treatment). It may be up to you to decide the context and degree of intensity on the page through design work. In reading the script, does it seem like Lee is just mildly frightened? Is he witnessing something that terrified him? Or is he being torn apart by a ravenous monster? My advice is to take a good look at Lee's face in the artwork and tailor your emphasis accordingly.

The examples below all use that simple "AAAIIIEEE!" as their basis . . . but as you can see, they all evoke a different intensity that will be read and imagined by the reader: the first example is shock, the second is truly terrified, but the third is so ear-splitting that it's represented more like a sound effect than dialogue.

Of course, another factor you'll have to take into consideration in these situations is how much available space you have to work with in the art.

QUICKLY CHANGING FONTS BY USING CHARACTER STYLES

By the end of this book, you'll be sick of me telling you that time is money and every process you can shorten will make your page rate that much more profitable. Case in point: once you start lettering in earnest, you'll notice that you'll end up doing a lot of switching of fonts from regular to italic or to bold italic. Even if the script you're copying from has bold or italic words already in it, you can't currently copy the styling into Illustrator . . . just the words.

Normally you'd use the Style drop-down menu in the Character window to change fonts, but that's tedious. With a little prep you can make any of those changes with a single click in the Character Styles window (Window > Type > Character Styles). You just have to go through the manual steps once and save them as Character Style options.

For example, let's say you've decided to use Might Makes Right Pro BB for the dialogue of a new series. I've already showed you how to style the three Area Type objects. I used Might Makes Right Pro BB Regular at the point size and leading I prefer, so let's continue with that example. You can use whichever typeface you used for your Area Type objects, of course.

Open up a copy of your lettering template and paste your Area Type objects on the Lettering layer if you haven't already. With one of your Area Type objects selected, click the Create New Style button at the bottom of the Character Styles window. You'll see a new entry called "Character Style 1" pop up. **(Fig. 4.44)**

Just double-click and rename it to the name of the font you used. In this case I'll call it "MMRP Regular." **(Fig. 4.45)**

That's it! The Regular style is saved with the point size, leading, and alignment of your default Area Type text.

You can repeat this process to make entries for bold italic: select one of those Area Type objects and manually change it to Bold Italic in the Character window.

Then, once again, press the Create New Style button in Character Styles, and finally, rename it by double-clicking on the entry and typing its new name. **(Fig. 4.46)**

Repeat the process again to create an italic Character Style.

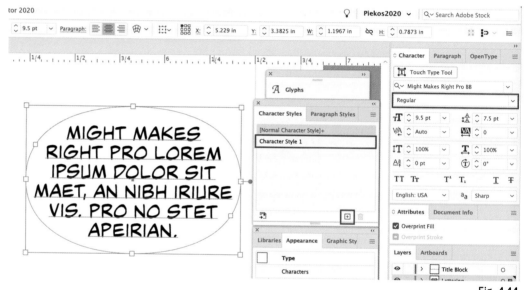

Fig. 4.44

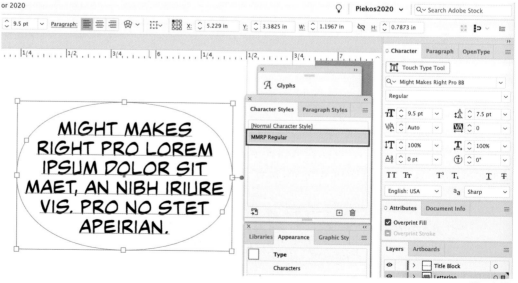

Fig. 4.45

Now if you use this particular Illustrator document and you leave the Character Styles window open somewhere in your workspace, you've got one-click buttons for any time you need to switch styles! You can select or highlight some text and click one of those buttons any time you need to switch to a particular style of Might Makes Right Pro BB in your preferred size, leading, and alignment. **(Fig. 4.47)**

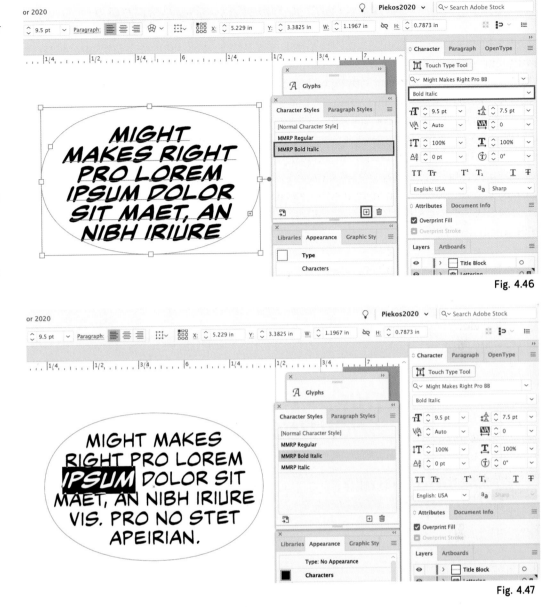

Fig. 4.46

Fig. 4.47

BREATH MARKS

Also known as "cat whiskers," "fireflies," and "crow's feet," breath marks are typically three small dashes that come before or after a cough, sputter, or some non-language vocalization. The word contained in the breath marks can be italicized, lowercase letters, or bold italic. Typically, a writer will indicate a word surrounded by breath marks with the greater than and less than symbols, such as . . . >COUGH!< . . . but most comic book dialogue fonts actually contain the breath marks in the *brace* keys, with the opening breath mark in the { key and the closing breath mark in the } key.

A fun tip: if you use an opening and closing breath mark together, they form a little burst that can indicate a character trailing off into unconsciousness or death!

TYPEFACES BEYOND NORMAL DIALOGUE

While I've mostly focused on the standard style of comic book dialogue typefaces, you will quickly discover that you're going to need interesting "voices" for all variety of odd characters. **(Fig. 4.48)** Since I presume you're just starting out, the most useful typefaces you might consider purchasing are: something scary and monstrous, something robotic, something wispy and ghost-like, and a weird alien language symbol font. Beyond that, I also recommend you buy something like your basic dialogue fonts, only in lowercase (some dialogue sets inlcude a lowercase version, or at least have a separate lowercase version for sale), and something more intense and "shouty" than your typical bold italic fonts (see "Extra Emphasis" in Chapter 3).

THE COMPUTERS WERE MORE FRIENDLY IN 1980, DUDE.

I'M A BIG, SCARY MONSTER! GRAAR!

I'm a lowercase tech pen style.

MONSTEROUS GROWLING!

Well now, I'm a prim and proper calligraphy pen.

I'M A CLEAN-CUT ROBOT!

DRAGON'S JUST LOVE TREAURE!

We small folk love a good party.

This is a voice from beyond the grave!

THIS IS FOR SHOUTING!

THIS IS A MORE ORGANIC ROBOT STYLE.

Yet another lowercase wedge pen!

Insert data chip to access engine operating system_

ENORMOUS ROBOT COMMANDS YOU!

I'm writing in my journal. These are my private thoughts.

IS THIS SOME SORT OF MONSTER? COULD BE!

I'm a very dignified old English phantasm.

TIME IS SHORT. YOU SHOULD HURRY UP, ORGANIC LIFEFORM.

THIS STARSHIP REFUSES YOUR REQUEST!

Humans are silly, finite creatures.

I'M STILL SHOUTING AT YOU!

I AM FROM THE GREAT BEYOND!

I CAN'T STOP YELLING!

AN ANCIENT EVIL AWAKENS!

I'm a goofy picture book character come to life!

Fig. 4.48

I will warn you that it's easy to get carried away. Once you have all these interesting options, it's understandable that you'd want to use them. But I implore you to use restraint. As always, a little goes a long way. Having dozens of characters with dialogue set in all different typefaces in a comic can quickly become an annoyance.

CREATING A TYPE MORGUE

Speaking of typefaces for lettering comics . . . if you don't already have a collection of them, *you will.* And it's not convenient to clutter up your lettering template with an Area Type object for every single one of them. "Morgue" isn't just a reference to a place where dead bodies are stored . . . it's an informal design term that means a collection of reference material. It's going to be handy to create a "type morgue" of all your most-used typefaces at their most-often-used point and leading sizes.

Take those first three Area Type objects we made and copy them to a new Illustrator document. The size of the artboard doesn't matter. Save this new document as "Type Morgue.ai" wherever you're storing your templates.

Any time you install a new dialogue typeface on your computer, you can open your type morgue, make a duplicate of those first three Area Type objects, and restyle them with the new fonts. Decide what point size and leading looks best in the new typeface and then resave your type morgue. Pretty soon you'll have lots of styles to pick from for any new project with no additional point or leading adjustments required—just copy and paste whichever ones you need into the lettering template of a new project!

Here's a look at my Type Morgue (**Fig. 4.49**) containing groups of the three basic Area Type objects, styled with the fonts I tend to use most often, in my preferred sizes. You'll notice I also keep a collection of my most-used time/locator caption styles, too.

By the way, if you set up Character Styles for all these typefaces in your Type Morgue, those Styles will copy over into new Illustrator documents when you copy/paste them.

Fig. 4.49

OPENTYPE AUTO-LIGATURES AND CONTEXTUAL ALTERNATES

It's commonplace for professionally made dialogue typefaces in OpenType format to feature ligatures and contextual alternates these days. When shopping for new typefaces, make sure to look for these features in the description.

Ligatures and contextual alternates are special features that the typographer has programmed into the fonts that discreetly perform some helpful (or design-related) function as you type. The point of these features in comic book typefaces is almost always to lend a slightly more organic look to better approximate hand lettering. While no one's going to be fooled into thinking a typeface is actually hand lettered, these features do lend a lot of pleasing variation.

The most common ligatures in dialogue fonts are duplicate adjacent letter variations. For instance, if you typed the word, "book," the two Os would look slightly different when next to one another.

My Might Makes Right Pro BB swaps out duplicate adjacent letters. **(Fig. 4.50)** Take a close look at the double letters in this short sentence . . . they vary just a bit . . .

AARON ADDED CREEPING MOSS.

Fig. 4.50

If you purchase a dialogue font that has ligatures like these, you may need to activate them in Illustrator. In the OpenType window, (Window > Type > OpenType) **(Fig. 4.51)** make sure the Standard Ligatures button is "on." It looks like a little conjoined *f* and *i*.

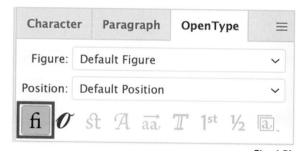

Fig. 4.51

Another OpenType feature that your dialogue typefaces might have are contextual alternates. These can correct errant use of the barred-I, or even make it seem like there are lots of letter variations that appear at random for an even *more* organic appearance than just duplicate adjacent letters.

In my typeface Collect Em All BB, there are six different versions of every letter, three versions of every number, varied exclamation points, question marks, and more . . . all of which just appear as I type or copy/paste from a script into my Area Type objects. Look closely at the letters in **Fig. 4.52.** Can you spot differences?

YOU MEAN WE HAVE TO DIG THROUGH 665 PLANETS IN THIS SYSTEM?!!

Fig. 4.52

It's subtle, I know. How about looking at a color-coded version **(Fig. 4.53)** to help you locate the differences. Focus on just the yellow *O*s, or the pink *H*s . . .

YOU MEAN WE HAVE TO DIG THROUGH 665 PLANETS IN THIS SYSTEM?!!

Fig. 4.53

Just like the basic ligatures, contextual alternates can be turned on in the OpenType menu. It's the button that looks like a cursive *O*. **(Fig. 4.54)**

Want to make sure any Area Type objects always have these features turned on when you use them? Open your Type Morgue, select your Area Type objects, and click those buttons in the OpenType window if they are available. Then resave your Type Morgue!

Fig. 4.54

A LITTLE CARE NOW GOES A LONG WAY LATER

As we wrap up this section, I want to take a minute to reinforce something I mentioned earlier: the more thoughtfully and carefully you design your dialogue, the fewer headaches you'll have when you move on to the ballooning stage.

Crafting dialogue for the whole page is my first step, and I make sure that all the text is as perfect as I can get it before I even think about shaping any balloons. This doesn't mean I never have to tweak things . . . but when I do, it's one small change here or there, and not recurring changes popping up page after page.

Ideally you want to make sure your Area Type objects have lines that are stacked exactly the way you want them. Floating balloons should have a nice oval shape with no distracting negative spaces. Your butted Area Type objects should flare out from their flat tops before they swoop back in towards their bottoms, and they should be properly spaced away from the panel borders to allow about a line's width of breathing room. Caption Area Type objects should be nice and rectangular (assuming you're planning for rectangular captions—there are lots of design options—but we'll cover those later!).

If you just slap these together at top speed, you're going to find later on that you'll be constantly stopping to tweak lines when you should be breezing through balloon design . . . it's an annoyance to constantly go back to the Dialogue layer to reshape an Area Type object and then check its balloon. Is it right? No? Adjust again . . . knock a word down to the next line and modify the balloon again . . . It's a ripple effect. The dialogue shape is the foundation of the balloon shape!

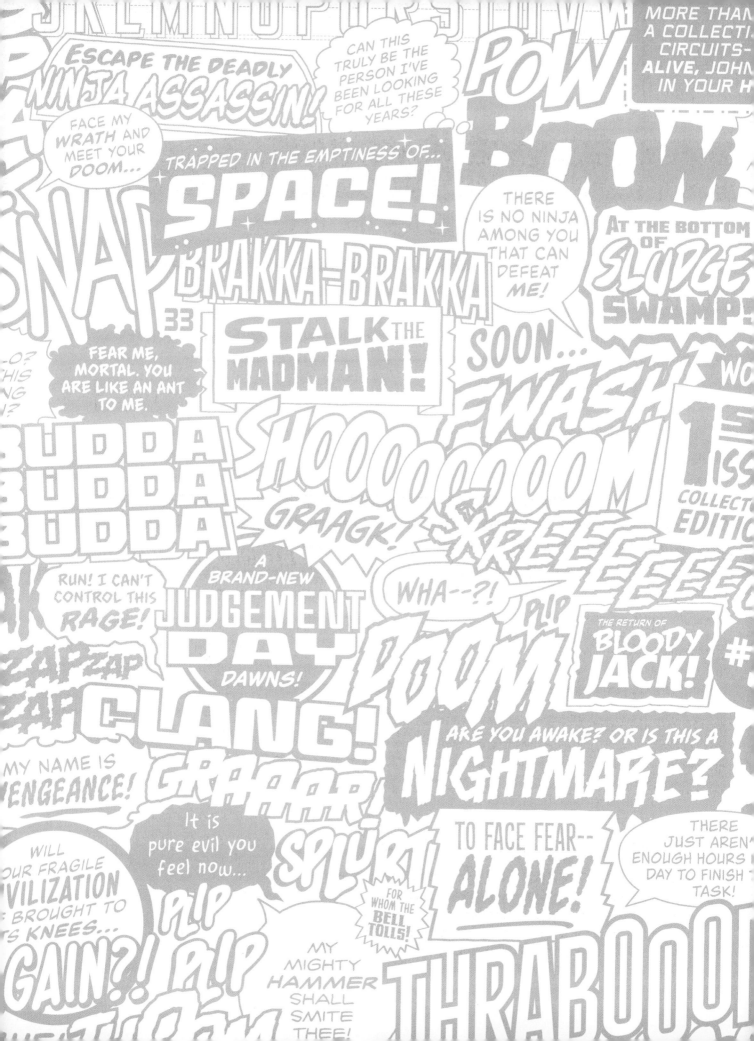

CHAPTER FIVE
BALLOONS

Dialogue balloons are design elements that virtually everyone recognizes as a universal representation of "comic books." When they're done right, the eye glides over balloons with hardly a second thought. When they're wrong, they pull the reader out of the reading experience and can ruin an otherwise wonderfully drawn page.

This is why people assume lettering is easy—and why it's often treated as an afterthought—because dialogue balloons are just a circle with a tail, right? Anyone can do that. Well, anyone can do it at an amateur level. Letterers end up spending hundreds of hours practicing so the dialogue balloons they've created have an effortless, consistent quality.

All styles of balloons share their roots with a basic white oval with a black stroke and a tail—from heavy, craggy balloons made to look like they're spoken by a monster, to ethereal, wavy telepathy balloons.

Before we get to work, let's make sure we're all on the same page with some descriptive terminology. Take a look at **Fig. 5.1,** which details the anatomy of balloons.

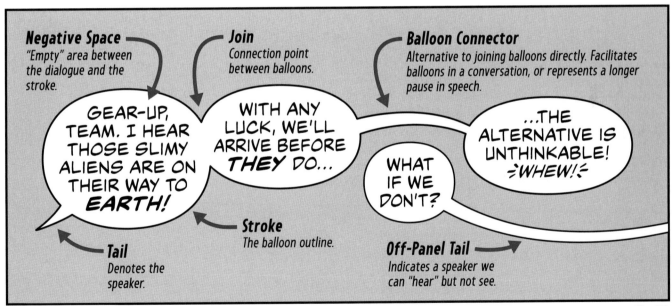

Fig. 5.1

CRAFTING DIALOGUE BALLOONS

Much like the Area Type objects I had you create in the last chapter, letterers generally don't craft a new balloon every time they need one. That would be too time-consuming. We create some standard styles that we keep as assets off to the sides of our template's artboard and copy/paste them around the artboard where they're needed.

It's handy to have two versions of standard balloons: the basic ellipse, and a slightly more squared-off ellipse for dialogue that stacks better in a more rectangular shape. Let's begin with the basic ellipse.

We're going to start out the same way we created the Area Type objects in Chapter Four. In the Balloons layer

of your template, switch to the Ellipse Tool (L) and draw a roughly 1" wide by ¾" tall ellipse. **(Fig. 5.2)** The exact size isn't all that important. Make sure it has a white fill and a K:100 black stroke in your Swatches window (Window > Swatches).

Fig. 5.2

The fill and stroke are represented by the pair of boxes in the upper left corner of the Swatches window. **(Fig. 5.3)** The solid box is the fill color, and the outlined box is the stroke color. You can toggle between them with the X key on your keyboard. Just under that you'll see a white swatch that you'll want to use for your balloon fill. Right next to it is a black swatch, which is the K:100 black for your stroke.

If you want to double-check that you're using the correct black, double-click the black swatch to bring up the Swatch Options window. **(Fig. 5.4)** You can see the exact color mix. In this case, black is at 100% and everything else is 0%. That's perfect.

As you already know, professional comic book balloons aren't perfect ellipses. Let's make another slightly squared-off ellipse the same way we started the Area Type objects in Chapter Four, in the section: Creating Three Basic Area Type Objects, Part 1 (See that section for detailed step-by-step images).

Make an ellipse with the Ellipse Tool (L) before switching to the Direct Select Tool (A). Shift + click on each of the four line arcs *between* the anchor points to select them.

Switch to your Scale Tool (S), click and drag just outside of one diagonal corner of the balloon. You'll see the lines equally square off. Again, you just want to do this a little bit. You'll end up with a barely squared-off ellipse as in **Fig. 5.5.**

Fig. 5.3

Fig. 5.4

Fig. 5.5

By default, Illustrator will give an object a standard 1pt stroke. But I find that just a tad too beefy in print. Preference of stroke weight for balloons varies slightly from letterer to letterer, but I've found a stroke weight of .75pt. is about right for visibility against most artwork without being too obtrusive. It also usually balances out nicely with the "pen stroke" of most dialogue fonts. Try it out by selecting your balloon, and in the Strokes window, give it a Weight of .75. **(Fig. 5.6)**

Fig. 5.6

In the last chapter I mentioned overprinting K:100 black fills. The same goes for K:100 black *strokes* on a balloon. Now is a good time to set your balloon's K:100 black balloon stroke to overprint. With your balloon selected, open the Attributes window (Window > Attributes) and check Overprint Stroke. **(Fig. 5.7)**

Fig. 5.7

This offers you some insurance against misprinting when the time comes, and it's generally a good idea to set any K:100 blacks that will appear directly "against" inked and colored art to overprint.

That's one balloon finished. The second variation is just a little more squared off than the first.

Make a duplicate of your first balloon (copy/paste, or Option + drag) and repeat the first step where you used the Direct Selection Tool (A) and the Scale Tool (S) to square off each of those four diagonals while holding the Shift key. You want your second balloon to be a little *more* rectangular than the first.

You should now have two balloons that look like **Fig. 5.8.**

Fig. 5.8

This second, more rectangular balloon is particularly useful for when you have dialogue that seems to stack neatly in a more rectangular shape. Some letterers prefer not to use this second variation. I prefer the rounder first balloon shape myself, but I will use the second variation when the stacked dialogue seems to fit better. **Fig. 5.9** shows some dialogue that fits better in the negative space of our slightly more rectangular balloon . . .

Fig. 5.9

There you have the two primary balloon shapes. You can drag them off to the side of the artboard in your lettering template for safekeeping. Don't forget to resave your template. You might want to copy/paste them over to your double-page spread template as well!

Just like you copy/paste your Area Type objects for dialogue, you will copy/paste these balloons where they are needed before shaping them to fit your dialogue text.

FREE-FLOATING BALLOONS

As I mentioned previously, before any ballooning happens during the lettering process, you should get all your Area Type objects where you feel they'll work best, and then copy/paste your dialogue from the script into them. Make sure you've also styled any emphasized text as well, since bold italic words may change the line width of text, and therefore, your balloon dimensions. Once you've resized the Area Type objects to fit the available space on the art and have the most pleasing line breaks, then you can move on to balloons.

You may have to make some small adjustments during ballooning, but for the most part, you don't want to be fiddling with text at this point. The text now dictates the shape and size of your upcoming balloons, and any changes to the text after ballooning may mean edits to the balloons as well.

Fig. 5.10

When you're reasonably certain that your text is as ready as it's going to be for balloon placements, I recommend locking the Lettering layer in your Layers window. **(Fig. 5.10)** I do this so that I don't accidentally nudge or grab any Area Type objects on that layer while I'm ballooning. You can easily lock or unlock any layer as needed by clicking one of the empty squares that corresponds to a particular layer in the second column of your Layers window.

Let's start with "ballooning" some basic elliptical Area Type objects. **Fig. 5.11** shows three free-floating elliptical Area Type objects shaped so that the text within them is optimally stacked in balloon shapes.

WHEN I
WAS YOUR
AGE, WE HAD
TO SEW OUR
OWN SUPER
SUITS!

GEE,
MACK, I DIDN'T
THINK YOU WERE
THAT **OLD!** I MEAN,
THESE DAYS, WE
JUST ORDER
ONLINE.

YOU LITTLE
PIPSQUEAK! I AUGHTA
SHOW YOU ANOTHER THING
THAT WE USED TO PRACTICE
IN THE OLD DAYS...A LITTLE
RESPECT!

Fig. 5.11

Just by looking at dialogue shapes like these, you should begin to train yourself to decide which balloon shape will best fit the text. The first two seem to call for the rounder balloon shape, and the last one could go either way, but let's use the more rectangular balloon for that one.

BALLOONS OR BUBBLES?

Among professional letterers, the preferred term for all sizes, shapes, and styles is "balloon," not "bubble." The follow-up question is usually, "But what if it's a thought bubble?" In every case, it's called a balloon—regardless of what kind of balloon you're referencing. (So to answer the question, it's called a "thought balloon.")

This is one of those nitpicky details that doesn't matter to the world at large, but for some reason, seems to get a lot of letterers all riled up.

Let's pretend the text has been placed on the art in the best location possible before locking your Lettering layer so none of it is accidentally nudged.

On your Balloons layer, copy/paste your balloons approximately where you'll use them. I like to drop them near the upper left corner of the text. **(Fig. 5.12)** Since your template's Balloons layer is below your Lettering layer, balloons will always appear beneath your text.

Fig. 5.12

Select each balloon in turn with the Selection Tool (V), and using the corner bounding box points, reshape it so that it fits around the text. **(Fig. 5.13)** It may take you a few tries. That's okay!

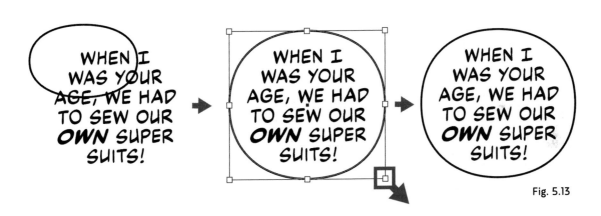

Fig. 5.13

With balloons comfortably shaped behind all three Area Type objects, we have **Fig. 5.14.**

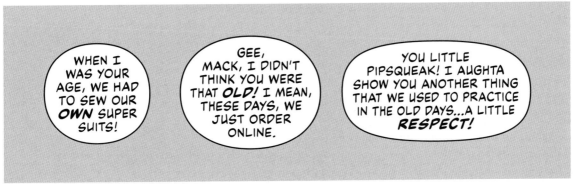

Fig. 5.14

One theory about negative space in a balloon is that there should be enough of it between the text and the outside stroke of the balloon that you could comfortably fit an uppercase letter from your dialogue typeface anywhere around that inside circumference. (**Fig. 5.15**)

This isn't an exact science, so rely on your intuition as well. Eventually you will just be able to "eyeball" it in a few seconds as you work.

At first, shaping balloons is going to seem to take forever, especially if you really zoom in and start tweaking things. Just remember that practice makes perfect. It all comes down to finding a balance between positive and negative space. Professional letterers can place and resize a balloon in seconds, most of the time on their first try. It gets easier after the first few hundred times!

If you'd really like to be precise while aligning the balloon to the very center of the text, there is a trick called Align to Glyph Bounds. In your Align window (Window > Align), click the hamburger icon in the top right corner (**Fig. 5.16**) to open a flyout menu. Click the last selection, Align to Glyph Bounds, and finally, make sure Area Text is checked. (**Fig. 5.17**)

Fig. 5.15

This will ensure that any object you try to align to your Area Type object will use the *center of the text* inside the Area Type object, not the *perimeter* of the Area Type object itself. This is important because often the Area Type object has slightly different proportions than the text within.

Fig. 5.16

Fig. 5.17

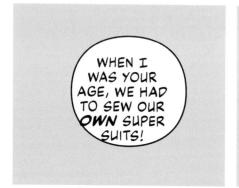

Fig. 5.18

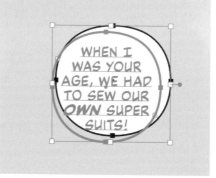

Fig. 5.19

Fig. 5.20

In **Fig. 5.18,** I've intentionally bumped the balloon off-center to show you how this works. Select the balloon and the Area Type object, and then click on the Area Type object *again* one time. This is important—you'll see the Area Type object highlight as shown in **Fig. 5.19**—this tells Illustrator to *center the balloon on the Area Type object,* and not the other way around. Now use the Horizontal Align Center button and Vertical Align Center buttons in the Align window (**Fig. 5.20**). The balloon will slide over and perfectly center on the text in the Area Type object, as in **Fig. 5.21.**

Fig. 5.21

Note that the Align to Glyph Bounds trick may not work on very organic or irregular balloons—they're asymetrical by nature—you may have to align those by eye. To be honest, I rarely use Align to Glyph Bounds. After years of lettering, and because I mostly use organically-shaped balloons, it's faster for me to just align by eye while I'm sizing balloons. (We'll talk more about organic balloons later!)

JOINING BALLOON TO BALLOON

A character may have a series of dialogue balloons in a sequence. This is an indication to the reader that the person is expressing more than one idea. We give them separate balloons as a visual cue to the reader that there are "beats" between their expressions, because that's how people actually speak in real life. If we lumped all of their speech together in one huge balloon it would seem as if they were speaking with one long, monotonous, "run-on" tone of voice. Alternatively, separating direct addresses to different characters in a scene helps the reader understand that the directives are meant for more than one character.

Typically, the writer will indicate a sequence of balloons spoken by a single character in a panel just by repeating the character's name:

ISABELLA: We must prepare for the worst. I fear the battle is at hand . . . and our resources are low.
ISABELLA: Tom, get the children and the elderly to shelter.

When you have two balloons finished, first overlap them slightly where you want them to be joined. **(Fig. 5.22)** Select both balloons, and in the Pathfinder window (Windows > Pathfinder), click on the "hamburger" icon in the upper right corner to bring up a flyout menu. **(Fig. 5.23)**

In that flyout menu, click on Make Compound Shape. **(Fig. 5.24)**

Fig. 5.22

Fig. 5.23

Fig. 5.24

You'll see the overlap disappear, seeming to make the balloons a single object (**Fig. 5.24**) . . . but this is actually a little sleight of hand on our part!

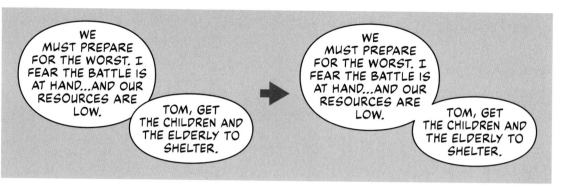

Fig. 5.24

The balloons may *look* like they're a single object, but because we used Make Compound Shape, Illustrator still remembers that they're two objects. If you select them, you'll see the perimeters of both balloons have been preserved where they overlap. **(Fig. 5.25)**

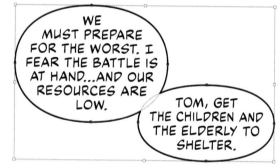

Fig. 5.25

We do this just in case there are any future edits that need to be made to the balloons. As with all compounded objects, if you ever need to make changes to the joined balloons, just select them with the Direct Selection Tool (A) and adjust, or separate them by going back to the flyout menu in the Pathfinder window and selecting Release Compound Object.

While we're on the subject of joining balloons, any time there's a series of three or more joined balloons, I always prefer to place the tail on the first or last balloon in the series, not the balloons in between. This is purely my preference, though. Do what looks right to you.

We'll talk about tails in a moment, but before we do . . .

A BRIEF REMINDER ABOUT CREATING ACTIONS

In Chapter Two, I demonstrated Illustrator Actions and suggested you begin to record all of your most repeated processes. Make Compound Shape and Release Compound Shape are absolutely the most essential Actions you can record if you're using the Stroke Method of lettering. As you'll see in the rest of this chapter and beyond, you will use Make Compound Shape and Release Compound Shape constantly to join and release balloons, tails, and connectors. Reducing their use from a three-step process to a pair of single-press F-keys will save you more time than any other Action, making the Stroke Method of lettering an even more viable technique.

REFLECTIONS DON'T SPEAK

You'll encounter this scenario more than you'd anticipate: you're lettering a page that has people involved in a conversation inside a car, and the artist has drawn a panel with a "camera angle" shot from the back seat, looking into the rearview mirror. In the reflection, we can see the eyes of the person speaking a line of dialogue.

Your first impulse may be to point a tail at the mirror, but since the mirror isn't speaking, it's my preference to point a tail, or an off-panel tail, in the direction of the person speaking. There are exceptions, of course . . . in the fantastical world of comics, enchanted scrying mirrors are possible!

INTRO TO BALLOON TAILS

Creating a standard balloon tail in Illustrator takes just three clicks with Illustrator's Pen Tool . . . which sounds deceptively simple, but there's a Zen art to perfectly crafting them. The name of the game is consistency.

Much like the importance of reading order with balloons, tails must always clearly indicate who is speaking. A tail should point toward a speaker's head (not their shoulder, or their shoes . . .) and while there's no rule about how long a tail should be, I find that most tails end up extending about 60% to 70% of the distance between the balloon and the speaker. Most of the time this decision has to do with how much room has been left in the art, and avoiding tangents (which are addressed in an aside later on . . .) The only time I like to bring the tip of a tail closer to a figure is when there is a group of characters off in the distance that is very small; it's important to be absolutely sure which character in the group is speaking.

As with Area Type objects and balloons, some letterers like to make a whole bunch of tails of different lengths and curvatures and save them for future use. However, for *basic* tails, I find that this approach is more work than creating them on the fly. It takes longer to hunt through my saved assets for a tail of the right length and curvature, then rotating it and tweaking it to get it just right—and you know how much I hate wasting time! For standard tails, I find it takes me just a few *seconds* to make them from scratch as I work. After many years, it's second nature to draw a new tail in exactly the right spot, with the right curvature and width, without even zooming out after placing a balloon . . . three clicks and done!

Note that process-wise, if you're creating fresh tails each time and using the Stroke Method of lettering, it's convenient to add your tails *as you make each balloon.* Illustrator "remembers" the fills and stroke weight of the last object you selected—therefore, if you just placed and adjusted a balloon, the same fills and stroke weight will be applied when you switch to the Pen Tool to make your tail. While I recommend creating basic tails from scratch as you move along, it takes more practice. There's no wrong way . . . it's all about what you're used to and comfortable with.

Fig. 5.26

Let's use one of our previous balloons as an example for making tails. **(Fig. 5.26)** For now, let's not worry about where the speakers are, but focus on the technical aspects instead.

The first thing to remember when drawing a tail is that no matter where it's pointing, its length or curvature, it should always seem to emanate roughly from the center of the balloon. Look at the following examples in **Fig. 5.27.** Notice how awkward the incorrectly designed tails look compared to those that emanate properly from the center of the balloons.

<div align="center">Correct</div>

<div align="right">Incorrect</div>

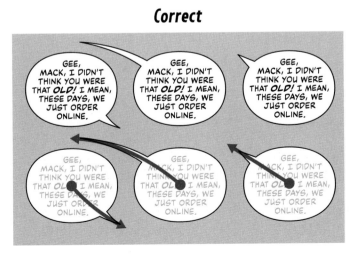
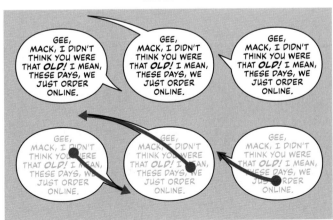

Fig. 5.27

CRAFTING A STRAIGHT TAIL

Let's begin with the simplest kind of tail—one with straight sides.

First, make sure you're on your Balloons layer and switch to the Pen Tool (P). Click once and make a point inside the balloon. Once you move off that point, you'll notice Illustrator previewing a line segment wherever you move your pen point. Use that to estimate where your next point should be placed, and click a second time to make the point of the tail. **(Fig. 5.28)** Finally, click a third time, inside the balloon, to complete the object, making an imperfect triangle. **(Fig. 5.29)**

This is going to take some practice. Visualize where the point of the tail should end up, and remember that the whole tail should seem like it's emanating from the center of the balloon.

If the tail does not already possess the fill and stroke of your balloons, now's the time to apply those. You can select the tail with the Selection Tool (V), switch to the Eyedropper Tool (I), and click on a balloon. The balloon's properties will be applied to the tail.

With that, you've drawn your first tail! Now we need to impermanently join the tail to the balloon in case we need to edit it later. This is the exact same process that we used to join a balloon to another balloon earlier. Select both the balloon and the tail, and in the Pathfinder window, click on the hamburger icon in the upper right corner to bring up a flyout menu. **(Fig. 5.30)**

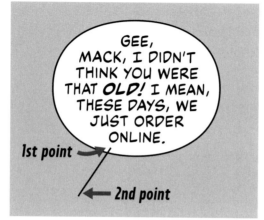

Fig. 5.28

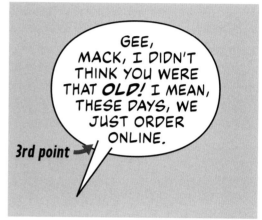

Fig. 5.29

Fig. 5.30

Fig. 5.31

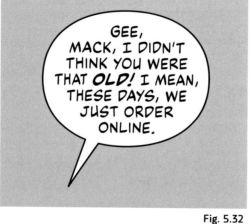

Fig. 5.32

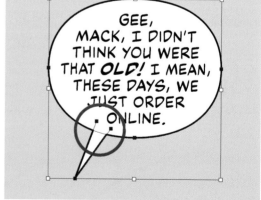

Fig. 5.33

In that menu, click on Make Compound Shape, **(Fig. 5.31)** which impermanently joins your tail to your balloon. **(Fig. 5.32)**

If you click on the balloon or the tail, you'll see that they are still individual objects. **(Fig. 5.33)**

Note that for quick edits, you can manipulate the points of the tail independently from the balloon, or vice versa, without releasing the compounded shape. Just select the Anchor Points of one or the other with the Direct Selection Tool (A).

You can also scale either the tail or the balloon by selecting one with the Direct Selection Tool (A), and then switching to the Selection Tool (V). You can then scale manually as you would if they were not compounded.

If you need to separate them, just return to the flyout menu in the Pathfinder window. This time, select Release Compound Shape. **(Fig. 5.34)**

Trap...
Repeat Pathfinder
Pathfinder Options...
Make Compound Shape
Release Compound Shape
Expand Compound Shape

Fig. 5.34

As I mentioned earlier, I can't stress enough the importance of reducing the entire process of Make Compound Shape and Release Compound Shape to a pair of Illustrator Action keys to save yourself the trouble of constantly moving through the Pathfinder menu.

ORPHANS AND WIDOWS

The terms "orphan" and "widow" are borrowed from broader typography and, for our purposes in comics, refer to a single short word at the beginning or ending of dialogue in a balloon. This creates disproportionate negative space in the balloon and is generally to be avoided. An orphan is a solitary word at the *top* of the balloon, and a widow is a solitary word at the *bottom* of a balloon.

I find that the length of the orphan or widow in question makes a difference. My personal rule of thumb is that a word of three letters or less (I, he, but, etc.) should be adjusted to a different line. A word of four letters or more (when, they, who's, etc.) is fine.

There are two instances when I will leave an "offending" orphan or widow as is. First, there are cases when it's unavoidable. In a very short bit of dialogue of only a few words, there's nothing you can do about it. This leads to the second instance . . . times when fixing an orphan or widow actually results in a *less* pleasing balloon shape than if you had just left it alone. It does happen, believe it or not!

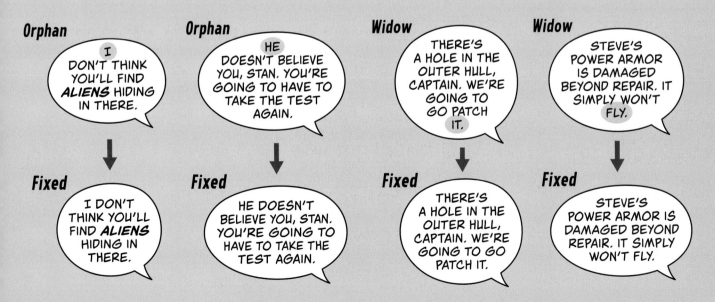

CRAFTING A CURVED TAIL

While I use straight tails occasionally to indicate urgency, a shout, or even sometimes simply due to space constraints, I'll admit that I find curved tails more aesthetically pleasing. There's something a little more "human" to curved tails that appeals to me, even if it's a barely noticeable curve.

In the example for the straight tail, you clicked once for each point of the tail. If we want to make a curved tail, you're going to proceed almost the same way. On your Balloons layer, click inside the balloon to place your first point, but when you click the second point, hold down your mouse button (or stylus), and drag. **(Fig. 5.35)** You'll see a set of direction points appear. Without releasing the mouse button or stylus, drag the direction point around to see a preview of a curved line that bends and shifts depending on which direction and how far you drag. When you release the mouse button, the curved line appears.

Illustrator wants to continue making curved lines, but we need the tail to have a sharp point, so click the second point *again* to tell Illustrator that we want the line to bend back on itself from that point. Finally, when you click the third point, you must hold and drag again to make the inner curve of the tail. **(Fig. 5.36)**

If the tail does not already possess the fill and stroke of your balloons, now's the time to apply those. You can select the tail with the Selection Tool (V), switch to the Eyedropper Tool (I), and click on a balloon. The balloon's properties will be applied to the tail.

Compound the tail and balloon by repeating the process of selecting both, then clicking on the hamburger menu in the Pathfinder window. Select Make Compound Shape. **(Fig. 5.37)**

You can make edits to either the tail or the balloon using the exact same instructions as provided for straight tails, and you can always separate the tail from the balloon at any time with Release Compound Shape.

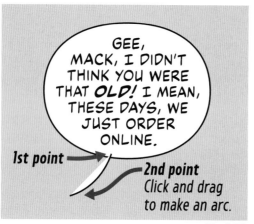

Fig. 5.35

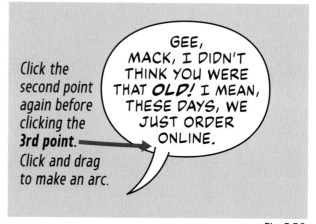

Fig. 5.36

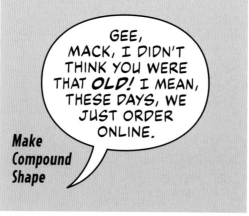

Fig. 5.37

CONSISTENT BALLOON TAILS

As a good rule of thumb, I like to recommend that the width of a balloon tail where it meets the balloon should be just about wide enough to fit a letter *O* from whichever dialogue font you're using. **(Fig. 5.38)** This is the case regardless of the size of the balloons, how much text they contain, or even the length or style of the tails.

One of the telltale signs of an unprofessional lettering job is when you see skinny little tails next to fat tails and all manner in between on a page. **(Fig. 5.39)** It seems to indicate sloppiness on the part of the letterer. Remember that consistency in your design work helps the lettering flow hand in hand with the art—so it does not distract the reader and interrupt the reading experience. It takes a lot of practice, but eventually you'll be able to make tails on the spot that are almost always the same width at their bases. **(Fig. 5.40)**

Fig. 5.38

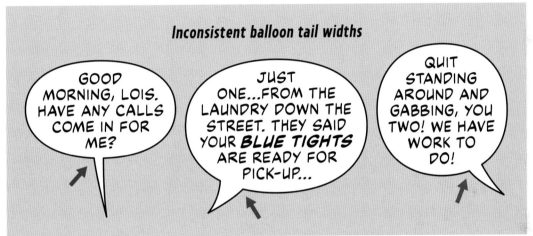

Fig. 5.39

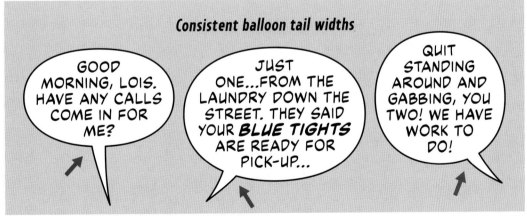

Fig. 5.40

While we're on the subject, avoid "needle-point" tails. This happens when the tail's angle at the point-end is too tight, and the tail ends in what looks like a single black line. **(Fig. 5.41)** The ends of these tails will be hard to discern against black-inked artwork. Instead, aim for tails that taper consistently until they reach their point. **(Fig. 5.42)**

"Needle-point" tail

Fig. 5.41

Consistently tapered tail

Fig. 5.42

THE 94% LINE WIDTH CHEAT

Here's a little trick I use often. In fact, I use it in many examples of dialogue in this book and I bet no one's even noticed unless they read this first.

There are times when it makes sense to horizontally compress a line of text so it fits better in the available space, or to make the oval shape of stacked text more uniform. If a line of text is a little too wide, you can highlight the entire line with the Type Tool (T), and in the Character window (Window > Type > Character), reduce its overall width up to 94%. For some reason, 94% seems to be the approximate maximum percentage before it becomes painfully obvious that you squeezed the text . . . to my eye anyway!

In this example, everything stacks into a pleasing shape except the word "inconsequentially," and it's not even a word that we could hyphenate satisfactorily. Note that it won't fit comfortably inside this particular balloon shape unless we use our secret weapon and compress the line.

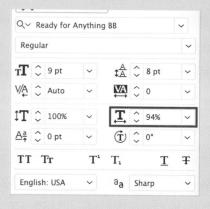

Before

After

BALLOON CORNER JOINS

There are three ways that Illustrator will treat corners of a line. **(Fig. 5.43)** This comes into play particularly with your balloons and tails.

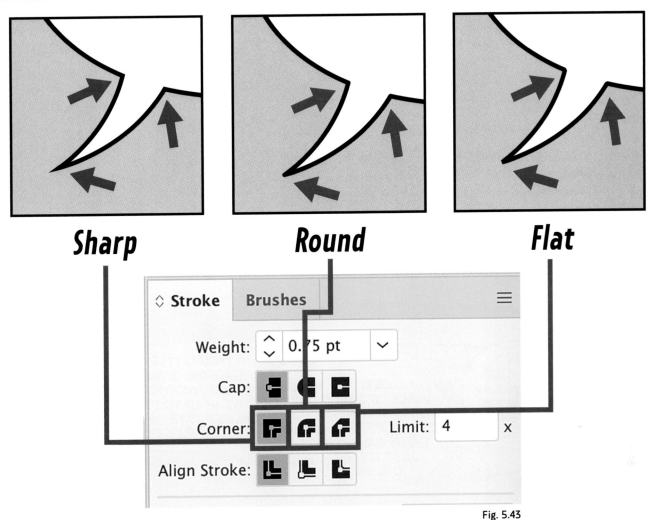

Fig. 5.43

If you select a balloon or tail (or a compounded version of both) and open the Stroke window (Window > Stroke), you'll see three buttons next to "Corner." If you click the first button, Miter Join, and increase the Limit field to about 40, you'll get very sharp tail points and corners where the tail joins the balloon.

The second button is Round Join, and will give you blunted ends on your corners and tail point. No need to adjust the Limit field if you select this one.

The final button is Bevel Join which caps corners with flat, blunted ends. No need to adjust Limit on this one either.

Keep in mind, the stroke on balloons as they appear in print is thin, and the corners and points of a tail are not noticeable enough to make this a make-or-break design decision, or a glaring eyesore whichever of these options you choose. It's just preference—but once you have a preference, it's handy to open your default lettering template, select all your balloon and caption assets, and apply the corner style you like best to all of them. This way, it's the default style whenever you need to balloon a page. If you make tails while ballooning, Illustrator remembers the preference of the last object you "touched" (in this case, your balloon) and will apply the corner style to your tails as well.

BALLOON CONNECTORS

Let's say that Balloons 1 and 3 in the following conversation are spoken by the same character. Those balloons need to be joined by what we call a "connector"—a long, arching tail between balloons. The process is much the same as a standard curved tail, but takes a little more practice to shape properly.

The most common style of connectors begins with a wider base on the first balloon and ends with a narrower base on the next balloon in the series.

Connectors generally have two purposes: to show a longer pause between two sections of dialogue from a single character, or to connect each participant's dialogue in a back-and-forth multi-balloon conversation, as with our example.

Note that when you're placing balloons in a conversation like this, balloons that come between two connected balloons should sort of "tuck up" between them a little to make reading order as clear as possible. In our example, Balloon 2 intrudes slightly in the horizontal gap between Balloons 1 and 3.

On your Balloons layer, switch to the Pen Tool, and place your first point inside the negative space of Balloon 1. Click and hold down your second point inside the negative space of Balloon 3, and then drag to create an arch. **(Fig. 5.44)** Your third point will determine the width of the smaller end of the tail. **(Fig. 5.45)**

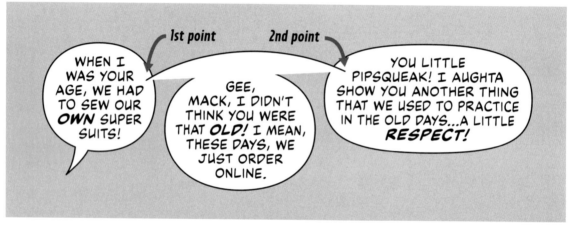

Fig. 5.44

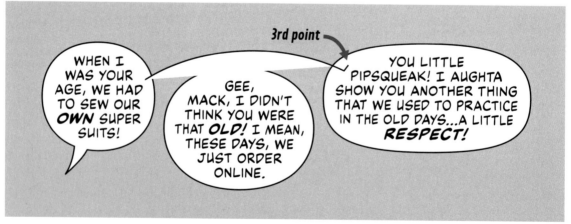

Fig. 5.45

See the weird white fill stretching between the first and second points that's partially covering Balloon 2? That's Illustrator trying to apply our default balloon fill any way it can between two points. Ignore it. The connector will be properly filled in a second . . .

Your fourth point should be held and dragged to create the opposing arch. **(Fig. 5.46)** You'll notice the connector is open at one end—there's really no need to close it up, as the opening won't affect our work here. If the connector does not already possess the fill and stroke of your balloons, now's the time to apply those. You can select the connector with the Selection Tool (V), switch to the Eyedropper Tool (I), and click on a balloon. The balloon's properties will be applied to the connector. Finally, you can select the balloons and the connector and use Make Compound Shape. **(Fig. 5.47)**

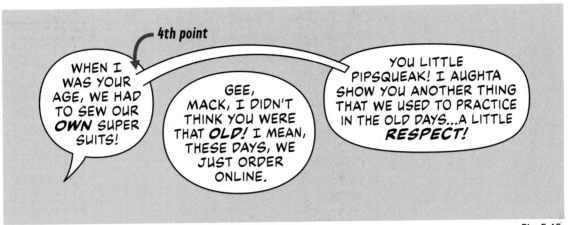

Fig. 5.46

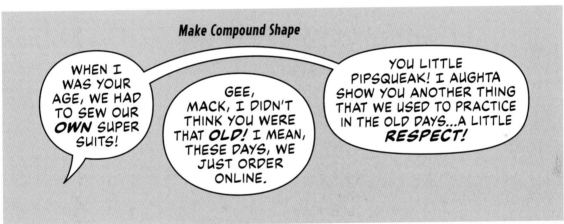

Fig. 5.47

It's not always possible, but whenever I can, I try to make sure balloon connectors make a smooth arc through the centers of the connected balloons, as in **Fig. 5.48.**

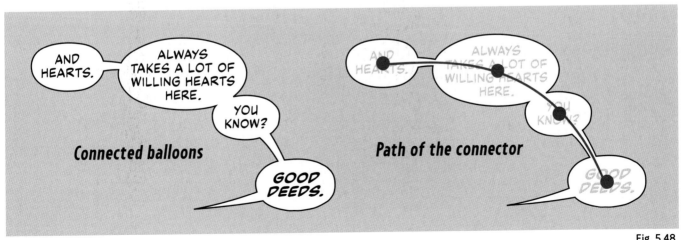

Fig. 5.48

OFF-PANEL TAILS

We've got one tail left to make for this conversation, and for the sake of demonstration, let's say Balloon 2 is being spoken by a character that's "off-panel." This means we can "hear" them, but not see them. For these examples, I'm going to add a black stroke to our gray background rectangle to act as a panel border.

On the Balloons layer, switch to the Pen Tool (P), draw a connector, but have it end *beyond* the panel border. **(Fig. 5.49)** I find it's faster to just draw past it and then trim the excess with a clipping mask. I'd argue that it helps to get the curvature just right. Impermanently join the connector to the balloon with Make Compound Shape. **(Fig. 5.50)**

Next, with the Rectangle Tool (M), draw a rectangle that covers the entire balloon and tail up to the *inside edge of the panel border*. You have to be precise. **(Fig. 5.51)** The rectangle shown here is blue, but the fill and stroke of the rectangle does not matter.

Fig. 5.49

Fig. 5.50

Fig. 5.51

Select both the balloon and the rectangle and use Make Clipping Mask (Command + 7). The rectangle will seem to vanish, and take the extraneous part of the connector with it. **(Fig. 5.52)** Congratulations, you just made your first clipping mask!

Fig. 5.52

Just like our connections between tails and balloons are impermanent, so too is the clipping mask we created. If you ever need to make revisions, select the balloon that has the clipping mask and Release Clipping Mask (Option + Command + 7). Make any desired changes and then create the clipping mask again.

NON-ENGLISH DIALOGUE

Occasionally, characters in English language comics speak in a language other than English. It's a tradition to visually indicate this by using greater-than and less-than symbols to enclose this dialogue. The first balloon of non-English dialogue usually ends in an asterisk that references an editor's note somewhere below the panel, or at the bottom of the page, which explains what language is being spoken.

*TRANSLATED FROM PORTUGUESE.

You may be wondering how to access the special characters and symbols included in a typeface that aren't accessible via your keyboard. In Word, the most common diacritical (accented) letters can be accessed by holding down the key for the letter you need. This will bring up a small menu with the available diacritical options for that letter. In Adobe Illustrator you can bring up the Glyphs window (Window > Type > Glyphs), which will show you all the glyphs included in the font you are currently using. You can double-click the character you want to insert, or copy/paste.

SQUINKS

You've probably seen these many times, but have no idea what they're called. Think back to a comic book you've read where someone is speaking, but they're inside a car or behind a door. Their balloon has a tail that ends in a little starburst against the car window or door to show that the dialogue is coming from behind that object. That little burst is called a squink! **(Fig. 5.53)**

To make that star, first make sure you're on your Balloons layer and switch to the Pen Tool (P). This object should have a fill (I chose white), but no stroke. You can adjust these in the Swatches window (Window > Swatches). Don't worry too much about how big it is, or getting it perfect just yet. We just want to have some points to manipulate. The goal here is to draw a small, irregularly shaped polygon with straight lines between the points. Something like **Fig. 5.54**.

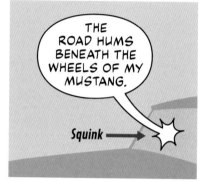

Fig. 5.53

Next, select the polygon, and go to Effect > Distort & Transform > Pucker & Bloat to bring up the Pucker & Bloat window. **(Fig. 5.58)** Adjust the slider to about -25% to -30%, or whatever looks best to you. **(Fig. 5.55)**

Now we've got to expand the effect so that we can make any adjustments. Go to Object > Expand Appearance, and you'll see the tips of the squink become points that you can manipulate. **(Fig. 5.56)**

Fig. 5.54 Fig. 5.55

Fig. 5.56 Fig. 5.57

Fig. 5.58

You can now add your standard balloon stroke to the squink: a .75pt, K:100 black stroke set to overprint. **(Fig. 5.57)** You can make any adjustments you'd like by grabbing the points with the Direct Selection Tool (A). Squinks shouldn't be perfectly symmetrical, in my opinion. Making them a little off-kilter gives them more personality.

You can resize the squink by selecting it with the Selection Tool (V) and scaling it with its bounding box corner points. When you're happy, save a copy of it somewhere off of the artboard of your lettering template to copy/paste any time you need one. There's no sense in drawing a new squink every time you need one. You'll probably want to make a few different ones and save them!

Once you've got a balloon all ready and placed on the art, you can draw a balloon connector that ends where the squink will be placed. Rotate your squink until two of the points comfortably straddle either side of the connector, and then compound all three objects with Make Compound Shape. **(Fig. 5.59)**

Fig. 5.59

BUTTED BALLOONS

I showed you how to make Area Type objects for butted balloons in the last chapter, and it's time to show you how to make the actual balloons they sit within. I'm sure you've seen a butted balloon before. Also called "top-lined" or "anchored" balloons, these are balloons that sit up against a panel border, seemingly flat against one or more plane of the panel. **(Fig. 5.60)**

My personal preference is to use a butted balloon in almost any circumstance where I can. In my opinion, they go further toward "marrying" the lettering to the art than just about any other technique . . . not to mention, they save a lot of precious space!

Fig. 5.60

Let's start again, using a bit of dialogue we used previously. I'm going to add a black stroke to the gray rectangle behind the balloon so we have a panel border to work off of.

On the Lettering layer, I've repasted the dialogue text into a butted balloon Area Type object and placed it near our pretend panel border **(Fig. 5.61)**, keeping in mind the appropriate negative space between the text and the panel border. On the Balloons layer, I shape a balloon to the text and overlap slightly where it will be trimmed against the panel border, **(Fig. 5.62)** and then add a tail as normal. **(Fig. 5.63)**

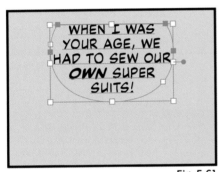

Fig. 5.61

Fig. 5.62

Fig. 5.63

Make sure you're still on your Balloons layer. Draw a rectangle with the Rectangle Tool (M) that covers the entire balloon (and its tail) inside the panel, with the *outer* edge of the rectangle sitting as close to the *inside* edge of the panel border as you can. **(Fig 5.64)** You don't want any gap between the final masked balloon and the inside edge of the panel border. Zoom (Z) in and double-check if you have to.

Note that the fill and stroke of the rectangle don't matter. I know it looks a little strange at this point, but next we're going to "trim away" the part of the balloon sitting outside the panel border with a clipping mask. It's the same basic method we used to trim those off-panel tails earlier.

Imagine it this way: you're making a "window" with these rectangles. Only what's inside the rectangle is going to be viewable through the "window."

Select the balloon and the rectangle and Make Clipping Mask (Command + 7). You'll see the rectangle disappear and take the extraneous part of the balloon with it. **(Fig. 5.65)** That's it. You've butted a balloon!

Fig. 5.64

Fig. 5.65

What about multiple joined balloons, or balloons with connectors? It's the same exact process. Here's that conversation from earlier. I've copied the text for Balloons 1 and 3 into butted Area Type objects, shaped balloons around them, added a tail, and joined them with a connector. **(Fig. 5.66)**

I draw my rectangle over the entirety of Balloons 1 and 3 inside the panel, right up to the inside edge of the panel border. **(Fig. 5.67)**

I select both the rectangle and the set of balloons that I made from Balloons 1 and 3, their tail, and their connector, and finish up with Make Clipping Mask (Command + 7). **(Fig. 5.68)**

Aesthetically speaking, avoid trimming a butted balloon at its widest width. It's generally considered visually awkward. **(Fig. 5.69)** Keep in mind that you want the curve of the balloon to bow back in a little before it meets the panel border.

Corrections are inevitable, and so this process of masking balloons is impermanent. If at any time you need to edit balloons that are masked, you can select individual parts of them with the Direct Selection Tool (A), or remove the mask entirely with

Fig. 5.66

Fig. 5.67

Fig. 5.68

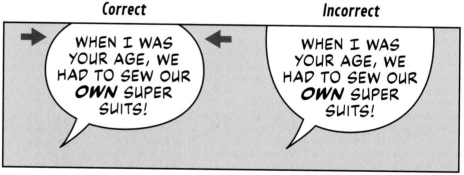

Fig. 5.69

Remove Clipping Mask (Option + Command + 7) and make changes. The rectangle you used to mask the balloons will remain, so when corrections are finished, you can recreate the clipping mask with the existing rectangle.

DON'T CROSS BALLOON TAILS

There will be times when an artist has drawn characters in the wrong speaking order. You will not be able to easily lay out balloons in order, left to right, top to bottom. It may be tempting to simply cross balloon tails, but this is frowned on, and considered sloppy lettering. Even the implication that the paths of the tails cross is to be avoided.

Consider this a challenge. It's your chance to problem-solve. Above all, the reading order must never be confusing to the reader. If you step back for a minute and give it some thought, there is almost always a solution within the panel waiting to be discovered, even when you've been left with a confusing layout.

When crossing balloon tails comes up in conversation, someone usually asks, "But what if I'm intentionally trying to make it seem like the characters are speaking over one another?" My reply is that there are better ways to visually represent this. My favorite is to overlap the balloons themselves . . . even going so far as to obscure some of the dialogue.

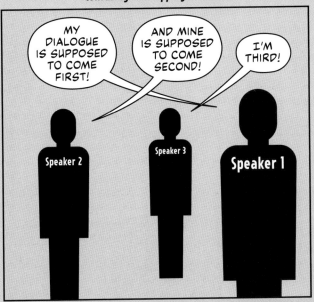
Characters drawn in the wrong speaking order.
Confusing overlapping of tails.

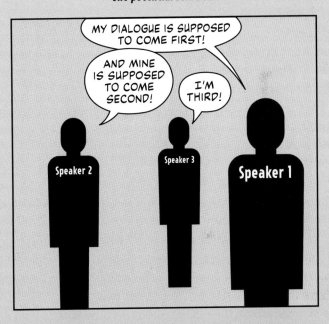
One potential solution.

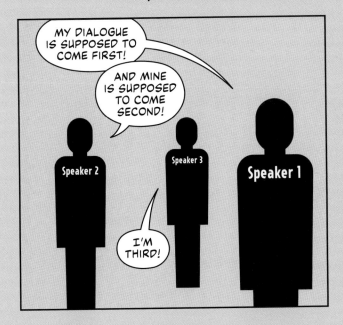
Another potential solution.

If characters are arguing over each other, overlapping balloons and dialogue is a better option than crossing tails.

RADIO BALLOONS

Any scenario where dialogue is spoken or broadcast over some kind of speaker or transmitter is generally represented with a radio balloon and a radio balloon tail. **(Fig. 5.70)** These are spiky, "electric"-looking balloons. While there are now a few accepted designs, the two most typical are what I'll call the classic radio balloon and the modern radio balloon.

CLASSIC RADIO BALLOONS

On the Balloons layer of your template, make a copy of your first standard balloon and remove the stroke in your Swatches window (Window > Swatches). We'll add it back later. You'll end up with a plain white ellipse.

Switch to the Pen Tool (P). Click all around the circumference of your standard balloon at roughly even intervals to create several new points. **(Fig. 5.71)** You can even use the existing four points at the poles of your balloon as guides. Make three or four new points between each of the four poles. You don't have to be absolutely equidistant between points—some slight variation adds character—but get them pretty close.

With the balloon selected, go to Effect > Distort & Transform > Pucker & Bloat **(Fig. 5.72)** just like we did to make a squink. You'll get the Pucker & Bloat window and you'll see a little slider. Slide it to about -8%, and curved spikes will appear where we made all those points. The percentage is totally up to you. When you're happy, click OK. Now expand the effect with Object > Expand Appearance. **(Fig. 5.73)**

You can now add your standard balloon stroke back to the balloon: a .75pt, K:100 black stroke set to overprint. **(Fig. 5.74)** With the stroke back on the radio balloon, you'll be able to gauge whether any of the points need to be tweaked. You can do that by selecting and moving any points with the Direct Selection Tool (A).

Fig. 5.70

Fig. 5.71

Fig. 5.72

Fig. 5.73

Fig. 5.74

Copying and pasting one radio balloon and stretching it all out of shape to fit each new Area Type object isn't very professional looking **(Fig. 5.75)**, so I recommend you make lots of different radio balloons of various sizes and keep them off to the side of your artboard as assets. **(Fig. 5.76)** Use them with the idea in mind that the frequency and size of the points should be almost uniform on a page . . . in other words, a small balloon should have fewer points than a really big radio balloon.

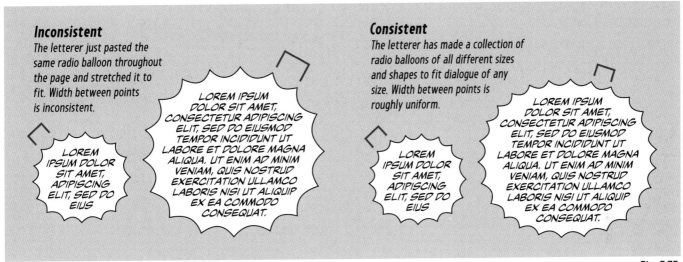

Fig. 5.75

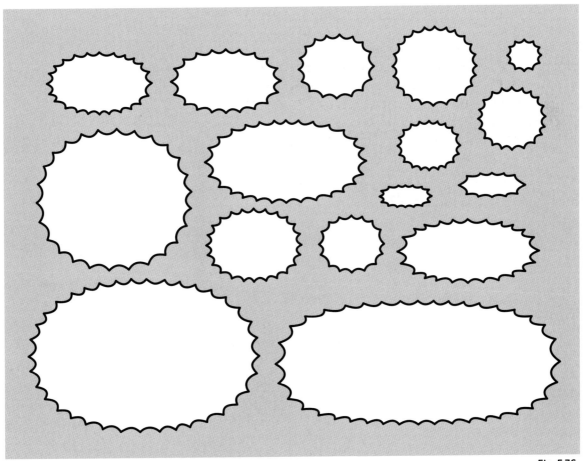

Fig. 5.76

RADIO BALLOON TAILS

Back to the task at hand! Let's fit our new radio balloon to some text before we add a tail. **(Fig. 5.77)**

Radio balloon tails are made with the Pen Tool (P) like standard tails, but take some practice and adjustment to get right. There are a few more points and curves involved. You click points and then drag to make curved lines **(Fig. 5.78)** just like the standard curved tail earlier in the chapter. Note that after you release Point 2, you need to click on it again before moving on to Point 3 and so on, so that Illustrator doesn't continue the curved angle between Points 1 and 2. Once finished, you just impermanently join it to the balloon with Make Compound Shape in the Pathfinder window menu.

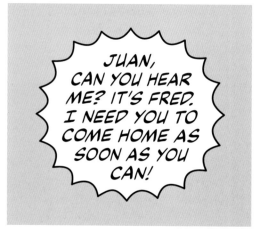

Fig. 5.77

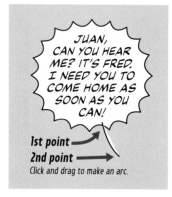
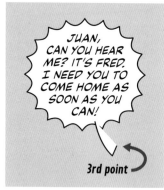
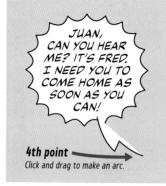
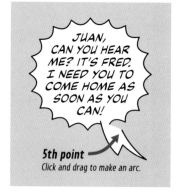
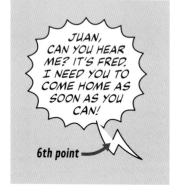
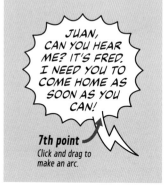
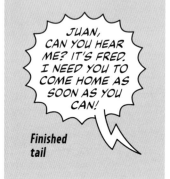
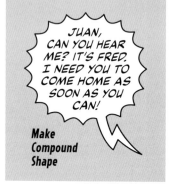

Fig. 5.78

Your first try will probably be a mess, and that's okay. These are pretty tricky!

Remember a few pages ago when I said I make my basic tails on the fly? Not these! Radio balloon tails (and the upcoming wavy and monster tails) are tricky enough that I suggest that you make a bunch at different sizes and curvatures and save them outside your artboard to be reused. **(Fig. 5.79)** You can rotate them with the Rotate Tool (R), or even mirror them with the Reflect Tool (O), for any scenario.

Fig. 5.79

MODERN RADIO BALLOONS

If you've read comics in the last twenty years or so, you've probably seen something similar to this version of the radio balloon. A regular, elliptical balloon with small spikes set at the poles or diagonals. Most letterers use a version of this balloon where the little spikes encroach inside the balloon **(Fig. 5.80)**—while attractive, this means the spikes are a permanent part of the balloon. This creates a problem where the spikes get stretched as the letterer stretches the balloon to fit different size blocks of text (see **Fig. 5.75**—inconsistent and consistent classic radio balloons—for a similar problem). Since I'm a stickler for uniformity, I attach my version of the spikes (which do not encroach inside the balloon) *after* the balloons are shaped to the text. This way my spikes are the exact same size and shape throughout the entire book.

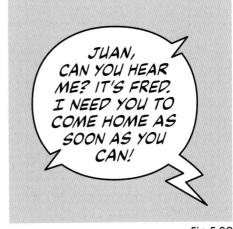

Fig. 5.80

Using my approach, modern radio balloons are easier to make than the classic style since this is just a modification of a standard balloon. All you need to do is make a set of spikes, which you can save as assets outside your artboard to use over and over.

Let's start by making sure you're on the Balloons layer of your template and switch to the Pen Tool (P). Draw what looks like a very small, uneven capital letter M **(Fig. 5.81)**, taking care to make sure the outside legs are lower than the arc in the middle—that's the part that will overlap the balloon. Make sure the spikes share the same white fill and .75pt, K:100 black stroke set to overprint as your balloons.

Now we'll take those spikes and make a mirrored set of four. Select the spikes and rotate them (Object > Transform > Rotate) about 30 degrees. **(Figs. 5.82 and 5.83)**

Fig. 5.81

Fig. 5.82

Fig. 5.83

Select the spikes and Shift + Option drag a copy of them to the right. **(Fig. 5.84)** Then select that second pair and mirror them with the Reflect Tool (O). **(Fig. 5.85)**

Fig. 5.84

Fig. 5.85

To make two into four, select the two sets of spikes and mirror them once again with the Reflect Tool (O). **(Fig. 5.86)** Now is a good time to scale these spikes down to the size you intend to use them. They should be very small. See below examples for proportional reference.

Before we move on, select all four of the spikes and press Shift + Command +] to bring them to the front of any objects on the Balloons layer. That way they will appear on top of any balloons you've already created and saved on that layer. Save a set of them outside your artboard for future use.

Fig. 5.86

To put these spikes to use, start with a standard balloon around an Area Type object. (Reminder: radio balloon text should be italicized.) Copy/paste your set of spikes near the balloon. **(Fig. 5.87)**

Move the spikes to the four "corners" of your balloon and make sure the bottom of each set of spikes slightly overlaps the balloon. **(Fig. 5.88)**

Add a radio balloon tail, then impermanently join the spikes and the tail to the balloon with Make Compound Shape in the Pathfinder window menu. **(Fig. 5.89)**

Fig. 5.87

Fig. 5.88

Fig. 5.89

Note that you don't have to use all four of the spikes. Lots of letterers only use two on opposite sides of the balloon. It's just a matter of preference. **(Fig. 5.90)**

In fact, there are lots more inventive alternatives to radio balloons out there—the classic and modern versions are just the most common. Experiment with your own creations!

Fig. 5.90

SHOUT BALLOONS

Shout balloons are used for particularly over-the-top dialogue, and most designs fall into one of three categories: the scalloped burst, the classic burst, and the double-outline balloon, as in **Fig. 5.91**. (There is a fourth catagory that we'll get to—dialogue that erupts from a balloon—but it's slightly less common.)

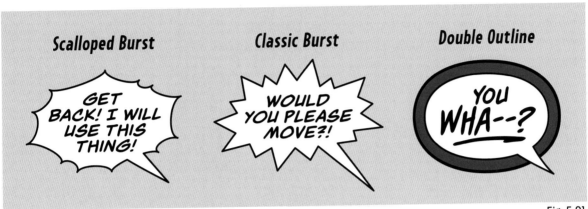

Fig. 5.91

Scripts rarely specifically call for shout balloons, but often have dialogue called out as yelling, with text styled as bold italic. It's often up to the letterer to decide how much visual emphasis should be placed on yelled dialogue. I encourage you to look carefully at the artwork as the deciding factor. How emotional and animated does the shouting character look? If they're just angry, bold italic text in a regular balloon may do. If they're particularly distressed, a stylized shout balloon may be the way to go . . . but I encourage restraint. Having these types of balloons all over a page is unappealing. It's also prudent to pick one style of shout balloon for the style guide of a series and stick with it instead of mixing and matching.

SCALLOPED BURST BALLOONS

These bursts are made of irregularly spaced points with wide, arcing lines between them. They're the most common shout balloon you'll encounter in mainstream comics these days.

Using the Pen Tool (P) on your lettering template's Balloons layer, make vaguely balloon-shaped object by clicking several points connected by straight lines. When the object is complete, make sure it has no stroke and only a white fill. **(Fig. 5.92)**

Fig. 5.92

With the balloon selected, go to Effect > Distort & Transform > Pucker & Bloat. You'll get the Pucker & Bloat window. Move the slider to about -8% **(Fig. 5.93)**, turning all those straight lines and points into sweeping arcs. How much you adjust the percentage is totally up to you. Whatever you think looks best. When you're happy, click OK.

Fig. 5.93

You'll end up with an object that looks like **Fig. 5.94.** Make sure you select the balloon and go to Object > Expand Appearance to make those points and arcs editable with the Direct Selection Tool (A) in case you want to make adjustments.

Now you can add your standard balloon stroke back to the balloon: a .75pt, K:100 black stroke set to overprint. Once we wrap the balloon around some shouted text **(Fig. 5.95)** we can make a tail **(Fig. 5.96)** and impermanently compound the tail to the balloon with Make Compound Shape in the Pathfinder window menu. **(Fig. 5.97)**

Fig. 5.94

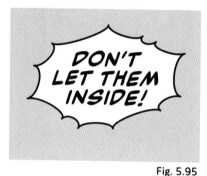

Fig. 5.95

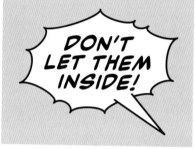

Fig. 5.96

Fig. 5.97

As with radio balloons, I recommend you make many versions of the scalloped burst in different shapes for your lettering template. You never know how the text inside them will be stacked. **(Fig. 5.98)**

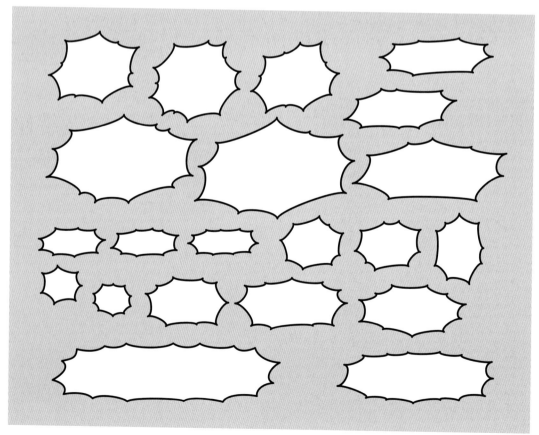

Fig. 5.98

CLASSIC BURST BALLOONS

The classic burst is great for a retro feel, but takes a bit more practice. It seems deceptively simple, but I find myself making more adjustments when I design them . . . probably because there are more points involved.

Fig. 5.99

With the Pen Tool (P) on the Balloons layer of your lettering template, begin making an irregular starburst, one point at a time with only straight lines. Always keep in mind that the negative space at the center needs to be able to accommodate an ovoid Area Type object later on. Continue point by point (as indicated by the numbers in **Fig. 5.99**) until you complete the object.

Make any adjustments you'd like, and add your standard balloon stroke to the balloon. **(Fig. 5.100)**

Fig. 5.100

Finally, you can apply it behind some text. **(Fig. 5.101)** The good news is, with classic burst balloons you don't have to make tails for them most of the time. Just grab one of the existing points with the Direct Selection Tool (A) and pull it out to the length you need. When doing this, keep in mind the tail's width compared to other tails on the page and the practice we discussed previously about tails appearing to emanate from the center of their balloons.

Once again, making and saving lots of variations of the classic burst for your lettering template is recommended. You'll need to accommodate different text blocks and prevent constantly repeating the same shape in a comic. **(Fig. 5.102)**

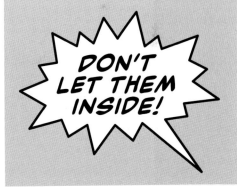

Fig. 5.101

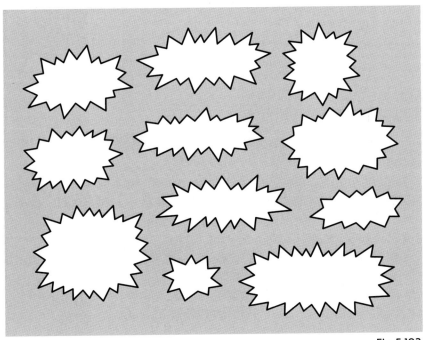

Fig. 5.102

DOUBLE-OUTLINE BALLOONS

Finally, we have the double-outline balloon, which obviously isn't a burst, but does represent the same idea—extremely animated shouting. I don't use them very often, but they are the easiest of the three variations to design.

Once your shouted text is set, place a standard balloon around it, but hold off on designing the tail. **(Fig. 5.103)**

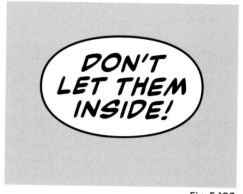

Fig. 5.103

Select the balloon and bring up the Offset Path window (Object > Path > Offset Path). Set the offset path anywhere from 3pt to 5pt and hit OK. **(Fig. 5.104)** You'll see a second balloon surround your first. **(Fig. 5.105)**

I like to use points as a unit of measurement for Offset Path only because typing decimal representations of inches is tedious. If your Offset Path window isn't displaying measurements in points, it's because your rulers aren't currently set to measure in points. You can either change the ruler value by right-clicking or Control-clicking your rulers and then switching the value, or (even easier) just type the number, a space, and then "pt"—Illustrator will understand.

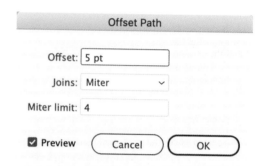

Fig. 5.104

You may also want to select the outer balloon and increase its stroke in the Stroke window to something a little thicker than your standard .75pt. I tend to use 1.3pt or 1.5pt. You can then give the outer balloon a fill of your choice in the Swatches window (Window > Swatches). Finally, you can add a tail to the inner or outer balloon—your choice. **(Fig. 5.106)**

The nice thing about double-outline balloons, is that if you record an Action of the Offset Path step, followed by the increased stroke step, you can create the effect with the touch of an F-key any time you need one!

Fig. 5.105

Fig. 5.106

DIALOGUE THAT ERUPTS FROM A BALLOON

While we're on the subject of using Offset Path, this method is also used for balloons that have the "Extra Emphasis" dialogue that seems so loud it pops out of the balloon.

The first step is to design the main text for the balloon in an Area Type object and the text that will be "erupting" out of it, per the directions in the previous chapter. Make sure that the text that is emerging out of the balloon is no longer live text (Type > Create Outlines) and all the letters are united into one object (Unite in the Pathfinder window). Wrap the main part of the dialogue and some of the bursting dialogue with the shout balloon of your choice. (**Fig. 5.107**)

Fig. 5.107

Select the text that's flowing out of the balloon and use Offset Path (Object > Path > Offset Path) to bring up the Offset Path window. With "Preview" checked in the window so you can see what the effect will look like, adjust the amount of offset to whatever you think looks best. Click OK. (**Fig. 5.108 and 5.109**)

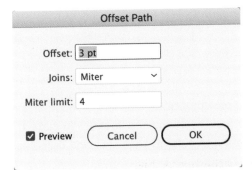

Fig. 5.108

Fig. 5.109

Because you were working with text on your Lettering layer, this object will be created on the Lettering layer of your template as well. We need to move that new object to the Balloons layer. Select just the object (not the text), and Cut it (Command + X). Switch to the Balloons layer, and Paste in Front (Command + F) so that both parts of the balloon are on the same layer.

Select the balloon and the object around the erupting text and Make Compound Shape to impermanently join them together just like you do with your tails. (**Fig. 5.110**)

Speaking of which, all that's left is to impermanently join a tail as normal. (**Fig. 5.111**)

Fig. 5.110

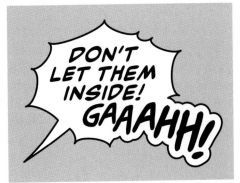

Fig. 5.111

If you find yourself using this effect often, consider recording the Offset Path step as an Action to save some time!

WAVY BALLOONS

A character in your script is very sick . . . or dying . . . or maybe just drunk . . . and their dialogue has to represent this. Wavy balloons and their matching tails are the way to go! These balloons are easier to create if you use a tablet and stylus, but you can create them with a mouse as well.

Switch to the Pencil Tool (N), and simply draw a wavy balloon shape loosely modeled after a regular balloon. The place where you started drawing should be the place where you end so the line is continuous. **(Fig. 5.112)** This sounds simple, and it is . . . but you'll find yourself redrawing or tweaking quite a bit.

Fig. 5.112

Wavy tails are a bit tricky and will take some practice. Imagine the shape of a radio balloon tail, but softer with rounder curves. You can use either the Pencil Tool (N) or the Pen Tool (P) to make these, but I find the Pen Tool allows for more control and no unwanted points. Start with a point, then click and drag each additional point to make curves as in **Fig. 5.113**.

Fig. 5.113

Once you have a wavy balloon around some text, you can impermanently attach the tail with Make Compound Shape as per normal. **(Fig. 5.114)**

Here's a little trick for making the *text* in the balloon wavy as well: select the text and then use Effect > Warp > Wave, or Effect > Warp > Flag (whichever you like better . . . but using Wave won't change the outer perimeter shape of the Area Type object). This will bring up the Warp Options window. **(Fig. 5.115)** Adding just a little of this effect goes a long way, so use with restraint. **(Fig. 5.116)** Applying this effect won't alter your ability to edit the text later during the corrections phase, so don't worry!

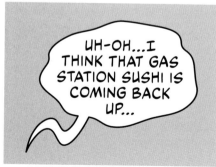

Fig. 5.114

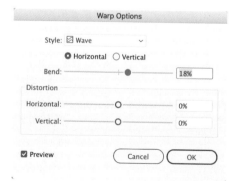

Fig. 5.115

Fig. 5.116

Since wavy balloons and especially their tails are a bit of a pain to create, I suggest you make lots of them and save them in your lettering template for future use. **(Fig. 5.117)**

Fig. 5.117

TANGENTS

As you place balloons and sound effects on a page, you should be careful to not create tangents—places where the outlines of your lettering seem to just barely brush up against, or "kiss" lines in the inked artwork. These create visual dissonance. If it can be helped, you should aim to either overlap inked lines or avoid touching them at all. Easier said than done! You will find yourself cursing under your breath at times as you spot, correct, and realize you've created even more tangents! Try your best.

Balloons creating tangents with the art

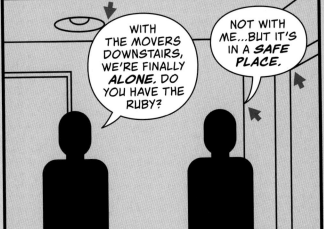

No tangents

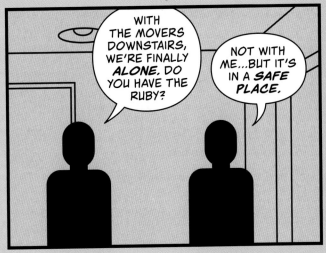

THOUGHT BALLOONS

Traditionally, thought balloons have been used to reveal a character's inner monologue. Largely out of fashion these days, these balloons have mostly been replaced by inner monologue captions. I still think thought balloons are a lot of fun, and their creation should be part of your skill set.

I'm going to show you two ways to make thought balloons. First up is the standard version, which is more common but less attractive. (**Fig. 5.118**) It uses methods we covered in the radio balloons section. The second, improved version, is more organic and visually attractive. That's the method I prefer.

Fig. 5.118

STANDARD THOUGHT BALLOONS

On the Balloons layer of your template, make a copy of your standard balloon and remove the stroke in your Swatches window (Window > Swatches). You'll end up with a plain white ellipse.

Switch to the Pen Tool (P). Click around the circumference of your standard balloon at uneven intervals to make additional points. (**Fig. 5.119**) You want to make fewer points than you did for the radio balloon, and their spacing should be more irregular.

Fig. 5.119

With the balloon selected, go to Effect > Distort > Pucker & Bloat to bring up the Pucker & Bloat menu. Adjust the slider to about 11%, or whatever looks best to you. (**Figs. 5.120** and **5.121**)

Next, with the balloon selected, go to Object > Expand to make the points editable. (**Fig. 5.122**)

Add your standard balloon stroke to the balloon: a .75pt, K:100 black stroke set to overprint before we make some final adjustments. (**Fig. 5.123**)

Fig. 5.120

Fig. 5.121

Fig. 5.122

Fig. 5.123

Most letterers stop here, and that's fine if you're happy with how this looks. But for me to consider this a viable option, some adjustments need to be made. In my opinion, the bulges of this style of thought balloon are too *V*-shaped. They should be slightly rounder. If you want to change that, you're going to zoom in close and switch to the Direct Selection Tool (A). Click on each arced line, bringing up a pair of Direction Points. Grab one at a time and rotate them outward to round off the arches. **(Figs. 5.124** and **5.125)**

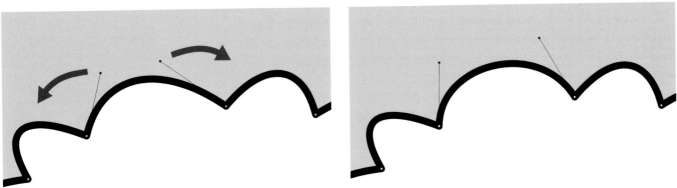

Fig. 5.124

Fig. 5.125

Repeat this process all the way around the thought balloon with each "bulge." **(Fig. 5.126)**

We can wrap this thought balloon around some text, and finally, with the Ellipse Tool (L), draw a few ellipses of decreasing size for the tail. **(Fig. 5.127)** The first should overlap the balloon slightly, the rest are up to you. Depending on the scenario presented to you in the art, you may need more ellipses for the tail. As long as they follow the path of an arc and each decreases slightly in size as they approach the thinker's head, you're all set. Note that thought balloon tails should always point in the direction of the thinker's head, not their shoulder, their feet, etc.

As with radio and burst balloons, it's in your best interest to make several different sized and shaped thought balloons to suit various text requirements. **(Fig. 5.128)**

Before **After**

Fig. 5.126

THEY CAN NEVER KNOW MY ACTUAL PLANS.

Fig. 5.127

Fig. 5.128

IMPROVED THOUGHT BALLOONS

After looking at some of my favorite hand letterers' balloons from the 1980s, I spent some time coming up with a version that has a more dynamic "hand-crafted" look . . . and it's virtually the same amount of work as the standard version.

Start by creating a small oval with the Ellipse Tool (L)—about the size of one "bump" on a thought balloon. With the oval selected, switch to the Shear Tool. With the Shift key held down to constrain, shear the oval upward just slightly. **(Fig. 5.129)**

Fig. 5.129

It's this shear that makes these thought balloons seem more organic, and is essential to the end result. Next, make four or five copies of the oval and scale them to slightly different sizes. **(Fig. 5.130)**

Make a copy of your standard dialogue balloon **(Fig. 5.131)** and begin placing these ovals around the circumference in no particular order. You want the balloons to overlap just a little bit, and cover the dialogue balloon's stroke completely. **(Fig. 5.132)** It may take a bit of repositioning and a little resizing of the sheared ovals to make this work. Don't worry, any slight resizing will improve the end result. When you're happy with the positioning, select all the ovals and the dialogue balloon and click Unite in the Pathfinder window (Window > Pathfinder) to turn them into a single object. **(Fig. 5.133)**

Fig. 5.130

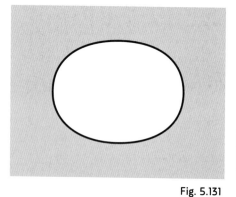

Fig. 5.131

Fig. 5.132

Fig. 5.133

Finally, use more sheared ovals as the thought balloon tail. When we compare the standard thought balloon to this improved version **(Fig. 5.134)** I think the benefit is subtle, but well worth it.

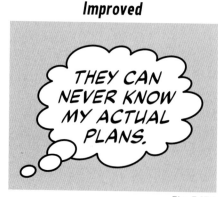

Fig. 5.134

As with all these other specialized balloons, I recommend you make lots of versions to save as assets in your template. **(Fig. 5.135)**

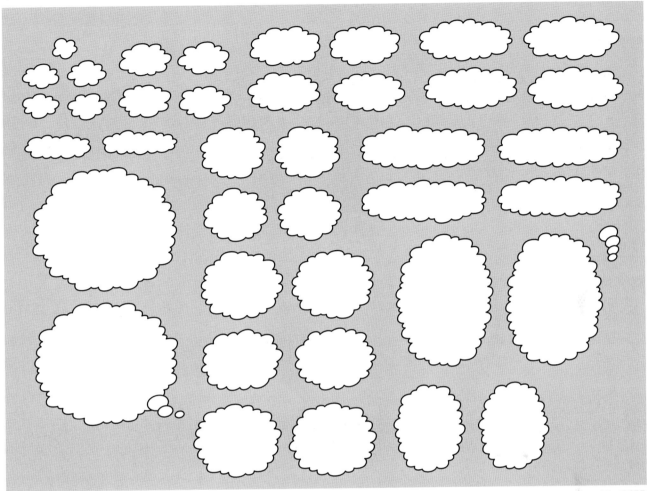

Fig. 5.135

QUESTION MARK/EXCLAMATION POINT COMBINATIONS

Shouted questions appear *constantly* in comics. You'll often see some combination of a question mark and an exclamation point expressed as ?! or !? or even ?!?. The "Big Two" publishers used to (and may still) require that in any shouted question, the question mark comes first (e.g. ?!), but there's no hard rule other than the one dictated by a publisher's preference. You may even encounter an enthusiastic ??!?!??!??! in a script. (It's okay to truncate those.)

In case you like to share boring trivia at parties, the combination of a question mark and an exclamation point has been given its own glyph design called an "interrobang." As of this writing, the interrobang has not become an everyday part of our written language, and that includes comics. For the forseeable future, you'll be using ?! or !?.

An example of the "interrobang" glyph. Interesting, but not adopted into comics.

When I was brought on to letter new issues of Wendy and Richard Pini's *Elfquest*—a comic that's been ongoing since the late 1970s—I was happy to try and create a seamless digital interpretation of Wendy's hand lettering. To remain as authentic as possible, I was even hired to create a custom typeface of Wendy's dialogue lettering before my work on the series was to begin. I was also thrilled to see that the series still made good use of thought balloons! And check out the stylized approach to telepathy balloons! The elves call it "sending," and the style relies on a change in balloon color and "sending stars" on their heads to indicate their private conversations.

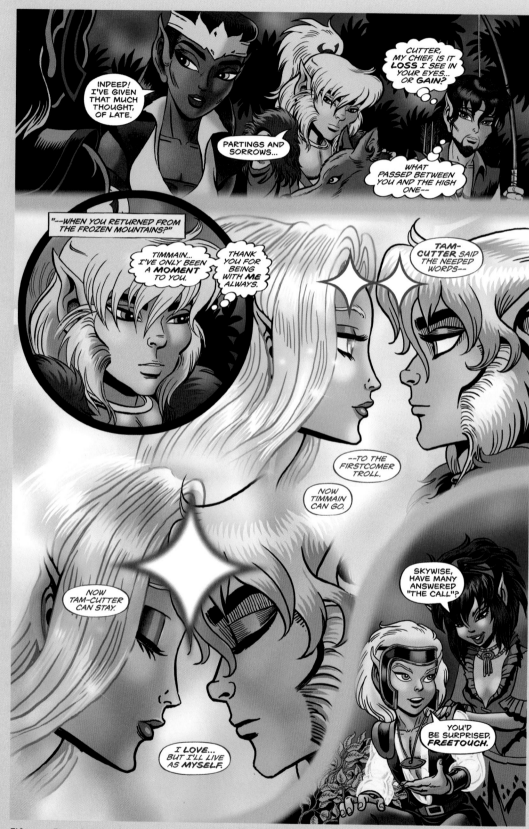

Elfquest: Final Quest #19 courtesy of Wendy and Richard Pini.

TELEPATHY BALLOONS

In the world of comics, telepaths aren't so unusual . . . but their balloons are a little weird. They may be the strangest balloons you'll be expected to work with. **Fig. 5.136** shows a traditional approach and a wavy alternative that I'll be explaining in detail.

These two versions are the tip of the iceberg. Lots of letterers come up with their own creative way to show telepathy, so feel free to experiment . . . keeping in mind that most of the time, the goal of telepathic balloons is to evoke a feeling of intangibility or evanescence.

Fig. 5.136

CLASSIC TELEPATHY BALLOONS

My "classic" telepathy balloon is inspired by the version that I grew up seeing in comics of the 1970s and 1980s, although their origin predates those decades. This design combines your standard (or my improved) thought balloon and adds some "psychic energy beams," usually on the diagonal corners of the balloon. They can also optionally sport radio balloon tails.

Since we've already covered thought balloons and radio balloon tails, let's get that ready right up front. Start with an Area Type object styled with your dialogue font. Surround it with a thought balloon and impermanently join a radio balloon tail to it with Make Compound Shape. **(Fig. 5.137)** Note that telepathic dialogue may be italicized.

To make the psychic energy beams, make sure you're on your Balloons layer. Switch to the Pen Tool (P) and draw a small, straight line with our default .75pt, K:100 black stroke set to overprint. **(Fig. 5.138)** I drew mine at roughly 5/32", or a decimal value of about .1555.

Fig. 5.137

Copy (Command + C) and Paste (Command + P) a copy of the line to the left and to the right of the original so you end up with three identical lines. Make sure the space between them is equal. **(Fig. 5.139)**

Shorten the two outside lines by about 20% **(Fig. 5.140)** before nudging the middle line up just a bit. **(Fig. 5.141)**

| Fig. 5.138 | Fig. 5.139 | Fig. 5.140 | Fig. 5.141 |

Next, select the shorter line on the left and open the Rotate window (Object > Transform > Rotate). **(Fig. 5.142)** Rotate the line about 8 degrees. Repeat the process with the shorter line on the right, except rotate it *negative* 8 degrees. **(Fig. 5.143)**

Fig. 5.142

When they're rotated, select all three lines and group them so you can't accidentally nudge them out of place.

Now we need to create a white object between the lines that will obscure the stroke of the thought balloon where the beams overlap it. Switch to the Pen Tool (P), and draw this vaguely crown-shaped object using the lines as a guide. **(Fig. 5.144)** Make sure the object overlaps the lines but does not go outside of them. Remove any stroke from this object and make sure its fill is white.

Select the object and use Shift + Command + [to move the object behind the lines. **(Fig. 5.145)** Group the lines and the object together (Command + G).

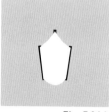
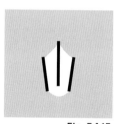

Fig. 5.143 Fig. 5.144 Fig. 5.145

Next we have to rotate and duplicate these so we end up with four of them for our telepathy balloons.

Select the set of beams and rotate them (Object > Transform > Rotate) about 30 degrees. **(Figs. 5.146** and **5.147)**

Fig. 5.146

Select the beams and Shift + Option drag a copy of them to the right. **(Fig. 5.148)** Then select that second pair and mirror them with the Reflect Tool (O). **(Fig. 5.149)**

Now let's turn two sets into four—select the two sets of beams, duplicate them (Option + drag), and mirror them with the Reflect Tool (O). **(Fig. 5.150)**

Fig. 5.147 Fig. 5.148 Fig. 5.149 Fig. 5.150

Before we put them to use, select all four of the beams and press Shift + Command +] to bring them to the front of any objects on the Balloons layer. That way they will always appear on top of any balloons you've already created and saved on that layer. Now would also be a good time to save a copy of these outside the artboard of your lettering template so you can copy/paste them whenever you need a set.

To apply them, copy your beams and add them at diagonal corners of the thought balloon we started out with . . . and suddenly, you have a telepathic balloon! **(Fig. 5.151)**

Note that if the sender of the telepathic message is not shown in a panel, but you have a scene where someone is receiving a telepathic message, you can leave the tail off the balloon and let it free-float to give it an ethereal feel.

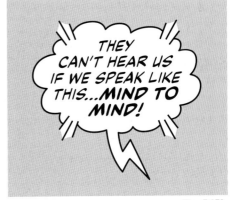

Fig. 5.151

STAGGERING BALLOONS

In another effort to keep lettering looking more organic and pleasing to the eye, try to avoid precisely aligning a series of balloons to their centers. It's almost always possible to stagger balloons a little even in a panel tight on space. (As always, don't be afraid to butt one or more of these balloons against a panel border to save space!) Staggering balloons also goes a long way to giving conversations a sense of rhythm.

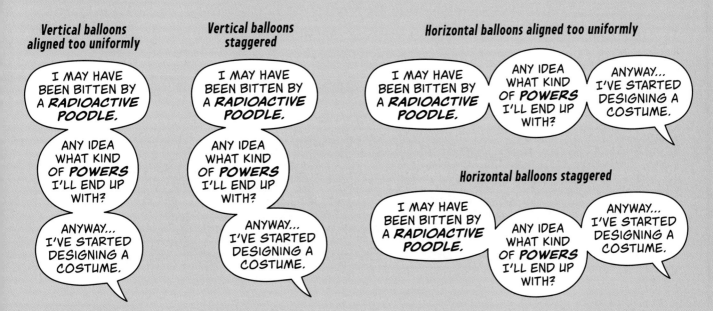

WAVY TELEPATHY BALLOONS

This telepathic balloon style uses the wavy balloons we've already covered and is a handy option if you need to color-code telepathy balloons to their telepathic "speakers." Since you're familiar with the steps leading up to this style of balloon, let's begin with an Area Type object with some dialogue that already has a wavy balloon. Change the color of the text and the color of the stroke on the wavy balloon to a medium-dark tone in the Swatches window (Window > Swatches). I've decided to use purple. **(Fig. 5.152)**

Since none of this will be black, make sure all fills and strokes are not going to overprint by unchecking the appropriate boxes in the Attributes window (Window > Attributes). **(Fig. 5.153)**

Fig. 5.152

Select the wavy balloon, copy it (Command + C) and then Paste Behind (Command + B), which will paste a duplicate exactly behind the original. By default, the bottom-most version will now be selected. Using its bounding box, stretch it a little bit to the right. **(Fig. 5.154)**

Repeat the process with the left side of the bounding box, stretching the bottom balloon to the left a little bit. **(Fig. 5.155)** There is no exact formula to this stretching step. It's about what looks best to you.

Fig. 5.153

Fig. 5.154

Fig. 5.155

In the Stroke window (Window > Stroke), change the weight of the bottom-most balloon's stroke to 1.5pt. **(Fig. 5.156)**

Finally, in the Swatches window (Window > Swatches) or Color window (Window > Color), change the fill of the bottom-most balloon to a slightly lighter version of the medium-dark color you used for the text and the strokes (or whatever you want!) and we're done. **(Fig. 5.157)**

Fig. 5.156

Fig. 5.157

WHISPER BALLOONS

While there are a few ways to visually explain that a character's dialogue is spoken softly, the classic way is with a dashed outline on a character's dialogue balloon. **(Fig. 5.158)** The next most common method is often referred to as "small text/big balloon," **(Fig. 5.159)** where a reduced point and leading size is applied to the Area Type object and the balloon has much more negative space than normal speech. Both are fairly simple to design, and preference for either style is totally up to you.

Fig. 5.158

Fig. 5.159

DASHED WHISPER BALLOONS

The dashed line whisper balloon starts with a standard dialogue balloon. **(Fig. 5.160)** Once your balloon is finished and has a tail, select it, and in the Stroke window (Windows > Stroke), check the box for Dashed Line. I set the dash field to 4pt and the first gap field to 3pt, but feel free to experiment. You may also want to click the option to align dashes to corners and path ends. **(Fig. 5.161)** You'll end up with something similar to **Fig. 5.162**.

Fig. 5.160

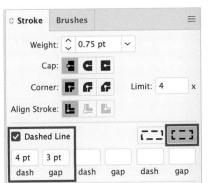

Fig. 5.161

Fig. 5.162

Note that in the event that you have to Release Compound Shape to separate the tail on a dashed balloon for corrections or any other reason, the individual objects will revert to their default stroke. You'll have to reapply the dash setting after you Make Compound Shape again. My recommendation is to either record the settings as one of your standard Actions, or save a balloon with these stroke properties in your template so you can sample it with the Eyedropper Tool (I) when needed.

SMALL TEXT/BIG BALLOON

This is my favorite option, and is nearly as easy as the dashed approach. Once you have created the text and finished a standard balloon **(Fig. 5.163)**, select the Area Type object and go to Object > Transform > Scale to bring up the Scale window. With the Uniform option selected, reduce the Area Type object text to 75%. **(Figs. 5.164** and **5.165)** I find that this percentage feels about right . . . still legible, but clearly distinguishable as smaller than whatever your chosen point and leading size is for a given typeface.

If you use this version of whispering often, the 75% scale is another Action you may want to consider recording for application with an F-key.

Fig. 5.163

Fig. 5.165

Fig. 5.164

ROBOTIC BALLOONS

There are virtually infinite ways to style balloons spoken by robots, androids, and all manner of artificial beings. While the variations are limited only by your imagination, there are some commonalities for dialogue that is meant to be metallic or machine-like: typefaces that are distinctly inorganic and balloons that are either rectangular, or at least clearly reminiscent of computer graphics. The first example below is made with the Rounded Rectangle Tool **(Fig. 5.166)**, and the second one stacks two ovals on top of each other with differing dashed lines. **(Fig. 5.167)**

Fig. 5.166

Fig. 5.167

ROUNDED RECTANGLE ROBOTIC BALLOONS

It's easy to go overboard with robotic balloons (partly because they're so much fun to design . . .) so I would encourage you to use restraint, especially if you have a robotic character that will appear often in a series. Reproducing very complex balloon styles can go from fun to drudgery pretty quickly. That said, let's start with the most basic of robotic balloons made with the Rounded Rectangle Tool. This style is easy to reproduce and works in almost any scenario.

I tend to use rectangles with 90-degree corners for captions, so I find that using rounded rectangles for robotic balloons is a convenient way to differentiate them. If you've never used the Rounded Rectangle Tool before, you'll quickly notice that the default radius measurement for the four corners is quite large for lettering purposes. I suggest you change the default. To do this, go to Illustrator > Preferences > General and change the Corner Radius field to about 0.06" or whatever you think looks best. **(Fig. 5.168)** It's in the top-center list of fields in the Preferences window. This way, every time you make a rounded rectangle, the corner radii will be perfectly sized no matter how big or small the rectangle may be.

Since we'll be working with rectangular-shaped balloons, start with your rectangular Area Type object (the one we made for captions) on your Lettering layer, and style it with a font that invokes the hard angles of a mechanical voice. Here, I'm using a typeface I designed, called Voice Activated Caps BB. **(Fig. 5.169)**

Switch to the Rounded Rectangle Tool, and draw a rectangle around it on your Balloons layer. **(Fig. 5.170)** You can find it in the flyout menu in your tool bar with the Ellipse Tool and Rectangle Tool. By default, it doesn't have a keyboard shortcut, but you can assign one by going to Edit > Keyboard shortcuts.

Make sure your new rounded rectangle shares the white fill and .75pt, K:100 black stroke set to overprint that is used on your basic balloons.

Fig. 5.168

Finally, add a radio balloon tail and impermanently join it to the rounded rectangle with Make Compound Shape in the Pathfinder window menu. **(Fig. 5.171)**

Fig. 5.169

Fig. 5.170

Fig. 5.171

DOUBLE-DASHED ROBOTIC BALLOONS

Here's a fun, but more complex, robotic balloon. The weird, irregular dashed outline is achieved a with a little sleight of hand—there are two ellipses, stacked precisely on top of one another, each with dashed strokes of different weights and variation!

Begin with your elliptical Area Type object filled with an appropriately mechanical typeface. **(Fig. 5.172)**

You can either fit it with one of your default dialogue balloons or draw a perfect ellipse with the Ellipse Tool (E). **(Fig. 5.173)** I find that a perfect ellipse lends a little more "artificial" flavor to the overall design. (You'll remember that our default balloons were squared off just a tiny bit.)

In your Stroke window (Window > Stroke), check Dashed Line and play with the dash and gap measurements until you have something you like. **(Figs. 5.174 and 5.175)**

(You can also adjust later after the balloon is complete.) Incidentally, for some reason, I think a stroke weight of 1pt looks better in this step than our default .75pt. I'm not sure why!

Fig. 5.172

Fig. 5.173

Fig. 5.174

Fig. 5.175

Now, select the dashed balloon, copy it (Command + C), and paste a copy of it *behind the original* (Command + B). While the duplicate balloon is still selected, go back into your Stroke window, bump up the Weight, and change the dash and gap settings until you get a result that you like. **(Figs. 5.176 and 5.177)**

Since the two balloons are exactly aligned to one another, the effects might be hard to conceptualize. In **Fig. 5.178** I've separated the two slightly so you can see what they look like individually.

Fig. 5.176

Fig. 5.177

Fig. 5.178

All that's left to do is add a tail. With the Pen Tool (P) I've drawn a slightly "unravelled" version of a standard radio balloon tail. **(Fig. 5.179)** This version just has a "kink" in it instead of having the traditional lightning bolt look.

Finally, impermanently join the tail to the top-most ellipse (which will take on its stroke properties) with Make Compound Shape in the Pathfinder window menu. **(Fig. 5.180)** And if you're so inclined, experiment with colors! **(Fig. 5.181)**

Fig. 5.179

Fig. 5.180

Fig. 5.181

MONSTER BALLOONS

Monster balloons are typified by unusual, animalistic, or primitive-looking typefaces surrounded by roughly shaped balloons. **(Fig. 5.182)** The goal is to invoke growling, savage speech, clearly much scarier than your standard dialogue.

There is more than one way to make these distressed balloons, and I'm going to show you two.

Fig. 5.182

STANDARD MONSTER BALLOONS

Typically, letterers start with a standard balloon with the stroke removed. Using the Pen Tool (P), add extra points to the circumference just as we did with the radio balloon, but with less uniform spacing. **(Fig. 5.183)**

Next, add a Roughen effect (Effect > Distort & Transform > Roughen) with settings like **Fig. 5.184**, or whatever you think looks good. **(Fig. 5.185)**

Fig. 5.183

Fig. 5.184

Fig. 5.185

Once you have a degree of Roughen that you're happy with, click OK, and expand the effect by going to Object > Expand Appearance. Then you can add your .75pt, K:100 black stroke set to overprint. **(Fig. 5.186)**

This looks okay, but with a little more effort I think there's a way to get a better-looking design by actually drawing it ourselves. Let's start over.

Fig. 5.186

IMPROVED MONSTER BALLOONS

Using a standard balloon shape as inspiration—and with our standard fill and stroke properties applied—switch to the Pen Tool (P) and click lots of small points in a sort of "crunchy" pattern until you return to your starting point and complete the object. **(Fig. 5.187)** This is similar to how we made the wavy balloons earlier, but with hard edges instead of soft, wavy lines.

Fig. 5.187

Let's place this around a decidedly "monstery" type treatment—an Area Type object styled with my Always Angry BB typeface. **(Fig. 5.188)** Next, we'll add a tail . . .

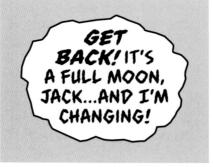

Fig. 5.188

MONSTER BALLOON TAILS

I find the best way to make monster balloon tails is to approach them the same way as the balloons, freehanded point by point with the Pen Tool (P). It'll take some practice, but try to focus on making a slightly wavy, irregular tail that's "crunchy," just like your monster balloons. When you've got something you're happy with, you can select the balloon and the tail and impermanently join them with Make Compound Shape in the Pathfinder window menu. **(Fig. 5.189)**

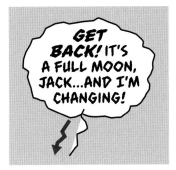 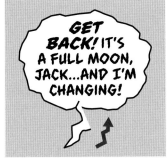 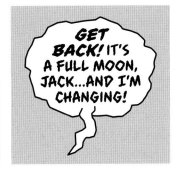

Fig. 5.189

If you think the design warrants it, feel free to play with colors. A classic treatment—and one that may be overused, so apply it thoughtfully—is a black balloon with a colored stroke. The Area Type object text can have a color fill as well. **(Fig. 5.190)** Make sure your overprints are set correctly if you're going to use this style!

Fig. 5.190

As I've repeated throughout this chapter, I suggest you make lots of monster balloons in different sizes to be saved outside the artboard of your lettering template for future use. **(Fig. 5.191)**

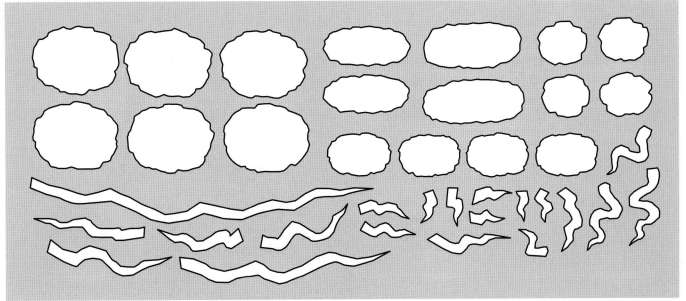

Fig. 5.191

BALLOONS THAT OVERLAP PANEL BORDERS

Some letterers have no qualms about placing balloons so they overlap panel borders, and others tend to go out of their way to fit balloons within the panel borders. This is purely preference. Personally, I fall in the second category. Since the advent of digital lettering, I feel that balloons and sound effects can very quickly look like "stickers" just slapped on top of the art. At its worst, overlapping panel borders creates the impression that the letterer didn't put forth much effort to work hand in hand with the art. Some might argue that overlapping panel borders is necessary because there just isn't room in the artwork. I've also had requests to overlap panel borders to help "guide the reader's eye" to the next panel in a particularly awkward panel layout. All those thoughts aside, I find that there's almost always a more elegant workaround than floating balloons over a panel border.

That said, there are times when I *will* overlap a panel border: sometimes there really is absolutely no room provided in the art, or there's an inset panel featuring a character in close-up with a particularly important line of dialogue . . . floating a balloon outside the border can be a particularly dramatic "beat." Otherwise, I can almost always find a creative solution to work within the panel border, usually involving butting balloons to panel borders, which I feel goes a long way to marrying lettering to art.

Look through some comics and find examples of balloons that overlap versus those that are placed inside panel borders and see what you think!

Balloons overlapping panel borders

Balloons placed within panel borders

ALTERNATIVE BALLOON PRACTICES

Up until this point, we've been covering the basics of balloon-making. I've included everything I could think of that encompasses most "house style" lettering. However, there are some other techniques that, while not necessarily more difficult, take a little extra effort on your part. Think of the rest of this chapter as useful options to add to your bag of tricks when coming up with lettering style guides for new projects. These are ways to custom-tailor your lettering beyond the norm. You may end up using some of these ideas all the time, and other techniques may be tucked away in your bag of tricks until you find just the right project!

ORGANIC BALLOONS

Savvy comic book readers aren't going to be fooled into thinking that lettering designed with typefaces and vector objects on a computer has been hand lettered—but we can add some organic touches to our lettering that create a more aesthetically pleasing end product. In addition to typefaces that have double-letter auto-ligatures and alternating characters, we can take some extra steps with our balloons to closer replicate a hand-drawn touch.

Many hand letterers freehanded their balloons, forgoing the use of circle templates. We can replicate that by taking the same approach digitally. This style of balloon is actually my preferred choice when lettering. Truth be told, I almost never use the symmetrical balloons that were covered at the top of the chapter.

Switch to your Pen Tool (P) or your Pencil Tool (N) (if you use the Pencil Tool, just make sure the Fidelity is set closer to "Smooth" in the Pencil Tool Options window). I also recommend using a tablet/stylus to make these. It's much easier than using a mouse. Try to freehand as perfect a balloon shape as you can on the Balloons layer of your lettering template. You probably won't be happy with the result. That's okay. Switch to your Direct Selection Tool (A) and adjust the anchor points as needed. You can even delete excess anchor points with the aptly named Delete Anchor Point Tool in the Pen Tool flyout menu of your Toolbar, or use Object > Path > Simplify.

The first image in the following array is an organic balloon that I drew with the Pen Tool. **(Fig. 5.192)** Beside it is the same balloon, with a standard, symmetrical balloon imposed in blue inside it. **(Fig. 5.193)** See the difference in the perimeter? The third image **(Fig. 5.194)** is the organic balloon with some text, a tail, and our standard .75pt weight, K:100 black stroke set to overprint.

Fig. 5.192

Fig. 5.193

Fig. 5.194

I want to stress that *less is more* when freehanding these balloons. Your end product should not look like you drank too much coffee and had the shakes that day. An imperfect balloon with too much "jitter" ends up looking like a monster balloon and quickly becomes an eyesore when used on page after page of a comic. The goal when drawing these is to be just slightly more irregular than the standard balloon. The difference (especially when you use several different imperfect balloons on a page), isn't something that the reader should immediately notice . . . it should lend a subtle, overall organic feel to the lettering.

As always, I recommend making lots of organic balloons in both elliptical and slightly more squared-off elliptical shapes. **(Fig. 5.195)**

Fig. 5.195

CALLIGRAPHIC STROKE

Another one of my favorite effects to use on balloons (particularly the imperfect balloons above), is to add a stroke that looks like it was drawn with a wedge-tipped calligraphy pen. Using this style of stroke goes a long way to marrying your lettering to hand-drawn art, particularly when that art is inked with a quill-point or a brush. It also complements dialogue typefaces that look like they were lettered with a similar pen. Compare a uniform stroke **(Fig. 5.196)** to a calligraphic stroke. **(Fig. 5.197)**

Fig. 5.196

Fig. 5.197

To create your own calligraphic Illustrator brush, finish all your text and balloons on a given page. Select all the balloons on the Balloons layer by clicking the small circle on the right side of the layer name. **(Fig. 5.198)**

With your balloons selected, press the New Brush button in your Brushes window (Window > Brushes). **(Fig. 5.199)**

Fig. 5.198

Fig. 5.199

When the New Brush window appears **(Fig. 5.200)**, make sure Calligraphic Brush is selected and click OK. This will bring up the Calligraphic Brush Options window. Experiment with settings, but you might want to start with my defaults. **(Fig. 5.201)**

Don't forget to name your new brush and hit OK. You'll see this brush applied to all your balloons, but also notice that the new brush appears in your Brushes window. Make sure the new brush uses our K:100 black stroke color set to overprint.

To save this setting for future use, store a copy of one of the balloons that has the custom brush to the side of your artboard in your blank lettering template and resave it. Any time you want to apply that brush, you can select all the balloons on your Balloons layer and click this brush in the Brushes window. Or better yet, create an Action and assign the effect to one of your F-keys.

Fig. 5.200

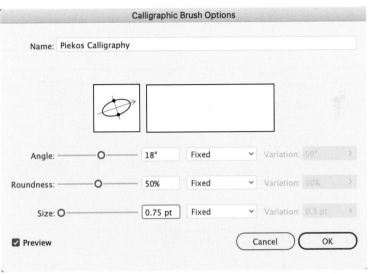

Fig. 5.201

OVERLAPPING BALLOON JOIN

Here's a simple way to make your balloon-to-balloon joining a little more interesting and organic. In this example, you can see an overlap and a break in the second balloon where it connects to the first balloon. **(Fig. 5.202)** Note that this approach works best with the calligraphic stroke, and with slightly more negative space than you might normally allow in your balloons. This might look complicated, but there's a very simple solution! The break in the second balloon is actually just a small oval drawn with the Ellipse Tool (L) with a white fill and no stroke! **(Fig. 5.203)**

Fig. 5.202

Fig. 5.203

BALLOONS THAT BREAK PANEL BORDERS

You've probably seen balloons that break panel borders instead of butting against them. **(Fig. 5.204)** This is an attractive stylistic choice, it saves space, and it's really easy . . . but note that this technique only works if you can match the fill color of your balloons to the gutter color.

Fig. 5.204

We begin at the dialogue placement stage. In Chapter Four, I instructed you to leave some space between your Area Type object and the panel border. Instead of doing that, I want you to place the Area Type objects with the text *touching* the panel border where you intend to break it. **(Fig. 5.205)** This looks weird now, but stay with me. It all works out when you add your balloons.

WHEN I WAS YOUR AGE, WE HAD TO SEW OUR **OWN** SUPER SUITS!

GEE, MACK, I DIDN'T THINK YOU WERE THAT **OLD!** I MEAN, THESE DAYS, WE JUST ORDER ONLINE.

YOU LITTLE PIPSQUEAK! I AUGHTA SHOW YOU ANOTHER THING THAT WE USED TO PRACTICE IN THE OLD DAYS...A LITTLE **RESPECT!**

Fig. 5.205

Add your balloons, tails, and any special strokes to the balloons as if you were going to butt them against the panel border **(Fig. 5.206)**, as I covered earlier in the chapter. If the page gutters are not pure white, use the Eyedropper Tool (I) to sample the gutter color and then use that color for your balloon fill.

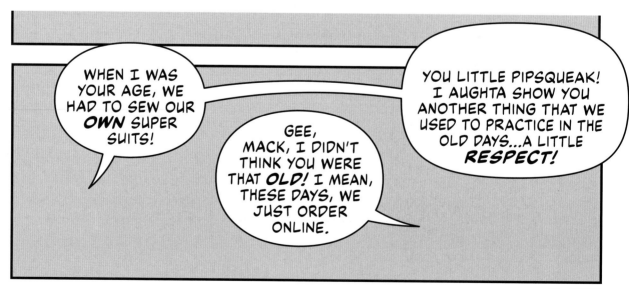

Fig. 5.206

Remember earlier in the chapter when we discussed butting balloons against panel borders? You're going to repeat that process by drawing an object to use as a clipping mask. **(Fig. 5.207)** In this example, I drew a blue rectangle, but this is just for demonstration purposes—the color and stroke don't matter. The important difference between drawing these masking objects for butted balloons and drawing them for balloons that break panel borders is that instead of drawing the rectangles up to the *inside edge* of the panel borders, you want to go *outside the panel borders a little bit.* Take a good look at the top and right side of that blue rectangle. See how it goes over the panel border and out into the gutter? This is because my version of this technique has an added "insurance" step coming up. You *could* just position the clipping object up to the outside edge of the panel border, but any slight misalignment could ruin the effect and show a sliver of that panel border.

Fig. 5.207

When you're happy with your masking object, select it and its corresponding balloon(s) and Make Clipping Mask (Command + 7). **(Fig. 5.208)** See how the balloons are clipped so they overlap a little and "spill" into the gutter? That's what we want.

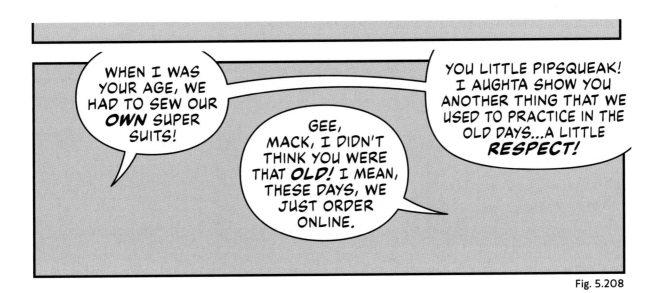

Fig. 5.208

Next, let's address that extra "insurance" step that that I mentioned previously. Since we can't always be in control of the final marriage of our lettering to the artwork for print (handled by a publisher's production department much of the time), we can try to mitigate potential errors in production. We need to cover up the parts of our balloons that are peeking out of the panel borders. If there is any accidental misalignment of the masked balloons, the result in print won't be as bad (in my opinion) as it would have been had we clipped the balloons right up against the outside edge of the panel border.

Draw some rectangles that cover any part of the balloons that stick out of the panel. Make sure the rectangles align very precisely to the *outside edge* of the panel border. **(Fig. 5.209)** Again, I drew blue rectangles for demonstration purposes, but the fill doesn't matter quite yet.

Fig. 5.209

Finally, fill the rectangles with the exact color used for the gutters—the same color you used for the balloon fill. **(Fig. 5.210)** To reiterate an earlier point, this technique will not work unless you're using the *precise* color of the gutters in the artwork. In fact, it may be a real mess in print.

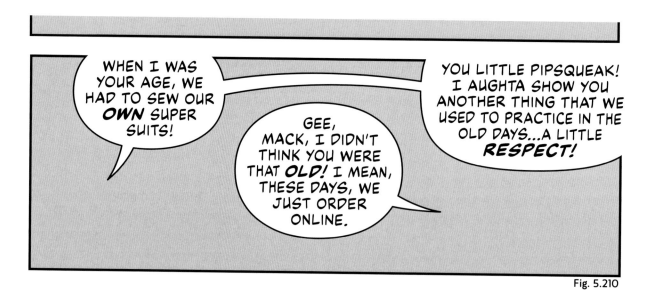

Fig. 5.210

That's the finished effect! If at any time you need to edit these balloons, note that you can select the clipping mask and Release Clipping Mask (Option + Command + 7), make the changes, recreate the clipping mask, and adjust those final white rectangles as needed.

CUSTOM ILLUSTRATOR BRUSHES FOR BALLOONS

The calligraphic stroke I mentioned previously is just one kind of Illustrator brush that you can use on your balloons. It's actually fairly easy to make your own original brushes that have much more interesting textures.

Do you need balloons that look like they were drawn in pencil? How about balloons drawn with a tech pen with just a *slight* bit of organic bleed? Or maybe you have a huge monster that could use a really irregular, "globby" balloon stroke? **(Fig. 5.211)** Custom brushes to the rescue! The only limit is your imagination.

The first step to making a custom Illustrator brush is coming up with the vector object you want to turn into a brush. There are two options: draw your source material with real-world art supplies and scan them, or create the source material as vector objects directly in Adobe Illustrator.

Fig. 5.211

For example, the pencil brush started out as hand-drawn pencil lines on watercolor paper made with a blunt #2 pencil and a T-square. **(Fig. 5.212)** I scanned those in and converted them to vectors. But the "globby" balloon's brush was just a long, irregular object I drew in Illustrator with the Pen Tool. **(Fig. 5.213)**

Fig. 5.212

Let's run through the more complicated option first: drawing our source material in the "real world" and scanning it. If our end goal is a brush to add to a balloon, then we need a nice long sample to work with that is also relatively straight. Here, I've drawn a long straight line with a black marker and then added some "crunchy" texture to it. **(Fig. 5.214)**

Fig. 5.213

Fig. 5.214

Next, you'll want to scan the the source material as a 600ppi grayscale image and save that as a .tif on your desktop or wherever you can find it. I also recommend opening this image in Photoshop before you go any further and adjusting the Levels (Image > Adjustment > Levels) to make it as crisp as you can, then resave it.

There is no point in trying to provide you with exact settings for cleaning up the image. Every time you go through the process of making a new brush, you'll have to experiment with settings every step of the way to get your ideal result.

Open a new Adobe Illustrator document and place that scanned image in your document by going to File > Place . . . and inserting it wherever you'd like. It doesn't matter if it's outside or inside the artboard. Here, I've placed it just above the artboard. **(Fig. 5.215)**

Fig. 5.215

At this point, we have a pixel-based .tif that needs to be turned into a vector object with points. We need to open the Image Trace window (Windows > Image Trace) and begin experimenting. Again, there is no perfect formula here. You need to experiment every time you do this. In this case, I find the settings shown in **Fig. 5.216** give me the result I'm looking for . . .

Make sure Ignore White is checked so that the white area of your scan isn't included in the vectorization. Also, Preview should be checked in the bottom left corner of the window so you can see how your adjustments affect the vectorization.

Fig. 5.216

When you have a result you're happy with, you can click the Expand button in the bar at the top of your Illustrator window. (**Fig. 5.217**)

With that, you have a vector object of your hand lettered line. (**Fig. 5.218**)

Fig. 5.217

Fig. 5.218

If we were making a vector object directly in Illustrator, we could skip the entire process of scanning and image tracing and simply draw what we needed with the Pen Tool. Surely, this is more convenient, but some things are difficult to convincingly recreate digitally (such as the pencil line from earlier).

If you were making a custom brush to use for lettering sound effects, or almost any other purpose, you could go right into the steps to make the brush. However, Illustrator wraps the *entire* length of your brush around the perimeter of whatever you apply it to (like our balloons, for instance), and the ends must be seamless where they touch. We need to make sure the ends of the brush stroke bookend. (**Fig. 5.219**) This is extremely important for brushes intended for balloons.

Fig. 5.219

We start by trying to get the vector object as close to 90 degrees horizontal as possible. For this, you must first make sure your rulers are showing in the document (View > Rulers > Show Rulers). Click anywhere on the top ruler, and drag down a guide. Place your vector object against it, and make rotational adjustments using Rotate (R). See how I've gotten it to line up as much as possible with this perfectly horizontal guideline? (**Fig. 5.220**)

Fig. 5.220

Now we need to make sure both ends of this brush will bookend. Click on your top ruler, and drag down another guide to create a visual representation of the inside thickness of the brush stroke (**Fig. 5.221**). Since we're focused on the left side, let's start there. Snip the end off by drawing a rectangle with the Rectangle Tool (M) of any size, any color (**Fig. 5.222**) and using it to clip the object by selecting the rectangle and the vector object, then use Minus Front in the Pathfinder window. (**Fig. 5.223**)

Fig. 5.221

Fig. 5.222

Fig. 5.223

We need both ends to have perfectly vertical end terminals, so repeat the process on the right side. And while you're at it, use the Direct Selection Tool (A) and try to get the anchor points on each end to be the same width as the space between your guidelines. **(Fig. 5.224)**

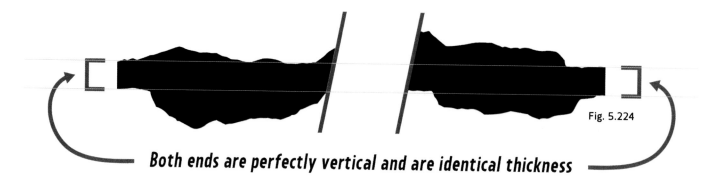

Fig. 5.224

Both ends are perfectly vertical and are identical thickness

One last step before we make our brush . . . brushes meant for balloons require a few versions of different lengths. This is because balloons come in all shapes and sizes, and as I mentioned, brushes work by wrapping around the entire perimeter of the balloon. Illustrator will stretch or compress the brush stroke to fit.

Imagine you tried to take a very long, very detailed vector object and wrap it around a balloon that was small enough to accommodate a single word. The whole brush stroke would be squeezed around that balloon. All that detail jammed together would end up looking like a hairy caterpillar. That wouldn't look good at all. Similarly, a huge balloon using a brush stroke that's too short would have all the detail stretched right out of it.

In order to look consistent across a multitude of balloon sizes, we need a very short version for small balloons, medium for average-sized balloons, and large or even extra-large lengths for big balloons or multiple joined balloons. Make at least three copies of your vector object and trim them at different lengths, making sure that the terminals of all the ends will bookend just like the previous instructions. We now have these three lengths **(Fig. 5.225)** (and we're about to actually make brushes, I promise . . .).

Fig. 5.225

Make sure your Brushes window is open (Window > Brushes), and with your shortest vector object selected, click on the hamburger menu in the top right corner. **(Fig. 5.226)**

Fig. 5.226

This will open a flyout menu, and you'll want to click on the top option: New Brush. **(Fig. 5.227)** This brings up the New Brush window. **(Fig. 5.228)** Select Art Brush and click OK.

This opens the Art Brush Options window, **(Fig. 5.229)** where you can give your custom brush a name. I've gone with "Cranky Creature Short," since this is the short version of our new brush. You can leave all these settings at their default as shown, except for two. The first is Colorization > Method, which needs to be set to "Tints" if you ever plan on changing the color of the stroke to something other than black. The second is Overlap, which has two button options that you'll have to experiment with once you start actually using the brush on balloons. Sometimes the way the brush overlaps itself can play tricks with the sharp end of a tail. Don't worry, you can simply double-click the new entry in your Brushes window and change the Overlap (or any other setting) without totally recreating the brush. When you're done, click OK and you'll see the name of your first new brush pop up in the Brushes window.

Fig. 5.227

Fig. 5.228

Fig. 5.229

Repeat this process for the other brush lengths, saving them as "…Medium" and "…Long."

Any time you want to apply them to a finished balloon just select the balloon and click the brush name in the Brushes window. **(Fig. 5.230)** You will probably have to adjust the Stroke Weight. Just go to the Stroke window (Window > Stroke) and play with the Weight setting until you're happy.

All that's left is the fun part: playing with colors and fonts! **(Fig. 5.231)**

Fig. 5.230

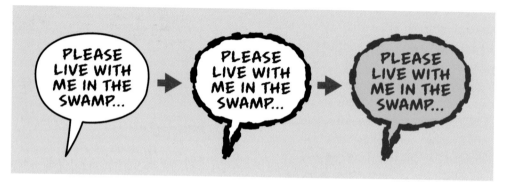

Fig. 5.231

As I mentioned, there are lots of creative ways you can use custom Illustrator brushes— and not just for organic lines. Almost any vector object(s) can be turned into brushes to be stretched around a balloon. Check out **Fig. 5.232**. That's just a bunch of broken lines of various thicknesses. Experiment on your own and try to figure out how I made that one!

Fig. 5.232

MURMURING

You'll be surprised to find out just how often a writer asks for indistinct dialogue in a script—something that can't be read. Ultimately, I came up with the approach below. At very small sizes, it has the visual breakup of dialogue but isn't readable text. It's a series of scribbly, italicized *Ms* drawn with the Pen Tool (P), and it has a light calligraphic brush stroke added to it.

Another option you may encounter is a series of ellipses without spaces between them (or a series of lots of periods, your choice) in a small balloon with a little extra negative space.

Try both approaches and see which you like better!

Murmuring balloons, shown at actual print size

Here are a range of balloon styles I've designed to inspire you! Obviously, many of these are larger than they would appear in print, but I wanted to make sure you could examine them in detail. See if you can use the skills we've covered up to this point to recreate these balloons, or use these ideas as a starting point to develop your own interesting concepts!

IT'S NICE. THE CITY STREETS ARE QUIET AT FOUR IN THE MORNING. THE WORST THAT YESTERDAY HAD TO OFFER IS **OVER,** AND THE BEST OF TOMORROW IS **YET TO COME.**

I CAN TAKE A BREATHER PERCHED ON THESE ROOF-TOPS.

I CAN ASSESS MY **WOUNDS** AND CHECK MY **GEAR...**

WE NEED TO FLANK THE CREATURE **NOW!** HOSHI, APPROACH FROM THE NORTH AND USE YOUR PULSE CANNON!

DO YOU FEEL THE **CHILL?** THE TERMPERATURE IS DROPPING. PRETTY SOON, YOU'LL SLEEP...

NO SIGN OF ALIEN LIFE OUT HERE. WAIT A MINUTE... IS THAT A--?

UNLEASH THE PLASMIC ENERGY UPON THE CITY!

Let's just figure it out, okay?

THE STONE PEOPLE SHALL **TRIUMPH** AGAINST ALL ODDS!

YOU?!

DANGER DANGER! DANGER! DANGER! DAAAANGER!

FINDING THE LOST **HAMMER OF THE GODS** MAY BE HARDER TO FIND THAN YOU THINK.

YOU SHOULD PROBABLY PACK A **HEARTY LUNCH.**

PURE FANTASY, DOCTOR. I CAN NOT BE KILLED BY ORDINARY MEANS.

WE CAN'T UNDO YOUR TIME TRAVEL MISTAKES, BOB. NICE WORK.

THAT WAS THE DAY WE HEARD THE SIRENS--ALL THAT CHAOS AND RAGE-- ALL THE HATRED AND FEAR--SPILLED ONTO THE **STREETS.**

YOU JUST CAN'T BEAT THE **CLASSICS...** THEY NEVER GO OUT OF STYLE.

My skin has become a thick, swirling ooze!

YOU KNOW I'M MORE THAN JUST A TIN CAN. I AM SENTIENT! I FEEL! I LOVE YOU, YOU **CREEP!**

THESE OLD CARS JUST OOZE STYLE AND SPEED... AND LOOK AT THAT PAINT JOB!

THIS **HAIR** KEEPS GROWING AND GROWING!

WE CAN SMELL THAT DELICIOUS FLESH!

YOU READY TO BUY?

THE SWAMP IS CALLING ME BACK TO ITS SLIPPERY EMBRACE...

I CAN HEAR YOUR THOUGHTS...BUT YOU'RE **NOT** SPEAKING! HOW IS THIS HAPPENING? IT CAN'T BE REAL!

WE CAN GO BACK IN TIME TO **UNDO** YOUR TREACHERY!

SAVING **THOUSANDS** OF LIVES IS WORTH THE RISK.

HE DISAPPEARS LIKE THAT **ALL THE TIME.**

SURE IT'S ANNOYING, BUT YOU'LL JUST HAVE TO GET USED TO THE **"MYSTERIOUS CRIMEFIGHTER"** SCHTICK.

THOSE BULLETS WON'T WORK ON ME, LAD. I'M 100% GENUINE LIZARD HIDE.

IF YOU COME ANY CLOSER, I'LL BURN YOU TO A CRISP. I'M NOT **KIDDING.** SO KEEP YOUR DISTANCE!

WE HAVE ALL THE TOYS YOU'LL EVER WANT TO PLAY WITH DOWN HERE...

I'M JUST YOUR STANDARD, RUN-OF-THE-MILL KILLER ROBOT.

CAR SEVENTEEN, DO YOU **READ** ME? ROBBERY IN PROGRESS!

I KNOW YOU CAN HEAR ME, MY DEAR. MY TELEPATHY IS **TOO STRONG** TO RESIST!

...AND THAT'S WHY YOU DON'T TANGLE WITH THE KID--HE'S ONE BAD HOMBRE...

DOCTOR, YOUR PATIENT IS READY...

...DOCTOR? ARE YOU..?

...OH NO.

⸱HIK⸱ I THINK I MAY HAVE HAD ONE TOO MANY...

THIS IS FLIGHT THIRTY-THREE, WE JUST SAW A U.F.O.

I've lived in this house for three hundred years. And I'll still be here long after **YOU.**

TURN THE MECH LEFT, MARTY--NO, YOUR **OTHER** LEFT!

WHAT DRAGON?

THE ENERGY IS BUILDING UP INSIDE ME!

MY SUPER HEARING HAS PICKED UP A BANK'S ALARM! I'M NEEDED ELSEWHERE, BUT IF I LEAVE NOW, EVERYONE WILL DISCOVER MY SECRET IDENTITY!

WHAT SHOULD I DO? I HAVE BUT SECONDS TO DECIDE!

YOUR SUMMONING CIRCLE CAN'T HOLD ME!

THANKS FOR CHOOSING APEX ENEMY DISPOSAL! WE'RE THE BEST AT MAKING YOUR PROBLEMS JUST... *DISAPPEAR!*

WE'RE AFFORDABLE AND PROVIDE OUR OWN SAWS AND STUFF, TOO.

UH-OH... I THINK I'M GOING TO *BARF!*

SHHHH! YOU'RE GOING TO WAKE THE DRAGON!

IF ONLY LIFE HAD TURNED OUT DIFFERENTLY...SO MUCH *MONEY,* AND SO LITTLE HAPPINESS. I WISH THERE WAS *SOMEONE* TO SPEND ETERNITY WITH...

GRRR... THERE WILL BE *BLOOD* TONIGHT!

STAND DOWN OR BE DESTROYED, MUTANT!

MY LIFE FADES... FADES... FA...

BE CAREFUL NOW, I'M ONE SLIPPERY LITTLE DEVIL!

I'M PROGRAMMED NOT TO HARM HUMANS...ARE YOU A HUMAN?

WHEN THE FULL MOON ARRIVES, YOU'LL BEGIN TO CHANGE--

IT'S A ROUGH IDEA. I MEAN, IT NEEDS TO BE FLESHED OUT.

BUT YOU HAVE TO ADMIT, THERE'S POTENTIAL!

GRAAAAHH!

IT'S JUST THAT...I'M NOT SURE I'M *IN LOVE* WITH YOU ANYMORE.

WE'VE GROWN APART THESE LAST FEW YEARS.

YOU WHAT?!

YOU WHAT?!

YOU WHAT?!

IT'S DANGEROUS TO PLAY YOUR HAND SO EARLY, YOU *FOOL!* WAIT TILL YOU FEEL THE *WRATH* OF STEVE!

YOU WHAT?!

YOU WHAT?!

CHAPTER SIX
CAPTIONS

SIMPLE YET COMPLEX

At their most basic level, captions are either information that is being *thought* but not spoken aloud by a character, or they are dialogue being spoken aloud by a character that we're intended to "hear" but not see. Captions can also be information that only the reader is privy to (like dates or editorial notes). **(Fig. 6.1)**

From a design standpoint, basic captions seem like the most easily crafted element to include in your repertoire. Most of the time they are essentially text within a rectangle—two things you've already learned to make in previous chapters. The complications arise when you consider that different kinds of captions require quick visual differentiation by a reader. A spoken caption should be styled differently than a location/time caption. There are also some grammatical conventions that you'll need to commit to memory.

I've broken down the variety of captions into these basic categories: spoken, internal monologue (including journals and text messages), location/time, omniscient narrator, and editorial. Before we get bogged down in details, let's cover the basics of caption creation.

Spoken caption	Internal monologue caption	Location/time caption
"THERE'S **NOTHING** YOU CAN DO ABOUT, JACK. THE CUBE IS ALL MINE!"	THE STREETS ARE QUIET TONIGHT--MAYBE I'LL HAVE AN **EASY** PATROL...	THE OUTER PLANES OF EXISTENCE...

Fig. 6.1

RECTANGULAR AREA TYPE OBJECTS AND CAPTION BOXES

When you made Area Type objects in Chapter Four, one of the objects you made was rectangular. This is ideal for captions, and the process is the same as using your balloon-shaped Area Type objects.

After copying/pasting your rectangular Area Type object where you estimate it will be needed in the Lettering layer of your template, you can go ahead and copy/paste dialogue from your script into the Area Type object. Using the control points of the Area Type object's bounding box, you can resize and reshape the rectangle to reveal the entirety of the text that needs to be displayed and break lines of text. Just as with the oval-shaped balloon Area Type objects, a little red plus sign will appear on the bottom right side of any Area Type object with an overflow of text that isn't being revealed. (Fig. 6.2)

Fig. 6.2

Your biggest concern at this point is trying to break lines of text in the most rectangular shape that you can. **(Fig. 6.3)** Your goal with captions of all kinds should be to minimize "gaps" or negative space before and after lines of text within the caption box. Available space in the artwork doesn't always allow enough room for optimal caption line breaks, but try your best!

Poor line breaks

"CAN'T YOU SEE THAT WE'RE IN *DANGER?* THE POISONED ARROWS? THE LAVA? THE GIANT, FLYING SCORPIONS?!"

"CAN'T YOU SEE THAT WE'RE IN *DANGER?* THE POISONED ARROWS? THE LAVA? THE GIANT, FLYING SCORPIONS?!"

Better line breaks

"CAN'T YOU SEE THAT WE'RE IN *DANGER?* THE POISONED ARROWS? THE LAVA? THE GIANT, FLYING SCORPIONS?!"

"CAN'T YOU SEE THAT WE'RE IN *DANGER?* THE POISONED ARROWS? THE LAVA? THE GIANT, FLYING SCORPIONS?!"

Fig. 6.3

Once your text is all set, you can create caption boxes on the Balloons layer of your lettering template. We use the Balloons layer for caption boxes instead of having a "Captions" layer since the Balloons layer performs the same function—a place for objects to frame text.

Switch to the Rectangle Tool (M). Draw a rectangle at roughly the size you'll need to surround the text. Style it with your standard balloon stroke (a K:100 black stroke at .75pt weight, set to overprint), and perhaps give it a fill color. Then you can tweak its size by dragging the bounding box's corner control points. **(Fig. 6.4)** As with balloons, the negative space inside a caption is typically about the size of an uppercase *O* from the font you're using. **(Fig. 6.5)**

Fig. 6.4

Fig. 6.5

SPOKEN CAPTIONS

Typically used as a means to transition from one scene to the next, spoken captions are used when a character, speaking out loud, needs to be "heard," but is far enough out of the presently unfolding action that an off-panel balloon would be misleading. After all, they're not just "off-camera"—they're not present in the unfolding scene and cannot be heard by the characters therein. Their speech should be presented in a caption box with quotation marks.

Things get a little confusing when we delve into the standard grammatical formatting for spoken captions in comics. Like balloons, spoken captions use text that is center-justified and set in the regular weight of your dialogue font (barring emphasis, of course). Unlike balloons, they use a specific system of quotation marks:

- All spoken captions begin with opening quotes.
- If a character has only a *single* spoken caption, then the caption should have closing quotes.
- If there is a series of captions spoken by a single character, only the *last* in the series should have closing quotes. The captions in between have no closing quotes.

That may be a bit confusing to understand at first, so let's use a graphic example. Note the opening and closing quotes appearing in a singular caption (**Fig. 6.6**), and closing quotes only appearing at the *end* of an uninterrupted series of quotes by the same character (**Fig. 6.7**).

Fig. 6.6

Fig. 6.7

If a speaking character is interrupted, or if there is a conversation going on, closing quotes are used as each speaker finishes their dialogue.

In **Fig. 6.8,** Speaker A (yellow) has a pair of captions, followed by a reply from Speaker B (blue). Speaker A then has one final caption in the conversation. Note that closing quotes are used as a way to indicate: *this character is finished speaking for the moment.*

Fig. 6.8

When captions are being used as voice-overs in a separate scene, when that scene ends and transitions back to the characters who are speaking, the dialogue continues as balloons since we are now "in the scene with them" again.

It's worth noting that in comics, smart or "curly" quotes (which look curved or just slanted to the left or right depending on use) are generally preferred over straight quotes (which look consistently vertical). Since you'll be copying text from scripts that have most likely been written in Word, it may be handy to know that writers can opt for smart quotes in Word's AutoCorrect window. Illustrator uses them by default, and those settings can be found listed under the Type tab of the Document Setup window.

Fig. 6.9

Color-coding spoken (and internal monologue) captions is the easiest way for a reader to understand that a caption belongs to a specific character. I often base my color decisions on the costume or clothes of the character.

To keep it simple, a superhero with a predominantly blue outfit (let's say, blue spandex with a yellow belt) might have a pale blue caption box. **(Fig. 6.10)** To be slightly more elaborate, they could have a dark blue caption box with a yellow open drop and pale-yellow text. **(Fig. 6.11)**

Simple caption styling

"CAN'T YOU SEE THAT WE'RE IN *DANGER?* THE POISONED ARROWS? THE LAVA? THE GIANT, FLYING SCORPIONS?!"

Fig. 6.10

Or...

More elaborate styling

"CAN'T YOU SEE THAT WE'RE IN *DANGER?* THE POISONED ARROWS? THE LAVA? THE GIANT, FLYING SCORPIONS?!"

Fig. 6.11

Letterers typically have free rein to be creative with caption styling unless you're taking over lettering duties for a series mid-stream, or are expected to letter in a "house style" for a publisher. You may have noticed some mainstream hero books use simplified versions of a character's chest emblem inset into the caption box. If you are creating caption styles from scratch, I recommend that you always keep in mind the frequency that a particular caption style will occur. You'll quickly regret designing captions that are time-consuming and hard to resize when you find out that future issues use lengthy spoken monologues by that character.

For each series that I letter, I keep samples of the caption styles as assets outside of my artboard in my Illustrator template. Each character's specific caption style is noted with their name, and I can reuse the boxes by copying/pasting. **(Fig. 6.12)**

JACK STAN MARY DEMON

Fig. 6.12

INTERNAL MONOLOGUE CAPTIONS

Closely related to the spoken caption, and often utilizing the same color scheme and design as spoken captions, internal monologue captions represent a character's private thoughts. **(Fig. 6.13)** There are no quotation marks used, and the text is sometimes italicized. As an added bit of differentiation, I like to left-justify internal monologue captions.

THEY HAVE NO IDEA WHO I REALLY AM!

IF I UNLEASH MY TRUE KUNG-FU ON THESE DUMMIES, THEY'LL REALIZE I'M AN IMPOSTER...

I JUST HAVE TO BIDE MY TIME...WAIT FOR THE BIG TOURNAMENT... AND THEN BEAT THEM!

THE CLOCK IS TICKING ON SARA'S NEW PLAN. DO I TELL HER IT WON'T WORK?

THE KILLER IS OFFICER JANET McVITTIE...I JUST KNOW IT IN MY BONES!

Fig. 6.13

For roughly the last twenty years, internal monologue captions have largely replaced thought balloons. In fact, in all the series for all the publishers I've ever worked on, I can only think of one still using thought balloons extensively.

JOURNAL CAPTIONS

As a variant of the internal monologue caption, you sometimes are called on to create captions that look like journals, diaries, or other text that acts much the same way—as if that character wrote down their private thoughts and we're reading them. **(Fig. 6.14)** These designs can go a long way to making your lettering style guides unique.

Fig. 6.14

Having a varied collection of typefaces to emulate all these approaches is important, but in most cases, it's the caption box that really sells the effect. With a little work, you can add a torn edge to a "piece of paper," or make a caption look weathered.

Making captions look like torn paper is a pretty simple trick, and it uses a trimming object and Minus Front. Begin these captions with a suitably handwritten typeface on your Lettering layer, and create a rectangular box beneath it on your Balloons layer. **(Fig. 6.15)** Try to break the lines of text so that you end up with a little negative space, usually on the right side, that you can "chop out." To do that, you need to create an object using the Pen Tool (P) to use as a trimming object that looks like the inverse of the torn edge. **(Fig. 6.16)** Finally, select the object and the caption box and in the Pathfinder window (Window > Pathfinder), click the Minus Front button. **(Fig. 6.17)**

Fig. 6.15

Fig. 6.16

Fig. 6.17

The notebook page caption is a little more complex. Draw a rectangle with the Rectangle Tool (M) on your Balloons layer. **(Fig. 6.18)** Switch to the Ellipse Tool (L) and draw a small circle to use as a trimming object, copying/pasting duplicates of it (precisely spaced!) down the length of the left side. **(Fig. 6.19)** Select the circles and the rectangle and use Minus Front in your Pathfinder menu (Windows > Pathfinder) to trim away some semi-circles. **(Fig. 6.20)**

Fig. 6.18

Fig. 6.19

Fig. 6.20

Zoom (Z) way in and draw the ruled lines with the Pen Tool (P). Hold down the Shift key as you draw to make perfect 90-degree lines. Change the single vertical line to magenta and the many horizontal lines to cyan in the Swatches window (Window > Swatches). **(Fig. 6.21)** Make sure the lines travel all the way to the edges of the

Fig. 6.21

Fig. 6.22

white space of the caption box but do not overlap the black stroke. Duplicate the cyan line (again, precisely spaced!) all the way down the caption box by using Shift + Option while you drag the first duplicate, and then Command + D to duplicate it at intervals of the same distance. **(Fig. 6.22)**

On your Lettering layer, use a rectangular Area Type object and pick a typeface that looks handwritten. Scale it so that it fits the cyan lines by adjusting its point and leading sizes in the Type window (Window > Type). **(Fig. 6.23)**

You want the caption box bigger than you'll need, so that you can cut away whatever is not used in each individual caption. You'll also want to save a copy of the whole thing somewhere outside your artboard that you can copy/paste whenever you need it.

To tailor the notebook page to the amount of text in a given caption, trim the bottom first by drawing a rectangle that you'll use as a trimming object. Select the rectangle and the white of the notebook page (only the white!) and trim it away with Minus Front in the Pathfinder window (Window > Pathfinder). **(Fig. 6.24)**

Fig. 6.23

Fig. 6.24

You'll be left with a bunch of extraneous cyan lines and a magenta line that's too long. **(Fig. 6.25)** Switch to the Direct Selection Tool (A) and resize that magenta line. The leftover cyan lines can simply be deleted. **(Fig. 6.26)**

Finally, with the Direct Selection Tool (A), grab all the anchor points on the right side of the caption (the white box and the cyan lines) and drag them to the left (holding Shift to constrain) to truncate the width of the caption box. **(Fig. 6.27)**

Fig. 6.25

Fig. 6.26

Fig. 6.27

While they look great, these notebook captions can be tedious to create and are not very forgiving in the event of lettering corrections, so I recommend you use them sparingly.

TEXT MESSAGES

Back in the day, letterers were often called upon to fill in the text on artwork showing the front page of a newspaper (I *hated* creating faux newspaper text—it was one of my least favorite lettering duties). Since newspapers have largely gone out of fashion, you won't have to worry about them too much . . . but you *will* be asked to letter text messages being sent between characters with about as much frequency as those old newspaper headlines. Much of the time, captions made to look like texting serve the same function as journal captions—a peek into private information.

Begin on your Lettering layer with your rectangular Area Type object styled in a modern, sans-serif font that looks suitably like a text message. **(Fig. 6.28)**

On your Balloons layer, draw a rounded rectangle around the text with the Rounded Rectangle Tool. It's in the flyout menu in your Toolbar under the Rectangle Tool—we used it for robotic balloons, remember? Make sure it has no outline and a medium to dark fill color that will be suitable behind white text. Blue and green are common. Then you can change the text color to white in your Swatches window. **(Fig. 6.29)** Double-check that neither the white text nor the rectangle will overprint in the Attributes window (Window > Attributes).

Create a small tail with the Pen Tool (P) and make sure it's the same color as the rounded rectangle. Finally, align the tail to the side of the rounded rectangle. **(Fig. 6.30)**

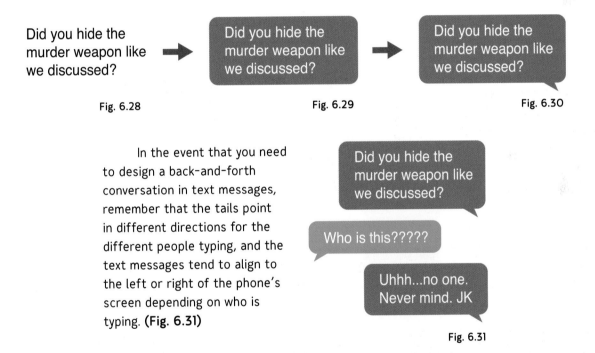

Fig. 6.28 Fig. 6.29 Fig. 6.30

In the event that you need to design a back-and-forth conversation in text messages, remember that the tails point in different directions for the different people typing, and the text messages tend to align to the left or right of the phone's screen depending on who is typing. **(Fig. 6.31)**

Fig. 6.31

LETTERING, THE "INVISIBLE ART"

When the subject of lettering comes up in conversation, sometimes you'll hear someone say that good lettering is "invisible." More importantly, *bad* lettering is obvious and distracting, even if you don't quite know why it's bad. Well-crafted lettering doesn't take the reader out of the story, it harmoniously meshes with the art and is free of poor balloon placement. It's there, but you're not focused on it. I like to compare this to listening to a new song . . . it's been mixed so that no one instrument is distractingly louder than another—but they're all heard. Upon subsequent listening, you're more able to pick out individual instruments in the mix. Lettering is that funky bassline or solid drumbeat that's doing the essential job of keeping the reader engaged and moving along.

Good lettering is not invisible—it's elevating the comic book without drawing attention to itself.

LETTERING STYLE GUIDES

I've mentioned lettering style guides a few times throughout the book already, but it's worth taking a few minutes to really explain what they are, and your part in creating them.

When you receive a new lettering project, it may be your responsibility to propose the general design aesthetic of the lettering on the series—assuming you're not taking over an already ongoing series, and you're not expected to letter in a "house style" (a homogenous style guide present across all of a publisher's comics). You'll consider the style of art and the genre of the series, and decide on the typefaces, balloon styles, caption styles, and sound effect styles that best complement the project. You may even create a few test pages in different style guides to propose to your editor or the creative team. But how do you decide these things? You develop your design chops and ask yourself some questions . . .

What's appropriate for the genre? If it's a western, maybe the captions could look like old, weathered wooden signs, and the balloons could borrow the wavy, cloud-like style from 1940s and 1950s comic lettering—the popular era of western comics. A police procedural might have

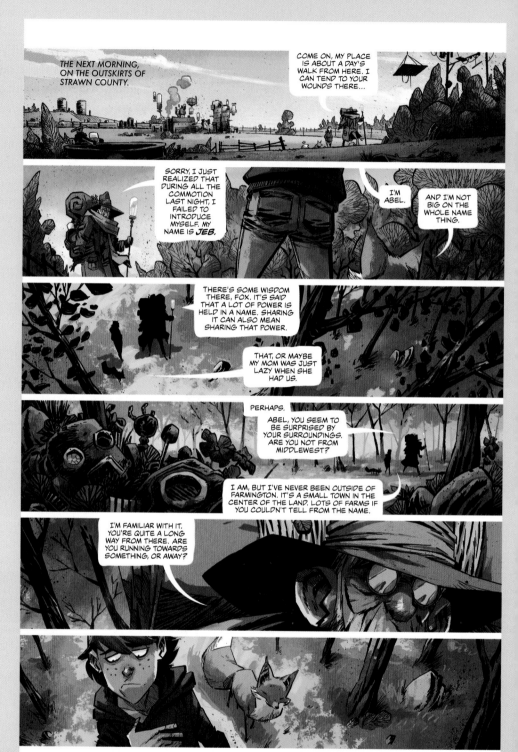

Middlewest #2 courtesy of Skottie Young and Jorge Corona.

captions more like strips of CAUTION tape at a crime scene and very modern, clean balloons and typefaces.

What can you do to make sure your lettering works hand in hand with the art? Take a good look at what the artist/inker/colorist is doing. Is the inking very painterly, or is it drawn with a tech pen? Look at the line weights. Can you approximate those with your lettering? Does the coloring have gritty textures, or is it glassy and clean? Are the

colors vivid or muted? Can you incorporate those things into your design and color choices?

How can you accommodate the script? Is the writer packing each page with dialogue, or is it sparse? If it's packed, you might consider breaking panel borders with your balloons to save space. If it's sparse, maybe balloons with lots of negative space is an option. Has the writer left you any notes in the script about any of these things?

All these considerations and more will help you shape your style guides.

Take a look at the finished pages on the left and right. The lettering style guides are *very* different. On the left we have *Middlewest,* a fantastical world of midwestern and steampunk sensibilities. I came up with a very "European" approach to the lettering with organic, rounded rectangles for balloons, clean text-only omniscient narrator captions, and you'll note that none of these elements have strokes or outlines . . . even the sound effects for the series. I felt this style guide worked well with Jorge Corona's art and saved some space in panels that were sometimes very busy.

On the right we have a page of *The Me You Love in the Dark,* which is a sinister, supernatural romance tale by the same creators: Skottie Young and Jorge Corona. This series had a much darker tone with prodigious use of black and moody, ethereal art. I chose extremely round

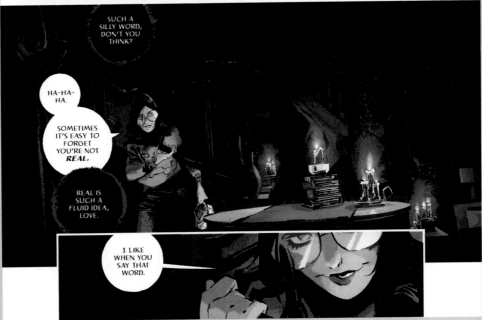

The Me You Love in the Dark #3 courtesy of Skottie Young and Jorge Corona.

balloons with lots of negative space, and a more calligraphic typeface to reinforce the Gothic horror aspect. The ghost's balloons were hand painted in black ink, scanned, and vectorized. Also note that the white balloons in this series break into the gutters, helping me to save a little of the space otherwise taken up by the large balloons.

LOCATION/TIME CAPTIONS

Comics can change locations and timeframes several times in a single issue. The easiest way to note this to the reader is with a location/time caption. These captions used to be treated much like omniscient narration, but have mostly turned into uniquely styled floating text without a caption box. There are no hard rules about location/time captions—they can be italicized or mixed case, as long as they're legible, look great, and complement the artwork, genre, and mood of the comic. (**Fig. 6.32**)

Fig. 6.32

THE APPEARANCE WINDOW

You'll notice that a lot of location/time captions are free-floating text with an outline, like the "New York City…" and "Chicago, 1947." examples above. Knowing that we may need to edit our text later in the proofing stage, it's important that these free-floating text-based captions are editable even though they may have some effects applied to them . . . this is where the Appearance window (Window > Appearance) comes into play. (**Fig. 6.33**) It allows us to apply effects to text without having to turn it into raw vectors first.

Start by switching to the Type Tool (T) and type your caption text, or copy/paste it from the script. Adjust the point and leading sizes in the Character window (Window > Type > Character) so the text is as close to the final size you want it to be before proceeding. In the Swatches window (Window > Type> Swatches), remove the fill and the stroke, essentially rendering the text invisible for the moment. We want to apply *all* strokes and fills to the text via the Appearance window. That's important. (**Fig. 6.34**)

Fig. 6.33

Fig. 6.34

Now we're going to add all our effects to the live text via the Appearance window. At the bottom of the Appearance window, you'll see a row of icons. With your caption text selected, click the Add New Fill button and change it to whatever fill color you'd like. **(Fig. 6.35)** Yellow is always a safe choice for visibility.

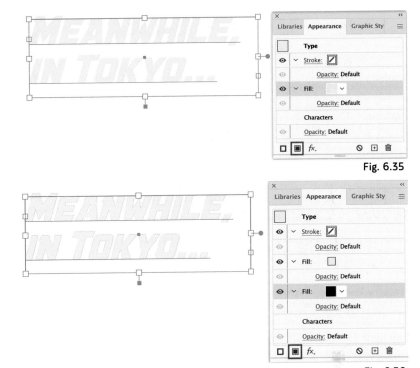

Fig. 6.35

Click the Add New Fill Button again, and a second fill will appear below the first fill. Change the second fill to K:100 black. **(Fig. 6.36)**

By the way, there's a blank Stroke field at the top of list by default. See it? Ignore that.

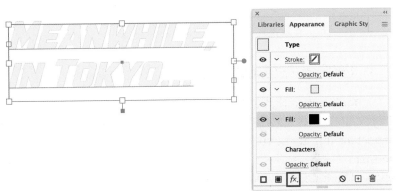

Fig. 6.36

With the bottom (black) fill selected, click on the FX button. **(Fig. 6.37)**

Fig. 6.37

This will bring up a flyout menu. Select Path > Offset Path. **(Fig. 6.38)**

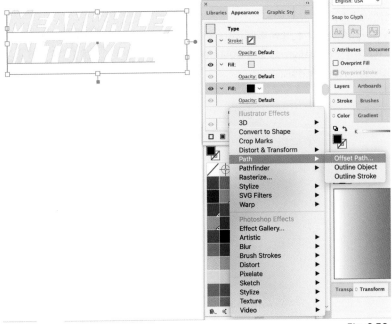

Fig. 6.38

This will bring up the Offset Path window. With Preview checked in the lower left corner, adjust the Offset field to whatever you think looks appropriate. In this case a 1pt offset looks right to me. **(Fig. 6.39)** You can also experiment with the Joins and Miter Limit fields if you want to. When you're done, click OK.

We could stop here . . . but what if we want to add a filled drop effect? For that, we need to duplicate the black offset path and then nudge it down and to the right.

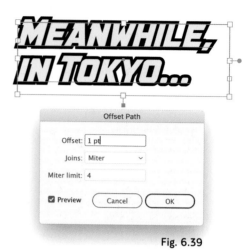

Fig. 6.39

To duplicate the Offset Path effect, highlight the black Fill field where you added the offset path and click Duplicate Selected Item. It looks like a little plus sign icon. You'll see the duplicate appear under the original in the list. **(Fig. 6.40)**

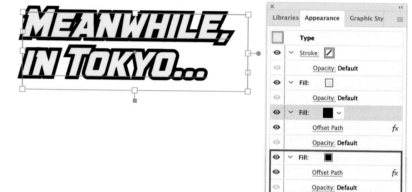

Fig. 6.40

Select the new duplicate Fill layer and click the FX button at the bottom of the window. **(Fig. 6.41)**

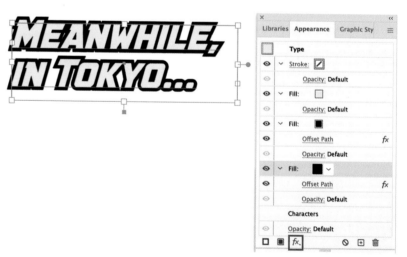

Fig. 6.41

In the resulting flyout menu, click Distort & Transform > Transform. **(Fig. 6.42)**

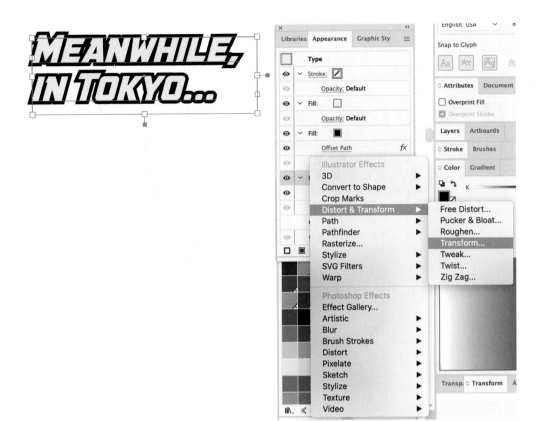

Fig. 6.42

This will bring up the Transform Effect window, where we will nudge the duplicated offset path down and to the right. In the Move section, experiment with the Horizontal and Vertical fields until you get a result you like (make sure Preview is checked in the bottom left corner). When you're happy, click OK. **(Fig. 6.43)**

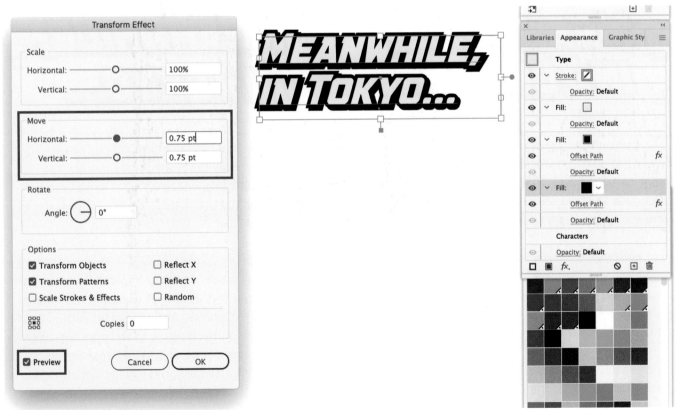

Fig. 6.43

Now is a good time to check your overprints. If you want your K:100 black offset paths to overprint, highlight the two black fill entries in the Appearance window, and then check Overprint Fill in the Attributes window (Window > Attributes). **(Fig. 6.44)**

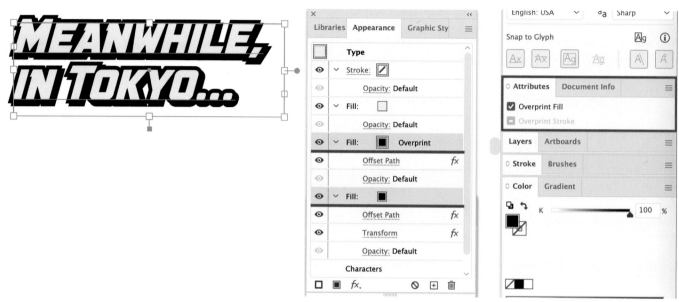

Fig. 6.44

This looks pretty good to me, although I think the leading needs to be opened up just a tad more . . . and that's okay because even though the text has all these effects applied to it, it is still live and editable! You can treat it just like any other text, making modifications by selecting it and adjusting things in the Character (Window > Type > Character) or Paragraph (Window > Type > Paragraph) windows. Here, I've opened up the leading a little bit, from 12pt to 13pt. **(Fig. 6.45)**

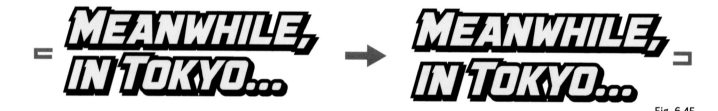

Fig. 6.45

You don't have to create this text style from scratch every time you need a free-floating caption (whew!); all you need to do is copy/paste several duplicates of this text block in your lettering template or type morgue and change the font for each! You may have to make adjustments to the offset paths depending on what looks best with a particular font, but that's much easier than starting from scratch. Then, as you use these in comics, all you have to worry about potentially changing are the colors!

Inevitably, you'll run into fonts that aren't designed to have offset paths or strokes applied to them—others may have some jagged corners. Adding offset paths or strokes to these fonts may create unsightly "spikes" in your designs. If you're dead set on using one of these fonts with these effects, I recommend that instead of using the Appearance window method I just detailed, you convert the text to outlines (Type > Create Outlines) and use Offset Path (Object > Path > Offset Path) directly. You will probably still get the dreaded "jaggies," but you can go in and manually correct them by switching to the Direct Selection Tool (A), grabbing those errant anchor points, and making adjustments. The drawback, of course, is that the text will no longer be live and editable. We'll be using this simpler Offset Path approach quite a bit in the sound effects chapter. Stay tuned!

OMNISCIENT NARRATOR CAPTIONS

Like thought balloons, this type of caption is less frequently used in modern comics. Omniscient narrator captions are just that—an "all-knowing" disembodied voice providing otherwise missing information in the story. **(Fig. 6.46)** Think of it like an unseen narrator in a movie. These are executed much like internal monologue captions, using your standard dialogue typeface (usually italicized) in a caption box. The text can be centered or left-justified. Be sure that your omniscient narrator captions are clearly distinguishable from characters' spoken or internal monologue captions whether by color or basic design.

Fig. 6.46

DESIGNING BANNER CAPTIONS

Banner captions are a fun way to frame omniscient narration, especially if you're lettering a fantasy comic. They're created with some simple pen work and a series of quick trimming objects.

Begin with your rectangular Area Type object filled with finalized left-justified text. On your Balloons layer, draw a rectangle behind it. Make sure you leave extra room on the right side for the torn edge effect. Give it your standard stroke and a tan fill like old paper. **(Fig. 6.47)**

SOMEWHERE IN THE FOREST, THE
ADVENTURERS HAVE DISCOVERED THAT
THEY **SHOULD** HAVE LISTENED TO THE
WARNINGS OF THE VILLAGERS...

Fig. 6.47

Switch to the Pen Tool (P) and draw an object to use as the trimming object for the torn edge. You can even use the irregular perimeter of the text's right side as a guide. Make sure to leave a little breathing room around the text. **(Fig. 6.48)** Select the caption and the trimming option, and use Minus Front in the Pathfinder window (Window > Pathfinder).

Fig. 6.48

Next, we have to draw the folded portion of the banner at the left side. Switch back to your Pen Tool (P) and draw an object that looks like it could be the same height as your banner, but draw curved lines for the top and bottom. Make sure it's the same color and stroke as the banner. You can always use the Eyedropper Tool (I) to copy one object's fill and stroke to another by selecting the object you want to change, switching to the Eyedropper, and clicking on the object that has the properties you want to copy. Use Command + Shift + [to drop this new object behind the main body of the banner.

You'll notice the small, irregular triangle shape that makes it look like the main body of the banner folds back on itself. That's an illusion created by using the Pen Tool (P) to draw a small, irregular triangle of slightly darker fill than the rest of the banner.

Assemble the three objects that make up the banner, and we're almost done. **(Fig. 6.49)**

Fig. 6.49

You could be done at this stage if you wanted to . . . but what if we want to add some small tears to "weather" the banner? They're just more trimming objects drawn with the Pen Tool (P) that we can knock out of the banner using Minus Front in the Pathfinder window! **(Fig. 6.50)**

Fig. 6.50

ELLIPSES AND DOUBLE DASHES IN COMICS DIALOGUE

An ellipsis is used when a character's speech trails off. If that character trails off at the end of a balloon and then has an additional dialogue balloon attached to it, the next balloon should begin with an ellipsis.

Double dashes are used in place of semicolons (which typically don't appear in American comics dialogue), or when a character stops speaking abruptly or is interrupted. Just like the ellipsis, if a character's speech ends with a double dash and they have a subsequent balloon attached, that balloon begins with a double dash. Note that in mainstream comics dialogue, there is typically no space before or after an ellipsis or a double dash.

In European, UK, and manga comics, you may see a standard Em or En dash in place of a double dash.

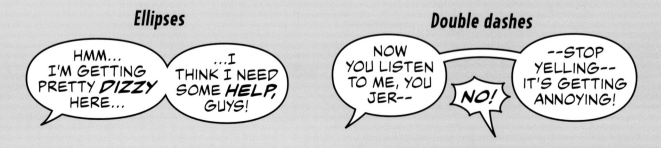

EDITORIAL CAPTIONS

Assuming you're a longtime comics fan, you're probably familiar with a scenario where a character's dialogue references something that happened in a previous issue and there's an asterisk at the end of their speech. **(Fig. 6.51)** This references what's known as an editorial caption. Editorial captions are typically located at the bottom of the page or somewhere below a panel. They represent the book's editor "stepping in" to refresh your memory about a past occurrence. **(Fig. 6.52)**

Stylistically, these are as simple as it gets. They're usually set in your italicized dialogue font, with or without a basic caption box, and sometimes a smaller size than your default point size. (I like to reduce these to 75%.)

Editorial captions are made with a rectangular Area Type object on your Lettering layer, and if required, a caption box drawn with the Rectangle Tool (M) on your Balloons layer. Just be sure that these can't be mistaken for any other style of caption that you're using on a particular series.

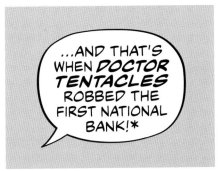

Fig. 6.51

Fig. 6.52

ORGANIC CAPTION BOXES

Just as with balloons, we can make caption boxes a little more organic. Obviously, hand-drawn caption boxes are typically inked with a pen and straightedge—they are pretty uniform, more so than a hand-drawn balloon. Thus, when we design them digitally, a tiny bit of imperfection is all we really need. I don't often use Illustrator's Roughen effect, but in this case, a little bit of Roughen is exactly what we're looking for.

To make this look like a typical example of what you'll be dealing with while lettering, I'm going to start with some basic spoken caption text in our rectangular Area Type object on the Lettering layer of our template. Next, I'm going to switch to the Balloons layer and draw a caption box with the Rectangle Tool (M), just as I described earlier in the chapter. I'll give it our standard .75pt, K:100 black stroke set to overprint. For clarity's sake, let's give this caption box a yellow fill. **(Fig. 6.53)**

Fig. 6.53

With the caption box selected, Go to Effect > Distort & Transform > Roughen, which will bring up the Roughen window. **(Fig. 6.54)**

Experiment with settings like these. Remember that less is more in almost every case. In the options, I prefer Absolute to Relative. In Points, you'll need to select Corner, since Smooth will turn your caption into a lumpy mess.

With Preview checked, you'll be able to see your setting choices reflected in real time. Your caption box will change from perfectly even lines to being slightly more irregular. **(Fig. 6.55)** Use this effect *sparingly*. Just a *hint* of irregularity is all you need.

Fig. 6.54

Fig. 6.55

I highly recommend that you save a copy of this caption box (sans text), with the active Roughen effect applied, outside the artboard of your template for future copying/pasting. With the effect active, any time you resize the caption box, the slight distortion will change a little, making all the caption boxes on a given page even more organic. You can even apply the calligraphic stroke I covered in the chapter on balloons. **(Fig. 6.56)**

When the effect is viewed at actual print size, you can see how subtle it becomes—just enough to convey the sense of irregularity without bringing attention to itself. **(Fig. 6.57)**

Fig. 6.56

Actual print size.

Fig. 6.57

Let's end with a gallery of caption styles to inspire you! All of these were made with the techniques we've covered thus far . . .

"MAYBE CHECK YOUR **BLOOD PRESSURE** BEFORE WE LEAVE. THIS IS GONNA BE **ROUGH.**"

"YOU DO SOMETHING BRAVE, AND IT'S GOING TO BE A BIG MISTAKE, KID. **THINK ABOUT IT.**"

SOUTH BOSTON
3:31 AM

 WINTER IN THE CITY BARELY CURTAILS THE STREET CRIME. IT JUST MAKES MY JOB MORE **MISERABLE...**

LATER THAT NIGHT, AT THE CEMETERY...

COLD SALT AIR FROM THE BAY STINGS MY EYES. IF IT WASN'T SO POLLUTED, THIS MIGHT BE ROMANTIC.

 The Swamps of Regret...

THINGS ARE GETTING A LITTLE HOT IN HERE. TIME FOR A **FAST** EXIT.

HOW MANY TIMES WIL I HAVE TO FLY OUT TO THE FARTHEST REACHES OF THE GALAXY TO PICK UP THIS **LOWLIFE?**

Here I am taking tests in Chem class, and I should be fighting crime on the East Side...I'm kind of ashamed.

UNLESS WE COME UP WITH SOMETHING FAST, THERE'S NO WAY WE CAN REVERSE THE TEMPORAL RIFT IN TIME...

I SHOULD HAVE SEEN THIS COMING. WHAT A **STUPID** MISTAKE...THIS PLACE IS ABOUT TO BLOW **SKY HIGH.**

Meanwhile...

SOMEWHERE BEYOND THE WORLD OF THE LIVING

THE FIRST DAY OF SUMMER VACATION...

ONE STEP CLOSER TO PLUGGING MYSELF INTO THE POWER GRID FOR THE ENTIRE CITY... JUST **SEVEN** MORE MILLISECONDS...

BACK AT THE CLEVELAND ACADEMY...

TERMINAL ERROR_ CODE 33 CODE 33 . . . REBOOT YOUR SYNTHETIC HUMAN

MY LEVEL 3 MAGE WAS THE ONLY MEMBER OF THE PARTY WHO COULD DISTRACT THE DRAGON--

"THANKS, FRANK-- FOR EVERYTHING. YOU WERE THE BEST BOSS I EVER HAD."

BACKSTAGE
PROVIDENCE, RI. 1994.

*THEIR HEADQUARTERS WAS DESTROYED IN ISSUE #33! -MIKE

"WILL THAT BE ALL, SIR? I'D LIKE TO POWER DOWN FOR THE EVENING."

 THERE'S NO WAY MY ARMOR WILL REPAIR ITSELF BEFORE THOSE DRONES COME BACK.

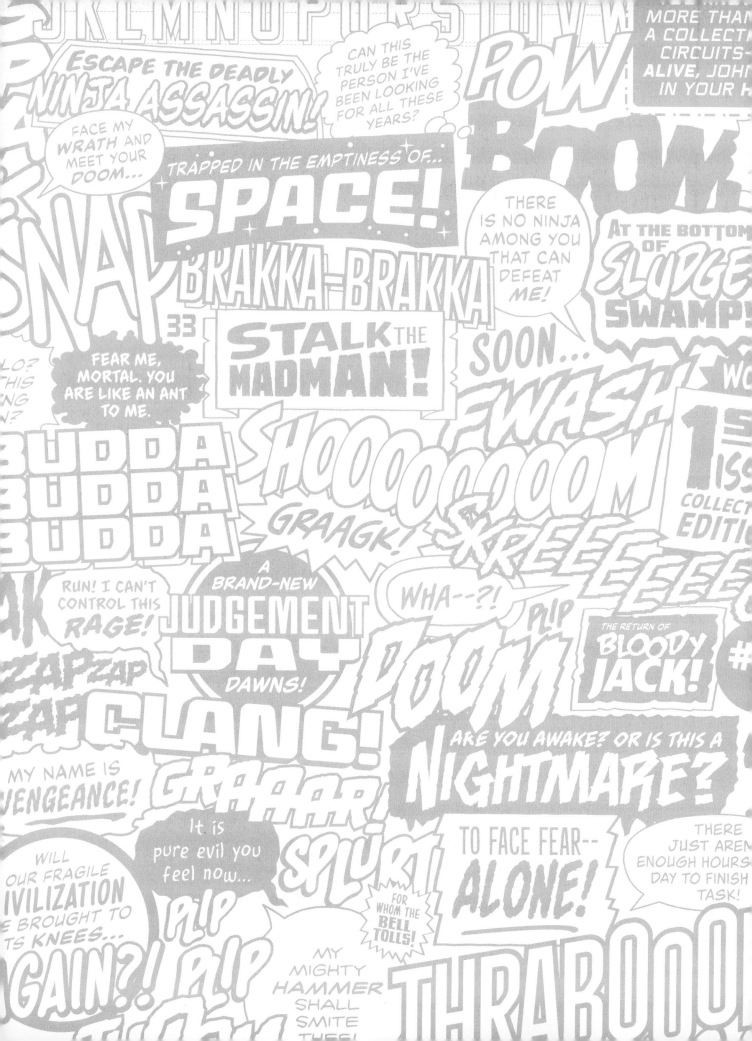

CHAPTER SEVEN
SOUND EFFECTS

I think designing sound effects is probably the most gratifying part of lettering. In fact, I save them until I'm done lettering everything else on a page. I could tell you it's because I want to prioritize available space for dialogue (a valid argument . . .) but to be honest, it's like getting chocolate cake because I ate all my vegetables . . . especially if it was a tough page. I can design sound effects all day long and never get bored. **(Fig. 7.1)**

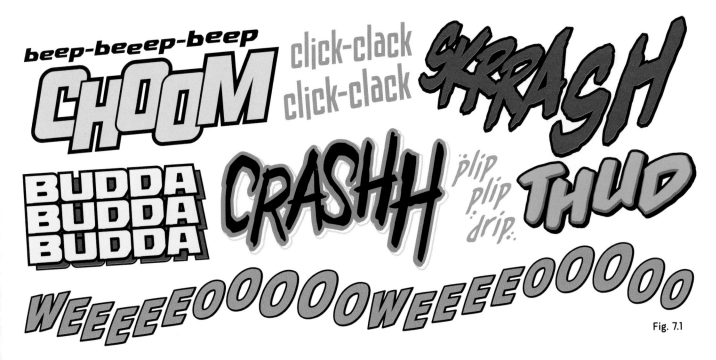

Fig. 7.1

THE PATH TO EFFECTIVE SOUND EFFECTS

Your job when it comes to sound effects is to accomplish something rather difficult: translate the qualities of a sound into a visual representation. Are you dealing with an ear-splitting teapot whistle or the bass rumble of an avalanche that is cascading down a mountainside? What about the delicate sound that a skeleton key makes as it unlocks a door in a haunted mansion? What sound does a raging fire make as it consumes the oxygen throughout a space station . . . ? In most cases the writer will have described the action going on in a panel and written a "BAWOOOM" or "click-clack" in the script . . . but it's up to you to really sell it.

As I described the scenarios above, I bet you created a mental image in your head of how those sound effects might look. That's the first step—trust your gut! Here are some things to keep in mind . . .

- How does the description of the sound make you feel? The sound of a panther roaring thunderously should create a more visceral impression than a sound effect of a squeaking mouse.

- How much room do you have in the panel? If space is tight, you might lean more towards letters that are condensed. If the available space is short but wide, then extended letters might work better.
- What typographical style will harmonize with the art? If you're lettering a book that has a vintage feel, you can lean towards something more classically designed. If the artist is painting the art, organic brush-like sound effects might work best.
- Where is the source of the noise? Is there a dramatic perspective in the art that your sound effect could match? I'm in favor of particularly loud sound effects looking as if they're emanating from the source of the noise. They should get bigger as they rush "towards" the reader, or vacillate as the sound ratchets up and down in intensity.
- What is the color palette of the page? It's rather rare for letterers to get final colors. We're usually lettering over inks. Much of the time we have to estimate what colors will work on the art—a situation that is far from ideal. This is why you see lots of yellow sound effects. Yellow can be seen against almost any color palette, so letterers use it to compensate for their lack of color reference. Knowing the color palette of the artwork is helpful when picking out your color scheme. In fact, you can sample colors right off the page with Illustrator's Eyedropper Tool (I). If you have access to finished, colored art, make good use of it in your color choices.
- Avoid designing sound effects that look like stickers slapped on a page. I can't repeat that enough. In my opinion, you've failed as a letterer when your sound effects seem to have no relationship with the art. You'll recognize this failure when the sound effect seems so disparate from the art that it almost "floats above it."

TYPEFACES ARE JUST A STARTING POINT

While sound effects can be conventionally or digitally hand drawn, the majority of letterers use typefaces designed for the job. It's important that you equip yourself with a comprehensive arsenal of typefaces that can be used for sounds that are mechanical, wet, delicate, energetic, snarling, thundering, and all manner in between. Just typing "THRAKA-DOOOM" with a beefy font won't cut it. Your ability to manipulate the letters of a sound effects font in Illustrator is important.

While designing sound effects in Illustrator, there are some technical steps that tend to repeat regardless of the style and size of the final design. The process goes something like this:

- Assessing the script and art and coming up with a design idea for the sound effect.
- Typing or copying/pasting the sound effect text from the script into the SFX layer of your lettering template as live text.
- Deciding on a typeface and applying it to the text as a starting point for your design.
- Converting that live text to outlined vectors so you can manipulate them.
- Sizing, stretching, shearing, and repositioning those individual vectorized letters into a pleasing design in the available space on the art.
- Adding any offset paths or strokes and deciding on colors.
- Possibly designing clipping masks to create the illusion that a sound effect is behind objects drawn in the art.

That may seem like a rather dull procession of events. Understand that those are just the technical steps . . . there are a whole lot of creative design decisions to make as you progress through them.

MANIPULATING SOUND EFFECTS LETTERS

Let's say we have a script that deals with two hulking monsters slugging it out. One panel calls for a "WHAMM" being made by a particularly hard punch. We type (or copy/paste) the WHAMM as live text on the SFX layer of our lettering template, then pick a font. In the following example **(Fig. 7.2)**, the letters on the left have been typed out in one of my fonts (Brushzerker BB Italic) with no modification at all. The letterforms are interesting—good building blocks—but don't have much life to them yet.

While some sound effects are intended to be small or subdued, most of them call for motion and impact. The letters on the right have that kind of creative design treatment. They're more dynamic, and seem to "leap out" from the source of the noise. You're going to see me use the word "dynamic" a lot in this chapter. It's important that you think about sound effects *dynamically.* That's what makes those impactful sound effects effective and aesthetically pleasing.

Fig. 7.2

Let's take a look at the steps I took to get from unmodified font to manipulated letters . . .

Since sound effects tend to be single words, I don't bother with using Area Type objects. You could, but it's faster to simply switch to the Type Tool (T), drop a cursor, and use basic Point Text in the SFX layer of your lettering template. It's not going to be live text for very long anyway.

Once the letters of the sound effect are typed out and your chosen font style has been applied, you'll need to turn the live text into outlined vectors so you can manipulate them. Select the live text and go to Type > Create Outlines (or Shift + Command + O). Each letter of the word is now an individual vector object made up of anchor points that we can manipulate. **(Fig. 7.3)**

Fig. 7.3

If you read the previous chapter, you may be asking yourself, "But, Nate, you made such a big deal about making sure our free-floating captions were *live fonts* so we could edit them in the event of corrections! You're throwing all that out the window with sound effects?"

Sort of, yes . . . we're less concerned with that now that we're making sound effects. While caption text is far more likely to require edits after proofing, sound effects are not (at least in my experience). Additionally, we want the full range of Illustrator's effects and manipulation tools at our disposal for sound effects. We want to really be able to reach down into our bag of tricks and pull out any crazy idea to make our sound effects the best they can be. This isn't possible if we keep the font live. If a sound effect needs to be changed later, we'll recreate it, but as I said, it doesn't happen all that often.

If you're an experienced Illustrator user, you might be wondering why we don't use the Touch Type Tool and have the best of both worlds—live text *and* effects. The Touch Type Tool (a button found at the top of the Characters window if you want to experiment) is *designed* for manipulation of live text. While it goes a long way towards addressing some of our needs, I find it doesn't go quite far enough. For example, I often want to alter individual anchor points that make up the shape of a single letter. However, I encourage you to try it out and see if it suits you.

Back to the subject at hand . . .

Even though this began as an italicized font, I sometimes like to add a little more shear to the letters . . . both horizontally and vertically. Select all the letters and then switch to the Shear Tool in your Toolbar. Drag right and you'll shear the letters to the right, then drag up to shear the letters up. If you find the Shear Tool a little hard to control, you can hold down the Shift key to constrain your dragging. By the way, you'll end up using the Shear Tool a lot. By default, it doesn't have a shortcut key, but you can assign one by going to Edit > Keyboard Shortcuts.

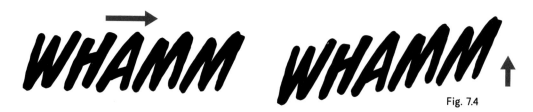

Fig. 7.4

Next, we can scale individual or groups of letters by selecting them with the Selection Tool (V), then dragging the corner anchor points. **(Fig. 7.5)** If you want to keep the proportions intact, make sure you hold down the Shift key to constrain. I made each letter slightly bigger than the letter before it, going left to right. You could just as easily enlarge them in the other direction based on the source of your sound.

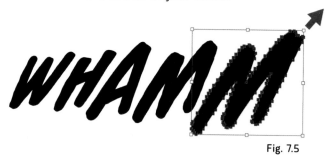

Fig. 7.5

Still using the Selection Tool (V), you can arrange the letters to your heart's content. For this example, I felt the letters should be a little bouncy and chaotic. **(Fig. 7.6)** It's up to you how many or how few letters should touch. Use your intuition . . . what looks best to you?

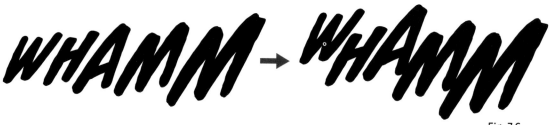

Fig. 7.6

I think this looks pretty good as is, but this is also a good time to decide if any individual letters need to be tailored to your liking. Is there a leg on the *M* that would look better if it was longer? It's totally up to you! Switch to the Direct Selection Tool (A), select the anchor points on the letter you want to alter, and make any changes you want. **(Fig. 7.7)**

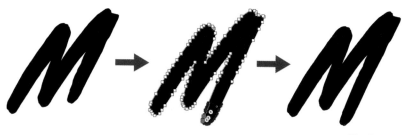

Fig. 7.7

You'll be working over the art, of course, and you'll be able to see the volume and shape of the space in the art available to you for your sound effect. Scale and manipulate it over the art and make sure you're happy before adding any effects.

ADDING OFFSET PATHS TO SOUND EFFECTS

If the sound effect doesn't overlap any inked lines (imagine placing a sound effect in an open sky, or against a blank wall . . .) we could just add an appropriate color to the sound effect and stop there if we wanted . . . but sound effects that don't cross over at least one inked line in the art are pretty rare. Chances are, you'll need an outline on the letters to make the sound effect readable against the inks. You could simply add a stroke to it in the Stroke window, but I'm never really happy with the results unless I'm using some sort of "monstery" custom brush (see Chapter Five). I prefer to use Offset Path.

Make sure your sound effect is placed and sized exactly how you want it over the art, then select all the letters of your sound effect and go to Object > Path > Offset Path to bring up the Offset Path window. With Preview checked, all you need to do is experiment with the Offset field until you get an outline with the right "weight." **(Fig. 7.8)**

I find that either 1pt or 1.5pt works well (. . . assuming your Rulers are set to Points. If not, right-click on them and adjust). In fact, I have 1pt and 1.5pt versions of Offset Path saved as Actions tied to F-keys so I can apply them to sound effects with the single touch of a button.

Fig. 7.8

In **Fig. 7.9,** you can see the original letters selected and highlighted, and the offset path around them (un-highlighted). You'll notice that the offset path will initially be the same color as your original objects. In this case, black. That's okay, we're going to experiment with colors next.

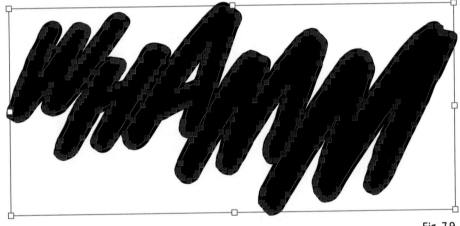

Fig. 7.9

Select the original (inner) vectorized letters and change the color to whatever you'd like using the Swatches window (Window > Swatches). As I mentioned before, if you are lettering over colored art, either pick something that complements the page's color palette or sample colors right from the page with the Eyedropper Tool (I). In this case, I'm going with a red tone. **(Fig. 7.10)**

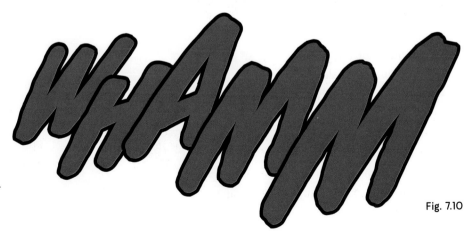

Fig. 7.10

Now that we have a clearer idea of how these letters are interacting, we can make any small positional adjustments. (I nudged the *W-H-A* a little to improve the design.)

If the outlines are going to remain black, make sure they're set to our default K:100 black with the fill set to overprint in your Attributes window (Window > Attributes). The "colored" parts of the sound effect (in this case, red) should not overprint.

We could stop right there . . . that's a decent sound effect with overlapping letters . . . but what if we want the letters to look like they're united together where they touch? Easy! We can just drop all the black offset paths behind the red letters: select all the black offset paths with your Selection Tool (V) and use Send to Back (Shift + Command +]). **(Fig. 7.11)**

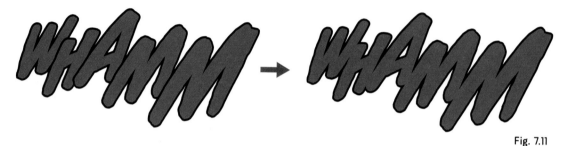

Fig. 7.11

One last trick: sometimes I like to add a little dimensionality to a sound effect by duplicating the black offset path vectors and nudging those duplicates slightly in one direction. Select all the black offset paths and hold your mouse button down along with the Option key. Now drag slightly in one direction or another—just a little—and release the mouse button. You'll drag a duplicate of the offset path in that direction! **(Fig. 7.12)** You may also need to send the new duplicate black vectors below the original red and black vectors with Send to Back: Shift + Command + [.

Original black Offset Path

A duplicate of the black offset paths skewed sightly down and to the right

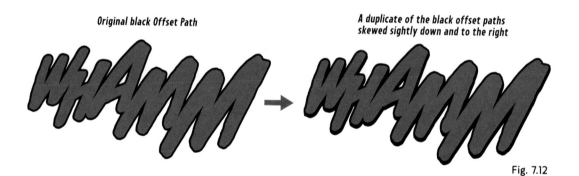

Fig. 7.12

It's subtle, but this adds more weight and personality than a single Offset Path. **Fig. 7.13** is a blown-up view for better detail . . .

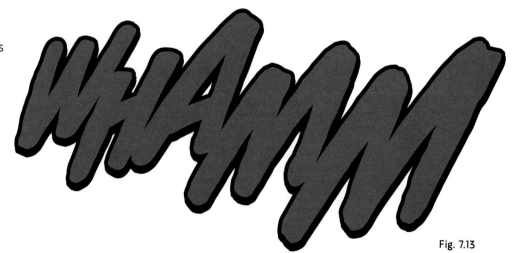

Fig. 7.13

MULTIPLE OFFSET PATHS

I like to use this approach for sound effects that represent fire, electricity, lasers . . . anything that needs to convey the elemental nature of raw energy! **(Fig. 7.14)** As I'm sure you've already assumed, offset paths around sound effects don't always have to be black. Creating multiple offset paths, each with a different complementary color, or variations on a single color, is a great way to lend brightness to your designs.

Fig. 7.14

Let's go through the steps of creating a sound effect for a huge fire erupting. Start with a suitably "crackly" font, converted to outlines (Shift + Command + O). Reorganize the letters in a dynamic shape, and to fit the space in the art. **(Fig. 7.15)**

Fig. 7.15

If you are very confident in the positioning of the letters, you can Unite them (Pathfinder window > Unite button)—this will make applying the next effects quicker, but you won't be able to separate or reposition the letters anymore. It's your call.

Select the sound effect, and change the color to a light yellow in your Swatches window (Window > Swatches). **(Fig. 7.16)**

Open up your Offset Path window (Object > Path > Offset Path) and add an amount of offset path that looks good to you. With the offset path still selected, change it to an orange color. **(Fig. 7.17)**

Fig. 7.16

Fig. 7.17

Finally, apply a second offset path to the first—this one slightly thicker. With the new offset path still selected, change the color to red. **(Fig. 7.18)**

Fig. 7.18

THIN/THICK OFFSET PATHS

Here's an option for sound effects with overlapping letters that I use quite a bit. Let's start over with new letters. Perhaps something more mechanical. Follow the steps in the section Adding Offset Paths to Sound Effects up to the point where you add the first offset path. This time use a slightly thinner offset path—1pt works well. **(Fig. 7.19)**

Make sure the offset path has a K:100 black fill set to overprint in the Appearances window if you want it to remain black for the final design. The original letters can have the fill of your choice. Here, I'm using a rich yellow selected from the Swatches window (Window > Swatches). As usual, make sure non-black fills are not set to overprint.

Fig. 7.19

With only the black offset paths selected, bring up your Offset Path window once again and add the exact same thickness of offset path . . . in this case 1pt. In essence you're adding an offset path to an offset path on each of those letters. **(Fig. 7.20)**

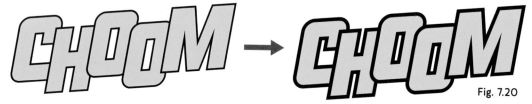

Fig. 7.20

If I zoom way in on the top of a letter and select everything **(Fig. 7.21),** you can see the original yellow letters, then the first offset path we applied, and then the second, outermost offset path . . .

With the Selection Tool (V), select *only* the second, outermost offset paths of every letter, and send them behind everything else with Send To Back (Shift + Command + [). **(Fig. 7.22)**

Fig. 7.21

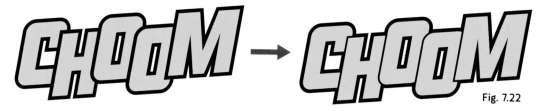

Fig. 7.22

Notice how there seems to be thinner outlines *between* the letters, but thicker outlines *around* the letters? **(Fig. 7.23)** This helps ensure that the sound effect is seen against the art, but the lines between the letters aren't too heavy—and it just looks cool!

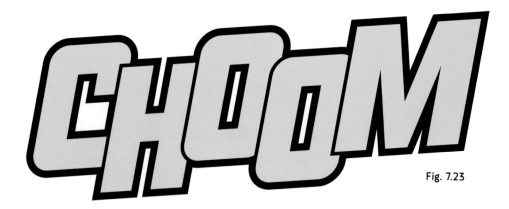

Fig. 7.23

UNDULATING SOUND EFFECTS

The sound of a police siren is a great subject for sound effects that seems to grow and recede, so let's make one of those! First, type a line of Point Text with the Type Tool (T) in a font of your choice on the SFX layer of your lettering template. **(Fig. 7.24)** Give them some extra shear with the Shear Tool if you're so inclined.

WEEEEEOOOOOWEEEEEOOOOO

Fig. 7.24

Convert the live text to outlines (Type > Create Outlines) so that you can manipulate individual letters. Move them up and down with the Selection Tool (V) and increase the size of the letters that ascend in the pattern by dragging anchor points. You also may want to spread them apart a bit to accommodate the offset path that we'll be applying shortly. **(Fig. 7.25)**

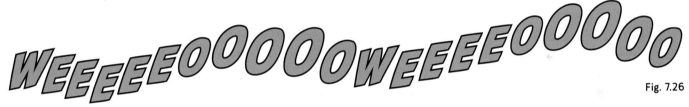

Fig. 7.25

Add an offset path to the letters (Object > Path > Offset Path) . . . and change the original letters to a color fill. In this case, I've selected a pale blue. **(Fig. 7.26)** If your offset paths are going to remain K:100 black, remember to set them to overprint in the Attributes window (Window > Attributes).

Fig. 7.26

A side note: while there is an easier way to make wavy sound effects with Illustrator's pre-programmed effects (explore Effect > Warp > Flag if you want to try it out), I find the results aren't as tailored or attractive.

ROACH CHEW

Here's one I bet you've seen but didn't know had a name! Used for titles and sound effects, "roach chew" is the term for small distressed lines that add a grimy, aged look to letters. Much more common in the days of hand lettering, but some comic book typefaces are designed with them!

"HOLLOW" SOUND EFFECTS

You'll encounter panels that require a large sound effect but are so packed with detail, you might find it hard to place your lettering without covering up too much art. A hollow sound effect might be the way to go. This is essentially a sound effect with negative areas that show the artwork beneath it. **(Fig. 7.27)**

Let's say our script deals with someone shooting laser beams out of their eyes at an opponent—as one does given the option. The panel of art is crowded and there's not much room for the sound effect. If we decide on a hollow sound effect here, we can still have a big impact without covering the art. The sound effect in the script is "FZAPPP," so we type or copy/paste that into our SFX layer with

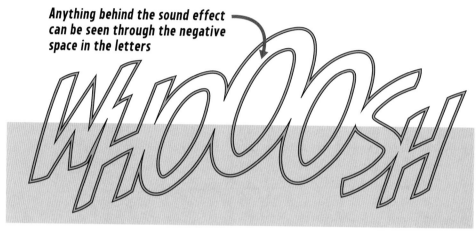

Anything behind the sound effect can be seen through the negative space in the letters

Fig. 7.27

the Type Tool (T). We'll convert the letters to outlines (Type > Create Outlines), adjust individual letters as we see fit, add some shear with the Shear Tool, and then Unite all the letters into a single object (Pathfinder window > Unite). Then place and resize the sound effect as close as you can to its final location over the art. **(Fig. 7.28)**

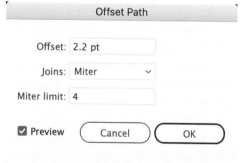

Fig. 7.28

Open the Offset Path window (Object > Path > Offset Path) and add a thin offset path—the amount will vary from sound effect to sound effect. You'll have to eyeball it every time. **(Figs. 7.29** and **7.30)**

Offset Path

Offset: 2.2 pt

Joins: Miter

Miter limit: 4

☑ Preview Cancel OK

Fig. 7.29

Fig. 7.30

With both the original letters and the offset path selected, go to the Pathfinder window and click the Minus Front button. You'll see the original letters clip through the offset path. **(Fig. 7.31** and **7.32)**

Fig. 7.31

Fig. 7.32

It'll have our black fill by default, so let's make this a little more exciting. In your Swatches window (Window > Swatches), give it a stroke color and fill color of your choice. I've gone with a yellow-green fill and black stroke. **(Fig. 7.33)** You can adjust the stroke thickness to your liking in the Stroke window (Window > Stroke).

You may recall me mentioning that I usually use offset paths instead of strokes on sound effects. That's true, but there are a couple of instances where using a stroke is quicker, and the results are nearly the same. I find that hollow sound effects are one of those instances.

Fig. 7.33

You'll also note that in **Fig. 7.33,** I removed the hollow counters in the *P*s with the Direct Selection Tool (A). I thought they might look more harmonious with the filled counter in the *A*. As you craft your sound effects, always be on the lookout for small adjustments that improve the design!

As a final optional step, I sometimes like to add a thin filled drop to hollow sound effects. To do this, select the sound effect and Shift + Option + drag a duplicate diagonally down and to the right. Select the duplicate and use Send to Back (Command + Shift + [) to drop it behind the original. Finally, I've changed the duplicate's color fill in the Swatches window (Window > Swatches) to black. **(Fig. 7.34)** As always, check your overprints in the Attributes window—and we're done!

Fig. 7.34

CALLIGRAPHIC STROKES ON SOUND EFFECTS

Speaking of using strokes on sound effects, the calligraphic stroke we discussed in Chapter Five can be applied to sound effects letters to add an extra organic touch.

To make more convincingly organic sound effects, it's important to first pick typefaces that lean more towards a hand-drawn look. Perfectly blocky fonts with lots of 90-degree angles won't benefit from this technique. It also makes more sense to use this approach across an entire comic book series. If you create just one sound effect like this, the inconsistency is noticeably odd and out of place.

Notice the thick/thin variation of the stroke around each letter in **Fig. 7.35**?

Let's start with a sound effect created with a slightly "retro" sound effect typeface and the instructions for sound effects with overlapping letters. Illustrator's default stroke is completely uniform. But if we open the Brushes window (Window > Brushes) and add the calligraphic stroke we use for balloons, the thin/thick variation looks more hand inked. **(Fig. 7.36)** If you saved the brush we used for balloons with a new name, it'll be listed in your Brushes window already—you'll just have to click the name to apply the brush. **(Fig. 7.37)**

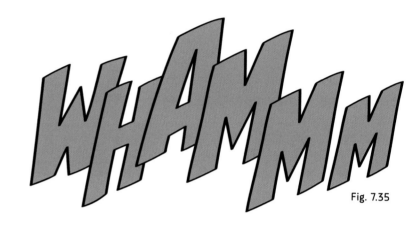

Fig. 7.35

Fig. 7.36

Fig. 7.37

You may have to experiment with the line weight of the calligraphic stroke so the sound effect looks more homogenous with the line weight of the art.

See the difference between Illustrator's default stroke **(Fig. 7.38)** and one with a thin/thick variation **(Fig. 7.39)**?

Default uniform stroke

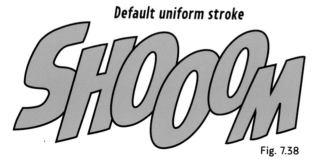

Fig. 7.38

Calligraphic stroke

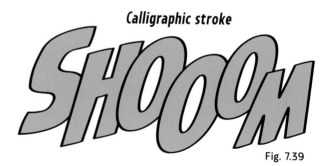

Fig. 7.39

ADDING PERSPECTIVE WITH THE FREE DISTORT TOOL

There will come a time when you'll just instinctively know that your sound effect will look better if it's in a dramatic perspective. Luckily, Adobe has recently made the Free Distort Tool easier to access and use.

Let's start with any old sound effect. Here's something beefy and clean with a gradient fill. **(Fig. 7.40)** You can add gradient fills in the Gradient window (Window > Gradient) just as you do solid color fills. Double-check any black overprints in the Attributes window (Window > Attributes) before adding any effects.

Select the entire sound effect and press E on your keyboard to bring up the little Free Distort window. **(Fig. 7.41)** It's important that you select the object you want to modify before pressing E to make that window pop up.

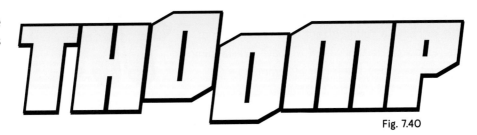

Fig. 7.40

Fig. 7.41

You can grab the corner control points of the bounding box surrounding the sound effect and drag them any way you'd like to add perspective. It's actually a lot of fun to experiment with. **(Figs. 7.42 and 7.43)**

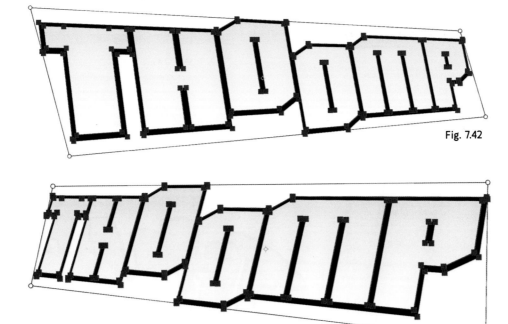

Fig. 7.42

Fig. 7.43

When you're happy with the results, just switch back to the Selection Tool (V) and you're done! **(Fig. 7.44)**

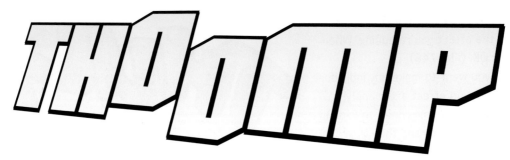

Fig. 7.44

USING WARP EFFECTS

There are a multitude of options you can apply to your sound effects in the Warp menu. Before we dive headfirst into that toybox, I want to take a moment to mention that a *little bit* of any of Warp's options goes a long way. Try to exercise restraint or your sound effects will begin to have an obviously "tortured into weird shapes" feel.

That said . . . let's play with Warp! First, we need a sound effect that needs some spicing up. **(Fig. 7.45)** If your design has black fills, double-check your overprints in Window > Attributes.

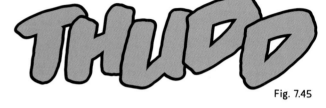

Note that if you have a sound effect that is made up of individual objects (as ours is in this case—we have overlapping letters), you will need to Group the letters (Command + G) before you add any of the Warp options. Otherwise, each individual letter will have its own Warp effect applied. If your sound effect has been United (Pathfinder window > Unite button), you can simply apply the Warp without grouping.

Fig. 7.45

With your sound effect selected, go to Effect > Warp and you'll see all the options available to you. **(Fig. 7.46)** All of these effects have a similar interface: a window will pop up with a set of sliders for you to experiment with. The sliders represent positive and negative amounts of whatever the effect is. Let's try out the first one: Arc . . . **(Fig. 7.47)**

Fig. 7.46

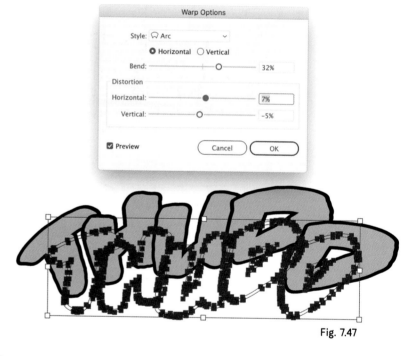

Fig. 7.47

As you fiddle around with the sliders, make sure you have Preview checked so you can see just how much of the effect you're adding. When you're happy, click OK. **(Fig. 7.48)**

Note that if you want to make any individual adjustments to the sound effect after applying any of the Warp options, you may need to Expand (Object > Expand Appearance) and then Ungroup (Shift + Command + G).

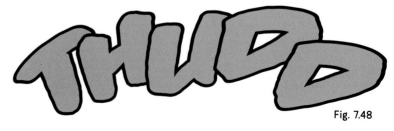

Fig. 7.48

But what about all those other options? **Fig. 7.49** shows duplicates of that same sound effect with some of the other Warp effects applied to it. I admit, I include these just to provide you with a better idea of what they do—I don't like to use most of them on sound effects (like Flag, Inflate, Squeeze). Others I only use very sparingly (like the Arcs and Arch). If I can achieve the same result by manipulating the letters directly, I generally prefer to do that.

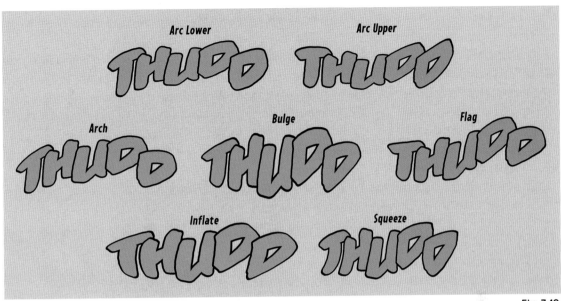

Fig. 7.49

CHECKING YOUR OVERPRINTS

I keep mentioning that you should check your overprints. But what does that really mean? Setting a fill or stroke to overprint determines what color gets printed last (on top) of other colors during the CMYK printing process. CMYK is an acronym for **C**yan, **M**agenta, **Y**ellow, and blac**K**—the physical inks applied to media during the printing process. For the purposes of lettering, it's safe to assume your black fills or strokes should overprint . . . and in most cases, only your black fills/strokes.

Select each object with a color fill and/or stroke, and if the fill is black, add a checkmark to Overprint Fill in the Attributes window (Window > Attributes). If the stroke of that object is black, check Overprint Stroke instead, as shown on the right.

Try to get used to checking all the objects as you finish lettering each page. If your overprints are set incorrectly, the sound effect, caption etc. may not print properly. Here's an example . . . the sound effect on the left has only the black portion set to overprint, and will print correctly. In the example on the right, the yellow portion has been erroneously set to overprint and the yellow ink will get printed after (and on top) of the black ink.

Correct: Only the black portion is set to overprint. The sound effect will look like this in print:

Incorrect: The yellow portion is set to overprint. The sound effect will look like this in print:

This is also a good time to remind you that you should avoid "rich black" in your day-to-day lettering. Rich black is made not only of black, but also cyan, magenta, and yellow (Usually a mix of C:60 M:40 Y:40 K:100). Stick to (C:0 M:0 Y:0 K:100), which is 100% black only, with no cyan, magenta, or yellow added to it.

DIGITALLY HAND LETTERING SOUND EFFECTS

I mentioned earlier that most letterers in the digital age use typefaces as the basis for their sound effects. While you could hand letter your sound effects with real-world ink on paper, you also have the option of digitally hand lettering them in Illustrator or Photoshop using custom brushes. I spent a year on DC's *Green Arrow* doing a combination of both conventional and digitally painted sound effects because Juan Ferreyra's artwork on the series was very painterly. The more organic approach to sound effects helped mesh my work to his. It's also becoming more commonplace for artists to add some of their own sound effects while they're drawing the art. If they haven't drawn *all* of the sound effects, you may decide to mimic the style of their existing sound effects with digital brushes for a more homogenous look.

The process for creating custom brushes for sound effects is almost exactly the same as Creating Custom Illustrator Brushes for Balloons in Chapter Five—but you don't have to worry about book-matching the ends. Head back there for detailed instructions. **Fig. 7.50** shows a set of Illustrator brushes I made from samples of oil pastels on bristol board specifically for sound effects.

If you don't want to go through the hassle of creating your own brushes from scratch, there are tons of professionally made commercial brushes available from Adobe and third-party designers online. I do recommend you invest in a tablet if you intend to use brushes often. Using a pressure-sensitive stylus is far easier than trying to "paint" with a mouse.

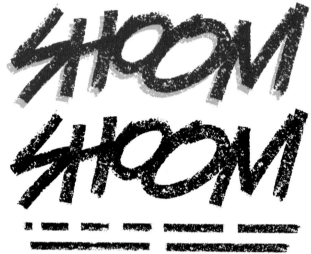

Fig. 7.50

In Illustrator, the process of drawing with a brush is the simplest since the brushes are already vector-based. Just switch to the Brush Tool (B), select a custom brush in the Brushes window (Window > Brushes), and begin free-handing your sound effects letters. You can then Expand (Object > Expand Appearance) and Unite (Pathfinder window > Unite button) your letters. Finally, you can scale, stretch, and add offset paths or strokes just like any of the previous sound effect examples (. . . depending on how textured the brush is—offset paths and strokes can go haywire on very textured objects).

Photoshop brushes offer an even more organic look than most Illustrator brushes—repeating patterns in the brushes are less obvious in my opinion. You'll gain texture, but you'll have to do some extra steps to take your pixel-based Photoshop sound effects into Illustrator to auto-trace and convert them to vectors. I covered this in Chapter Five as well. It's the same process that I used when I scanned those marker lines to be used for balloon strokes.

Take a look at **Fig. 7.51**. Can you tell which of these were drawn in Illustrator, which in Photoshop, and which were ink on paper?

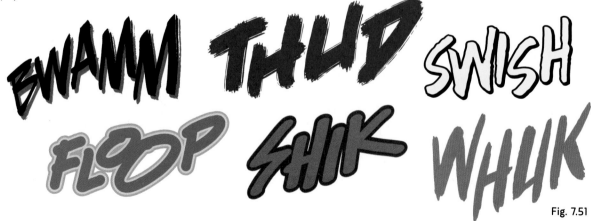

Fig. 7.51

A SOUND EFFECT CLIPPING MASK IN ACTION

Here is a stunning page of *Beasts of Burden: Occupied Territory* by Evan Dorkin, Sarah Dyer, Benjamin Dewey, and myself, showcasing a very upset Japanese *Oni.*

You'll recognize that this sound effect began with the offset path technique covered earlier in the chapter. In fact, there is more than one. It's also worth noting that this is technically *dialogue* designed as a sound effect. The monster is speaking this sound, but treating it like a sound effect gives it an intensity that a balloon probably could not—and I wanted it to be intense!

There wasn't a lot of room in this panel, and I wanted to make sure this sound was nice and big, so I used a clipping mask to make the sound effect appear as if it was behind the club. This way, I could utilize more space, make the sound effect bigger, and I didn't have to cover any important art.

Wondering how to create a clipping mask for sound effects? Read on!

Beasts of Burden: Occupied Territory #3 courtesy of Evan Dorkin & Jill Thompson. Art by Benjamin Dewey.

CREATING CLIPPING MASKS FOR SOUND EFFECTS

I bet you've seen a comic book panel where a sound effect looks like it's partially obscured behind some element in the art. This is achieved with a clipping mask—the same process we used to butt balloons against panel borders in Chapter Five. The major difference here is that the clipping objects are a bit more complicated.

Say we're working with a script that indicates a monster is stalking some characters through a forest. We have a reverse shot of the forest, and the monster's growling ("GRRRAAAAARRR") can be heard echoing through the trees. **Fig. 7.52** is what we want to end up with when our sound effect is finished. It looks as if it's behind the tree.

Fig. 7.52

Once the art is placed on the Art layer of our lettering template, the image will be grayed out a bit. **(Fig. 7.53)** You'll recall that when we created the template, we set the Art layer to dim any images placed there. This helps us have a clearer view of our lettering while we work in Illustrator.

Fig. 7.53

We pick a font and design an interesting "monstery" sound effect on our SFX layer using the skills we learned earlier in this chapter. We end up with something like **Fig. 7.54.**

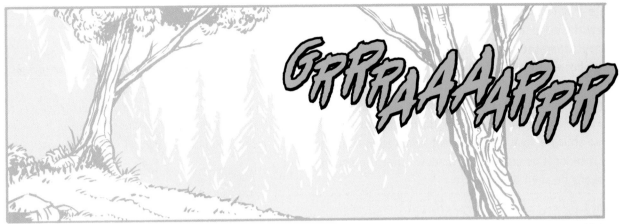

Fig. 7.54

Try to get the placement, size, and shape exactly where you want them. You will be able to make modifications later, but why not save yourself some work? While you're at it, check that any black fills or strokes will overprint in the Attributes window (Window > Attributes).

Now we can formulate the plan for the clipping mask. We can see exactly what part of the tree the sound effect will be clipped "behind." We can also trim the final *R* to the panel border if we want to.

It's important to design the sound effect before creating the object you'll use to make the clipping mask because the process can be very time-consuming. You only want to make enough of a clipping object to get the job done. In this case, there's no need to make clipping object of the *whole* tree . . . we just need to concetrate on the approximate area of the tree where the sound effect *crosses over it*.

In order to draw the clipping object, we need to see all the details in the area of the tree that intersect the sound effect. This means we need to temporarily hide the sound effect. Simple enough—select the entire sound effect and use Hide Selection (Command + 3). You'll see the sound effect disappear. Don't worry. It's still there. You can toggle it back into view with Show All Selections (Option + Command + 3) any time you want to check your work.

Zoom in very closely on the tree using the Zoom Tool (Z), then switch to the Pen Tool (P). As closely as possible, point by point, trace the *outer inked line* of the section of the tree that intersects the sound effect, being as precise as possible. If the clipping mask doesn't precisely match the areas of the tree that the sound effect crosses over, your end result will not be convincing. The fill color of the clipping object doesn't matter—it'll end up invisible anyway. I made mine blue just so you can see it clearly. With the clipping object finished and the sound effect toggled back into view, we end up with **Fig. 7.55**.

Fig. 7.55

Note that I made that clipping object in three sections:
first I drew the large left side, then the middle part between
the branches, then the right side. **Fig. 7.56** is a close-up of the
masking object where the sound effect intersects the tree.

It may seem a bit counterintuitive (at least to me, anyway),
but you want to make sure that the clipping object covers any
part of the sound effect that you want *revealed* in the end
product. Think of it as creating a "window" that the sound effect
will eventually be seen through.

If you made the clipping object in various pieces, like the
one I made here, make sure you select all the pieces and Unite
them (Pathfinder window > Unite button) before proceeding.

Fig. 7.56

All you have left to do is select the clipping object and the
entire sound effect **(Fig. 7.57)** and use Make Clipping Mask (Command + 7). You'll see the clipping object disappear and
the sound effect reappear with the portion "behind" the tree clipped away! **(Fig. 7.58)**

Fig. 7.57

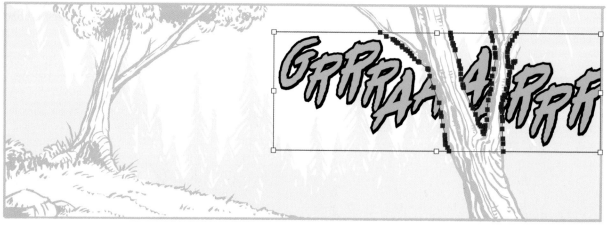

Fig. 7.58

If we remove the dimness on the Art layer of our lettering template, we can see the inks at their full richness behind the sound effect. **(Fig. 7.59)**

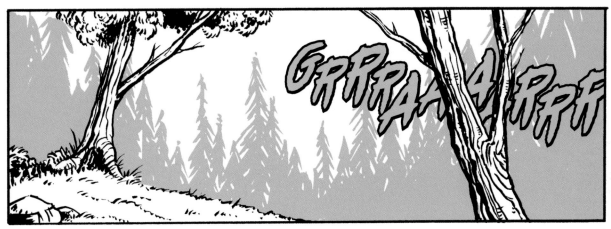

Fig. 7.59

If at any time you need to modify the clipping mask or the sound effect, you can select them and use Release Clipping Mask (Option + Command + 7), make your adjustments, and then select all your elements once again and Make Clipping Mask (Command + 7).

I'd like to remind you again (I know, I know . . .) that the most frequently used processes involved in creating sound effects can be programmed as Illustrator Actions and linked to your F-keys. (See Chapter Two.) You can work through several steps in seconds instead of minutes. They add up! You're better off spending that time focusing on the *creative* aspects of sound effects design!

PUNCTUATING SOUND EFFECTS

You'll encounter plenty of scripts that use exclamation points at the end of sound effects. It's a bit contentious among letterers whether the punctuation should be kept or omitted. Those that never use punctuation in sound effects explain that sound effects should "sell" their intensity through convincing design work . . . or that they represent noises, not dialogue. Other letterers are just fine with punctuating sound effects and may or may not use any punctuation on sound effects in the script.

There's no right or wrong approach. Comics are full of sound effects designed both ways—it comes down to personal preference. While I rarely punctuate sound effects, I have no problem with others doing it.

In any case, we can all agree that *one* exclamation point is enough and any more than that is excessive, right? No? Three? *Nine?!*

THINKING DYNAMICALLY

I've said it and said it, but how do you *do* it? How do you make sound effects dynamic? It's about movement, depth, and perspective. You have to get good at making sound effects look like they're *in motion*. I've drawn a panel with an explosion. (Sorry, explosions aren't my specialty . . . but it'll do.) Do you see the "movement"? How about if I use some red arrows? Everything is moving *away* from the epicenter and *towards* the outside of the panel.

If you're not thinking dynamically, this is what you might end up with. It's okay. It gets the job done . . . but it's kind of boring—and I think "boring" can be worse than "bad" when it comes to graphic design. This sound effect isn't working *with* the art. It looks like a sticker slapped on top as an afterthought.

What if we think in terms of movement? The design improves after adding some creative positioning of the letters, a little perspective, and a slight arc—all while keeping the source and direction of the sound in mind. I also used a clipping mask to trim the sound effect to the panel border, but that's a matter of personal taste.

We could place the sound effect on the other side, too. There's room. Again, shearing the sound effect a little bit, letters that get bigger as they "fly towards" us . . . all these things make better sound effects. Note that this time, I used a clipping mask up at the top, but I let the *M* pop out of the panel. Try lots of different things and see what you like!

For your enjoyment, here's a gallery of inspirational sound effects. All the designs presented here were created with the techniques covered in this chapter. Now *you've* got the building blocks to create sound effects, from sloshing water to raging infernos!

WHUB

BOOM THUNG

HURK! THIKSH SNAP

CRASSH BUDDA

THRASH! BUDDA

BUDDA

clikk SKRRRK!

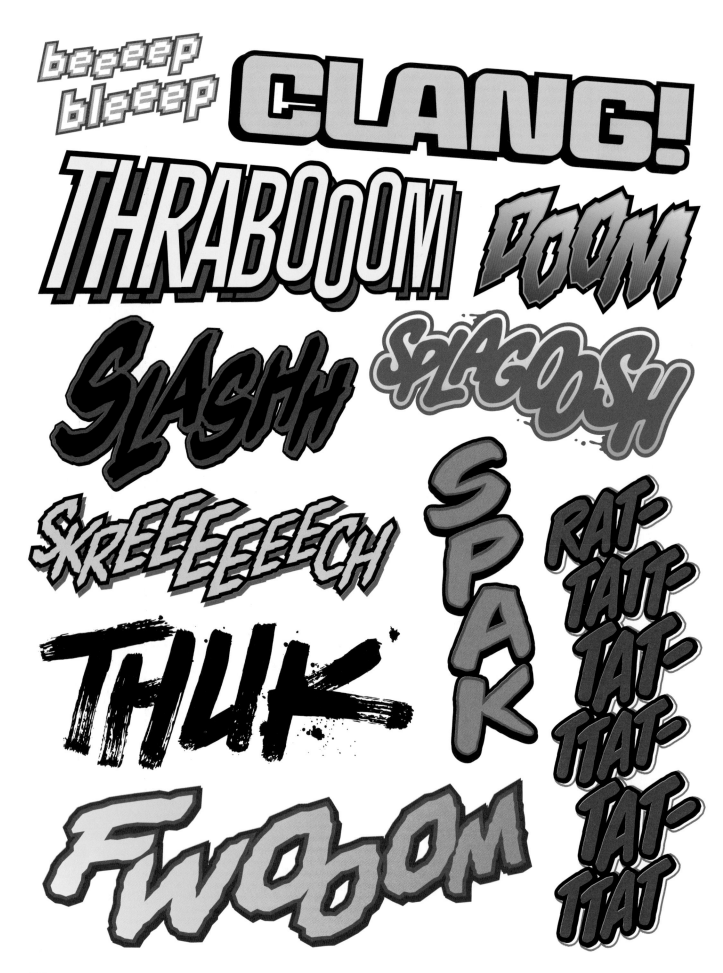

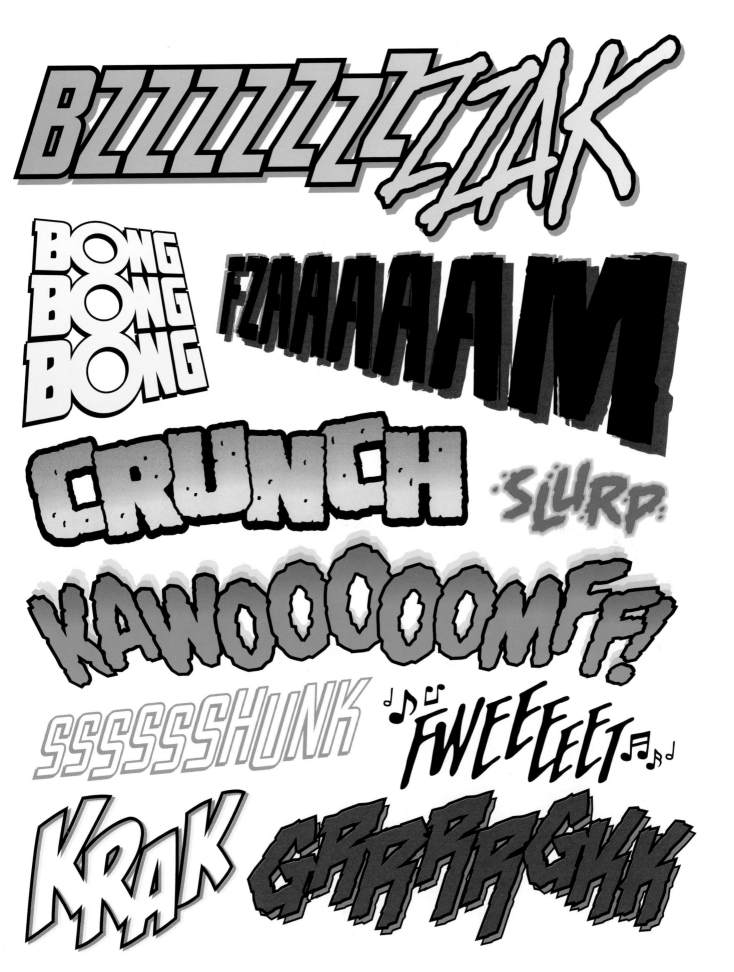

TITLES, LOGOS & MORE

TYPOGRAPHIC TERMINOLOGY

Before we start designing with type, I'd like to share a lexicon of typographic terminology with you. It'll help you discuss type with the universal shorthand that designers use . . .

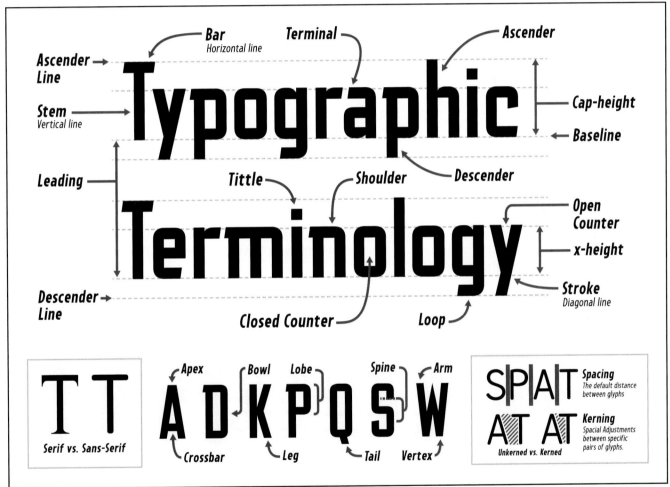

Fig. 8.1

That's a lot to digest, I know. Don't sweat it. I'm not suddenly going to switch to "type-speak" and leave you running back to this page to look up words you might not be familiar with. I just want you to know that these terms exist and are used in the design/typography community. Learn them at your own pace . . . and in the meantime, if you encounter a word you're unfamiliar with, you've got this handy reference right on the first page of the chapter.

DESIGNING WITH TYPE

You are surrounded by text-based design, whether you're at the grocery store, at school, or just walking down the street. In fact, you don't even have to leave your house. Your kitchen cabinets are filled with product packaging, you've got logos on your clothes, and when you turn on the TV, you're inundated with commercial advertising.

This chapter, more than any other, is about graphic design . . . the skill that separates the work-a-day letterer from those that stand out—and are sought out—for that skill.

Up until now, we've been designing with text in a fairly "controlled environment"—live typefaces in Area Type objects, a little manipulated "shouting" text in balloons, etc. We got a bit more expressive while creating captions and sound effects . . . but this chapter is all about creativity with text. I'd like to share the thought process involved in these endeavors, and the development of efficiency, planning, dependable tips, and good habits that will serve your work in the future.

We're going to cover four topics in this chapter in order of how frequently you'll encounter each one. The first two, Titles and Stingers, are duties expected of all letterers. The other two, Cover Copy and Logos, are more specialized, particularly logo design, which requires a lengthier schedule and a separate higher fee than a standard page rate.

If you've worked your way through the previous chapters, you already have the technical know-how to work with text-based designs in Illustrator. From here on out, I'd like you to focus on developing your *design sense*. We're going to talk less about "how-to" steps and more about how to think through the graphic design process. I think the best way to do that is simply by taking you through some examples.

TITLES

Let's begin with the most common subject you'll encounter as a letterer . . . titles. A title is equivalent to the chapter name for a particular issue or multi-issue storyline in a series. The page featuring a title also usually includes the credits of the people who worked on that issue.

Some publishers like to have their title and credits page on the inside front cover, and often that will be the responsibility of the publisher's production/design department. Other publishers expect the title and credits page to fall on a story page of an issue. In this case, it'll be your responsibility as letterer to design an appropriate title and the accompanying credits. Something like **Fig. 8.2** . . .

Fig. 8.2

Much of the time, the title and credits will fall on an opening splash page of a comic . . . the artist will probably have given you plenty of room to execute the design. But where to begin?

Presumably you have some feel for the series just by looking at the art and reading the script. If the project is a slick science fiction tale drawn by an artist with very precise tech pen linework, your title won't work if it's inspired by "old west saloon" lettering. (Although, you will sometimes be asked for unusual genre juxtapositions . . . until then, follow our prime directive: complement the artwork.)

Titles are not expected to be the most elaborate, time-intensive text designs for which you'll be responsible. They need to fit within the timeframe of lettering a standard page, and you'll only be getting your standard page rate

for a title/credits page. The trick here is to create the best design in a reasonable timeframe . . . so keep a diverse selection of typefaces to use as building blocks, and keep it simple and punchy.

Let's take a look at the design process of a fictitious title/credits design. We'll pretend this is a typical hero book and the art is very technical and clean. Those two factors are our guideposts for the design. We've received a script with the following information for the title/credits page:

Title: INTO THE . . . INFINITE SILENCE!
Credits: Writer: Mary Pagliotti / Artist: Steven Delgado / Jaime Hathaway / Colorist: Carrie Jones /
Letterer: (Your name here!) / Editor: Mike Hashimoto / Asst. Editor: Sandra Quinn

I recommend you have some plan before you actually start manipulating text. The last thing you want to do is flounder around for hours, indecisive and unhappy, while your page rate is being whittled down due to wasted time.

Because I like juxtapositions, my first thought is to keep "INTO THE . . . " very organic and "INFINITE SILENCE!" clean and blocky. Since "INFINITE SILENCE!" seems to be the focal point of the title, we should start there.

I settle on a blocky, heroic typeface that I designed several years ago (Bulletproof BB) and type INFINITE SILENCE! with Point Type. **(Fig. 8.3)**

INFINITE SILENCE!

Fig. 8.3

I like this look, but the S and C don't appeal to me anymore, so I decide to change them. First, I convert the font to outlines and edit the anchor points with the Direct Selection Tool to make more legible versions of the S and C. **(Fig. 8.4)**

INFINITE SILENCE!

Fig. 8.4

Since there will be complicated art behind this title, I need to make sure the letters stand out. As we've discussed, an easy way to do this is with Offset Path.

Unfortunately, most of the time, letterers work over inks, so pale, bright colors are more dependable. I'll give it a simple gradient fill from a medium to a light yellow in the Gradients window. **(Fig. 8.5)**

Fig. 8.5

These letters are starting to look like something! For a little extra pop, I'll create a filled drop by copying one of the offset paths behind the letters, nudging it down and to the right, and filling it with pale blue. **(Fig. 8.6)** I'm happy with that.

Fig. 8.6

Now we can deal with the secondary text, "INTO THE . . ." As I mentioned, I like pairing organic type with clean, angular type, so I sift through my typeface list and come up with Brushzerker Heavy BB—a font that I usually use for sound effects. Never let a typeface's intended purpose prevent you from experimenting! "INFINITE SILENCE!" is already very wide, so I want "INTO THE . . . " to be smaller, and stacked in front. This also creates some variety in the design.

The font as it stands is great, but it needs some adjustments to suit this design. I convert the live text to outlines, and I shear it slightly more to the right. Even though this text is smaller, I don't want it to be lost, so I adjust the height of the / with the Direct Selection Tool and add an offset path. I'll use the blue of the previous filled drop in these letters as well, to help tie the sentence together visually. **(Fig. 8.7)**

Fig. 8.7

I place this in front of "INFINITE SILENCE!" and it's pretty good. Almost there. **(Fig. 8.8)** Once all the elements are together, we have a better idea of how they interact and can adjust accordingly. You never really know if your plan is working until you see the parts coming together.

Fig. 8.8

I decide the design needs just a little more . . . *something.* Which brings us to one of the most difficult aspects of graphic design . . . how many adjustments are too many? What is *too much,* and what is *not enough?* When does a design fail because we over-worked it? You'll struggle with these questions for the rest of your career. Only experience can help you recognize when you're over- or under-working a design. My advice: be mindful of every change you make along the way. Take a minute after each change and reassess the design as a whole. You'll also find that opinions vary. What you think is "just right" might be someone else's "too much" or "not enough."

In this case, I decide to shear "INTO THE . . . " upward a bit so that I can overlap the ellipsis with the initial / in "INFINTE." **(Fig. 8.9)** I reassess the design. It seems more dynamic compared to the last version, and the interaction between the two styles of text makes the unit stronger.

Fig. 8.9

I'm happy with this. It's legible, it'll work with the subject and artwork without competing for attention, and it didn't take very long from concept to completion. That's perfect for a title. Finally, we can move on to the credits.

To complement the title, I need credits that are clean and legible. I copy/paste the credit text from the script into Illustrator with the Type Tool and experiment with a narrow range of typefaces I suspect will work. When I land on the best option, I make the names bolder than the credits to add some visual interest and attention to the names.

I suggest you apply any offset path and color effects with the Appearance window technique I covered in Chapter Six (see Location/Time Captions) if you want to keep the text live for future editing. Otherwise, duplicate and save a copy of the live text somewhere off your artboard and apply the effects to an outlined version of the text.

To tie the credits into the title, I decide to use the same basic style that we used on "INFINITE SILENCE!", but with solid pale yellow instead of the gradient fill. **(Fig. 8.10)** Small text with a gradient fill tends to be harder to read.

Writer **MARY PAGLIOTTI** • Artist **STEVEN DELGADO** • Colorist **CARRIE JONES**
Letterer **NATE PIEKOS** • Editor **MIKE HASHIMOTO** • Assistant Editor **SANDRA QUINN**

Writer **MARY PAGLIOTTI** ◦ Artist **STEVEN DELGADO** ◦ Colorist **CARRIE JONES**
Letterer **NATE PIEKOS** ◦ Editor **MIKE HASHIMOTO** ◦ Assistant Editor **SANDRA QUINN**

Writer **MARY PAGLIOTTI** ◦ Artist **STEVEN DELGADO** ◦ Colorist **CARRIE JONES**
Letterer **NATE PIEKOS** ◦ Editor **MIKE HASHIMOTO** ◦ Assistant Editor **SANDRA QUINN**

Writer **MARY PAGLIOTTI** ◦ Artist **STEVEN DELGADO** ◦ Colorist **CARRIE JONES**
Letterer **NATE PIEKOS** ◦ Editor **MIKE HASHIMOTO** ◦ Assistant Editor **SANDRA QUINN**

Fig. 8.10

When we put the credits and title together we have **Fig. 8.11** . . .

INTO THE... INFINITE SILENCE!
Writer **MARY PAGLIOTTI** ◦ Artist **STEVEN DELGADO** ◦ Colorist **CARRIE JONES**
Letterer **NATE PIEKOS** ◦ Editor **MIKE HASHIMOTO** ◦ Assistant Editor **SANDRA QUINN**

Fig. 8.11

. . . and the title is done. As usual, when I finish a design, I check to make sure the K:100 black fills and strokes are set to overprint (and only the black) in the Attributes window.

Before we move on, I want to mention the "Rule of Odd Numbers" or the "Rule of Three." In design, it's generally accepted that objects in odd numbers are more pleasing to the eye than objects in even numbers. I find that's true most of the time, and it's something I keep in mind while designing. Notice that we have three visual elements in this title/credits design . . . **(Fig. 8.12)**

Fig. 8.12

I hope you enjoy this page of inspirational title treatments. As you know, they come in all shapes, sizes, and themes. As we discussed, titles aren't meant to take up all your time . . . each one of these took me roughly ten to twenty minutes to design.

THE PRICE OF WARFARE

DESTRUCTION OF THE FINAL DIMENSION

OUR HERO... UNMASKED!

GHOST IN THE COMPUTER

KAIJU VS. MECH

YOUR PREMATURE BURIAL

FOREVER IS NEVER ENOUGH!

NIGHT OF THE VAMPIRE

CHAOS COMES TO TOWN

DIGITAL DISASTER!

STINGERS

Stingers are usually much simpler and faster to design than titles. **(Fig. 8.13)** A "stinger" is the industry term for the caption at the very end of a comic. They include everything from a basic *To Be Continued* to a tease of what's to come in the next issue: *Join us next time when the Revengers reach their BREAKING POINT!* I could have covered these in the chapter on captions, but as some of them can be more elaborately designed, I decided to discuss them here.

<div align="right">Fig. 8.13</div>

Stylistically, stingers are up to the letterer, although you should always aim to make them fit within the overall aesthetic of the project. A stinger should always be in harmony with the style guide you've been using throughout a series. For short stingers, I like to just use whatever typographic treatment I've been using for a series' location/time captions. The longer stingers tend to be a bit of throwback to classic comics . . . and they're more fun to design!

Like titles, it's worth noting that no matter how wordy the stinger, you're not expected to spend hours designing them. Stingers are meant to be quickly made and should not compete for attention with the art they appear on. A comic's final page is often a big reveal in the plot and the art is necessarily dramatic and important. Stingers are generally less complicated than a title/credits page design, and you'll probably have less room available within the art to design them.

Let's work our way through one of the long-form stingers. I'm a huge fan of horror, in particular the classic horror comics of the 5Os. Let's suppose we're working with a script of that genre . . .

Stinger: That's all for now, BOILS and GHOULS . . . thanks for keeping an old CRYPT-DWELLER company . . . SLAY YOU LATER!

My first impulse is to try something with a drippy, putrid caption box. But before I can design the box, the text needs to be finalized. I start with the supporting text (everything before the last three words), and I think that can be formatted in whatever typeface I had been using for the rest of the comic. I'd like to punch up the inevitably corny horror pun "SLAY YOU LATER!" I decide on a suitably creepy font and convert it to outlines. I'll also add a little offset path. **(Fig. 8.14)**

<div align="right">Fig. 8.14</div>

You could probably create a drippy horror caption box with Illustrator's Roughen effect, but I don't want an algorithm making those creative decisions for me, so I stick with the Pen Tool. Just as we drew monster balloons in Chapter Five, I'm going to drop anchor points around the perimeter of the text, making sure to leave enough negative space between the text and the outline of the caption box. **Fig. 8.15** is an example of the process, moving clockwise around the perimeter of the text . . .

<div align="right">Fig. 8.15</div>

When you freehand a shape like this, you'll undoubtedly need to adjust the anchor points individually with the Direct Selection Tool, but that's to be expected. I've never drawn one of these that was perfect on the first try.

Let's finish up. In **Fig. 8.16,** you can see I've picked a swampy green color scheme. Next, I've applied the calligraphic stroke covered in Chapter Five, and lastly, I've created an open drop by copying/pasting a duplicate of the caption box behind the original and offsetting it a bit. I've also changed the open drop's color fill to a darker green. Finally, I check to make sure only my K:100 blacks are set to overprint, and I'm done!

Fig. 8.16

Most of the time stingers will be very simple or short, but in the event that you're assigned a longer stinger, I've included a small gallery of inspirational examples . . .

COVER COPY

Cover copy is the first of the two topics in this chapter that you probably won't be asked to design on a regular basis, or at all. Cover copy is typically the responsibility of the design/production department of a publisher, or a particular in-house letterer. Not only has cover copy become less common, but most freelance letterers are only responsible for the *interior* lettering in a comic. Nevertheless, they are a load of fun to design, and they're still an important topic to . . . *cover.* (**Fig. 8.17**)

Fig. 8.17

Historically, cover copy is a way to help tease the exciting contents of the issue—usually a dramatic hint of what's awaiting the reader inside. These are often more elaborate than a stinger and smaller than a title. Let's run through the design of a typical example . . .

We've just been handed text for a cover copy that reads as follows:

The torch has been PASSED, and a HERO is . . . REBORN! You can't afford to miss the ISSUE OF THE CENTURY!

That's pretty wordy, but it's our job to make it fit and make it look organized and appealing. Clearly the word "REBORN!" is the main emphasis, and I always like to start with the words that will feature most prominently. I hope you're sensing a pattern regardless of what kind of type design we're executing—starting with the focus words is the easiest path "into" the design.

I think I'd like this copy to be contained inside a circle, since "REBORN!" seems to fall roughly in the middle of all that text. We could make it big and bold, and the text that comes before and after it may stack nicely above and below it in an ellipse.

I begin by typing "REBORN!" in a blocky font, convert it to outlines, and change it to a medium yellow. Then I add a light Offset Path effect in black since this will need to stand out. I also think maybe it should break out of the circle. I switch to the Ellipse Tool, draw a decent-sized blue circle, and send it behind the text. (**Fig. 8.18**)

Fig. 8.18

To deal with all that supporting text, I feel like we should keep it simple. I decide to use a typical dialogue typeface and copy/paste the copy we were given. Instead of going through the more elaborate process of creating Area Type objects in half-circles, I just use Point Type and manually break the lines so they stack in opposing half-circle shapes. I fill the text with white so we can see it against the blue circle. There's a little dead space below "CENTURY!" at the bottom, so I freehand an underline with the Brush Tool.

The text after "REBORN!" seems almost like an editorial aside to the reader— so I make it smaller, and to add a little extra spice, I decide to set that bottom text against a black background. To do that, I select the blue circle and create a negative offset path (so the offset path is created *within* the blue circle), then trim off the part I don't need using a rectangular trimming object and Minus Front in the Pathfinder window. **(Fig. 8.19)**

Fig. 8.19

And finally, to make the design stand out against the artwork, I add an exterior offset path to the blue circle and make that black. **(Fig. 8.20)** I check to make sure my K:100 blacks are set to overprint (and only the black fills), and that cover copy is finished!

Fig. 8.20

IS IT A TYPEFACE OR A FONT?

Technically, "typeface" should be used when referring to an entire family of fonts. When you say, " . . . the typeface, Might Makes Right Pro BB," you would be referring to all the styles in that family, such as Regular, Italic, etc.

"Font" is used when referring to a particular variation *within* a family, such as when saying, " . . . the font, Might Makes Right Pro BB *Italic*."

The distinction has been blurred in common use, so don't feel bad if you've been using them interchangeably. Almost everyone does . . . I have no doubt that I've slipped and typed "font" when I meant "typeface" a couple of times in this book.

Like some of the other inpirational design pages in this book, I've enlarged some of these examples of cover copy so you can more easily examine details.

IS SHE AWAKE? OR IS THIS A... NIGHTMARE?

TO FACE FEAR-- ALONE!

STALK THE MADMAN!

FOR WHOM THE BELL TOLLS!

THIS IS IT, FOLKS...THE GRAND FINALE! WITNESS THE FALL OF A TITAN!

WILL OUR FRAGILE CIVILIZATION BE BROUGHT TO ITS KNEES... AGAIN?!

TRAPPED IN THE EMPTINESS OF... SPACE!

WOW! 1ST ISSUE COLLECTOR'S EDITION!

A BRAND-NEW JUDGEMENT DAY DAWNS!

WILL THEY SURVIVE THE... MURDER MOONS of MARS?

DON'T EVEN THINK ABOUT MISSING MIDNIGHT DOUBLE FEATURES!

THERE CAN BE NO ESCAPE FROM SLIME-O-TRON!

WE CAN GUARANTEE THAT YOU'VE NEVER SEEN A BATTLE QUITE LIKE THIS!

TRAPPED IN A FAR-FLUNG FUTURE!

LOGOS

A logo is an incredibly important representation of a publisher or comic series. It's going to be consistently featured on every iteration of that project. I bet there are a dozen or more comic book logos that you associate with pleasant memories of the stories and characters that shaped your love of the medium. If you close your eyes and think of your favorite covers from a certain series, those logos are a part of that memory. They hold a special magic and importance related to that experience, don't they?

Logo design duties within the comics industry can generally be broken down into two categories: logo designs for a series (usually seen on the top third of a comic book cover) and logo designs for a publisher's mark (mastheads that represents the entire publishing brand and are present on all of their publications).

Of all the topics in this chapter, this is the most specialized, time-consuming, and lucrative. A logo designer charges far more than a lettering page rate for this service. A separate project agreement is required, and the designer generally has weeks to develop several options based on the information provided by the client.

GUIDEPOSTS TO SUCCESSFUL LOGO DESIGN

My focus in college was corporate identity design . . . that's a fancy way to describe logo design and the development of materials that accompany a change in brand (business cards, letterhead, etc.) My design professors drilled a set of principles into us that acted as reliable guideposts to successful logo design. These principles became essential to our work process. A few years after graduation, I decided to tailor these to my needs a bit more and compile them into a checklist. I've used these as my touchstone ever since.

What a Logo Isn't

First, let's discuss what a logo *isn't.* That's a weird statement, I know, but there's an important distinction to be made. In my opinion, there's a difference between a logo and a word or phrase typed out in a font. A logo may start life as a word or phrase typed out in a font, but it shouldn't end there. (I often forgo typefaces altogether and design the letters completely from scratch.) A client is paying for something unique, something that they will most likely trademark and use as a representation of their business or product. If they hire a designer, they're expecting a certain amount of skill, experience, and effort. Anyone with a computer can type a word and claim it's a "logo." A designer should strive to deliver something more tailored and iconic.

Too Much Information is Never Enough

Be clear and concise about your prices, payment schedule, project agreement terms, and turnaround time. Your clients may not be able to express themselves in very artistic terminology, so be patient with them. Get as much information as you can out of them about the project *before* you start designing. Knowing what they want up front is the best way to prevent frustrating revisions later. Also, sometimes a general "how do you want this logo to make people feel when they see it?" is as important as very specific details.

The Ends Justify the Means

You are not limited to any certain set of media for the development of a logo. You should use whatever materials work best to achieve the goals of your clients. Also, think about the most efficient way to accomplish your designs. After all, time is money, as I've repeated ad nauseum.

I'm a guitar player, and I like to use the adage that Jimi Hendrix could have picked up a yard sale guitar for $5 and played it in front of a crowd of thousands without anyone walking away from that concert disappointed in his choice of guitar. The magic is in your *hands,* not your tools. Just because certain materials are more expensive does not make them superior or faster. I was once asked to come up with a logo for a series where the author asked for a design that looked like bloody gauze. Could I have painstakingly digitally painted this in Photoshop? Sure, but why do that when I could run to the local pharmacy and buy some gauze? I stained it with tea, let it dry in the sun, wrapped it around the

cardboard backing of a pad of bristol board, and took high-resolution photos . . . then I manipulated *that* in Photoshop, saving myself hours of work and lending an element of realism that would have taken forever to create from scratch solely as a digital painting.

Legibility

With very few exceptions, legibility is the most important factor in a text-based logo design. Don't forget that you're trying to sell a product. If you can't read the logo, it's poorly designed and needs more work. A successful logo should be legible on everything from billboards to business cards. (Unless you're designing a logo for a death metal band, then go nuts!) One of my first design professors taught me to print out a new logo design on a sheet of 8.5" x 11" copy paper and tape it to the wall . . . then start walking backwards. If you can't read it from more than a few feet away, it's not a legible design.

Black & White and Color

A logo should work both in color and black and white/grayscale. Contrast is important, and once a logo leaves your hands, you never know how it will be used by the client. You can mitigate the chance that your design could become a very public eyesore if you think about this now.

Overlay

Remember that you can't predict what kinds of backgrounds the logo will be placed upon. When you are developing a logo, try it out on everything from a single-color fill to a busy illustration or photograph. If your client has cover art already drawn and colored, it's a good idea to try the logo on that as well.

Print and the Web

Make sure a logo will work in print and online. Print is fairly easy . . . you can print the CMYK logo on a desktop printer at various sizes, but also try out some RGB versions in a web browser. This will be particularly important if the logo is for a webcomic.

The Hook

Ask yourself, "what's the hook?" As I mentioned before, typing out words in a font doesn't constitute logo development. Text needs a conceptual touch to tailor it to the needs of the client. A logo should have a cohesive, unique design to conjure a feeling beyond what the text reads. It should convey a feeling that reflects the subject matter. A comic about a swamp monster might have drippy letters, or a comic about identical sisters who are master knife throwers called *Dagger Twins* could have some element of a blade worked in . . .

No Designer is an Island

Sometimes we're too close to our work. Make sure that any gimmicks or hooks are successful. Sure, you understand that the letter *T* in your newly designed *Dagger Twins* logo is supposed to look like a dagger . . . but will other people? If they don't seize on the hook ("Oh yeah, it's a dagger!") without being told, then you need to go back to the drawing board.

Icons

Should the logo include an icon? That *T* in *Dagger Twins* can be designed to imply a dagger shape, or it can be a very literal dagger icon. I tend to steer clear of overtly rendered symbols in most logos. I'm not really a fan of photo-realistic elements beside text treatments, to be honest. It's a slippery slope to go from a cleverly implied shape to an over-rendered, too-literal element. Tread carefully.

Never Show a Client an Option You Don't Want Them to Pick

Never deliver a logo option to a client that you are not happy with. If you come up with a design that you are particularly in love with and you think you can steer the clients toward it by padding out the options with a bunch of

lesser, throwaway designs . . . it's almost guaranteed to backfire on you. They're going to pick one of those "clunkers" as their logo almost every single time. It's some sort of cosmic constant. You don't want a logo out in the universe that you designed that is lousy . . . particularly if that project becomes a runaway success, and suddenly your subpar logo becomes the most recognizable work you've *ever done.*

CLIENTS AND PROJECT AGREEMENTS

A client will approach you with a potential logo design project asking for more information about your services. Most of the time these queries come in via email, and I try not to overwhelm the potential client with info upon first contact. Just give them the essentials—if the project moves forward, you can be more specific. You'll want to provide an idea of price, payment structure, payment methods, and turnaround time. Something like this:

The minimum price for logo design is $_____ USD each. Once I know more about the specifics of what you have in mind, I can estimate projected time for research, illustration if any, etc., and give you an actual price quote for your project. I'll then need to see when I can fit it into my work schedule. The terms are 50% down payment, under signed project agreement, with the remaining balance due upon completion. Turnaround is typically three to four weeks per project, but this may change based on further discussion. I accept payment by credit card or most online payment services. If you have any further questions don't hesitate to ask. Thanks.

It's also important to know your limits. If your schedule is already very full and you can't (or shouldn't) accept a new project, you should say so . . .

Thanks for thinking of me, but my schedule is just too full to take on a new project right now.

You should never, *ever,* do freelance work without a project agreement. The industry is overflowing with nightmare stories where both designers and clients have gotten ripped off with no legal recourse. As I'm not an attorney, I shy away from providing you with an example of a legally binding project agreement, but you can pay to have one written. There are also many books and online resources for graphic designers that you can research.

Once you've reached terms with your new client, you can get to work.

LETTERING WEBCOMICS

It won't be long before you're hired to letter a comic specifically designed for viewing online. Other than the size of the art, the creative approach is largely the same.

Many publishers are still working on ways to homogenize the process. Several years ago, I worked for a webcomics publisher on comics that were designed to scroll top to bottom. I developed a specific lettering template for that work that was 4" wide by 32" tall. As long as I received the art at this specific size to match the template, I could use a process very much like lettering print comics.

Typeface point size and balloon stroke weight are other considerations. Both need to be bumped up a bit (about 150% to 175%) as the comics need to be legible on everything from a monitor to a cellphone screen. The artist will have to leave even more room for lettering than usual.

Remember that webcomics are meant to be viewed in RGB (the color spectrum for screens) and not CMYK (the ink ratios for print). If it's your job to prepare the final files for viewing, you'll probably be saving them as a raster format like .tif, .jpg, or the like. Make sure you check the color of these files in Photoshop. Colors can look very different when changing from CMYK to RGB.

MY LOGO PROCESS

I had already lettered a few projects by artist Rafael Albuquerque when he emailed me about designing a publisher's mark for Stout Club, his new studio with Eduardo Medeiros, Rafael Scavone, and Mateus Santolouco. Rafael was always a pleasure to work with so I was thrilled to help.

After the paperwork was taken care of, we got down to discussing what he and his teammates were looking for. They were after a masthead . . . something to grace the cover of their projects. They were fans of beer and comics, and had come up with the name Stout Club to reflect this.

Over the course of a few weeks, I started researching reference materials and color palettes online (lots of classic beer labels) and then I began developing ideas in Adobe Illustrator. All of the designs for this project were totally vector-based. The icons (pint glass, bottle caps, etc.), were all drawn with the Pen Tool and various shape tools, and based on some quick thumbnail sketches I'd made on copy paper. You may notice that some of these make use of typefaces (mostly of my own design), but others feature type that I created from scratch.

Here is the first batch of designs I sent to Rafael after a couple of weeks of work . . .

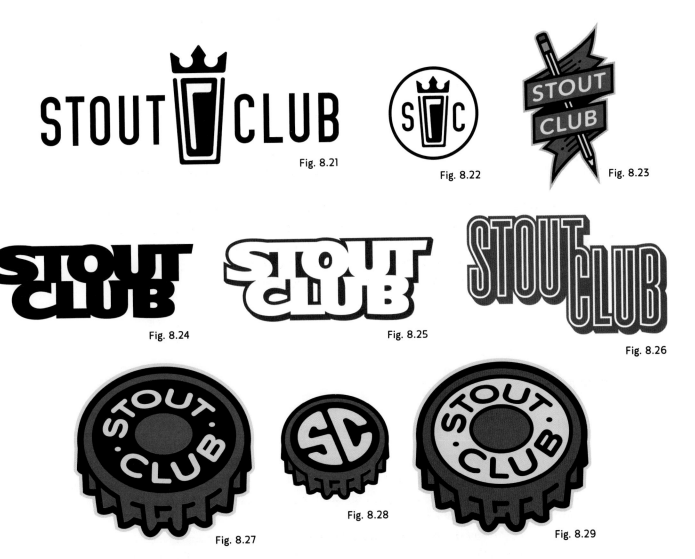

Fig. 8.21

Fig. 8.22

Fig. 8.23

Fig. 8.24

Fig. 8.25

Fig. 8.26

Fig. 8.27

Fig. 8.28

Fig. 8.29

Fig. 8.30

I initially seized on imagery associated with beer, hence the pint glass and bottle caps. I thought some of these would look great not only on the studio's comic covers, but also on t-shirts, business cards, and other promotional materials when the team exhibited at comic conventions. I had high hopes that those bottle caps (**Figs.** **8.27** through **8.29)** might be a hit as stickers! But after further conversations, I discovered they were more interested in a logo that was totally text-based . . . and less focused on beer. While **Fig 8.21** was my overall favorite, I went back to work on some simpler ideas that were just text. A week or so later, I sent this next batch to Rafael . . .

Fig. 8.31

Fig. 8.32

STOUT CLUB

Fig. 8.33

STOUT CLUB

Fig. 8.34

STOUT CLUB

Fig. 8.35

STOUT CLUB

Fig. 8.36

Fig. 8.37

Overall, these were much more warmly received. For this batch, I started playing with gritty textures—rounding and distressing letters, and using vector scans of grimy surfaces that I'd photographed, vectorized with Illustrator's auto-trace, and used to trim textures into the designs. One of them was a picture of an ice puddle (**Figs. 8.33** and **8.34**), and another was the floor of my garage (**Figs. 8.36** and **8.37**)! I highly recommend stockpiling photos of textures to use in designs. In my virtual library, I have hundreds of photos of things like newsprint paper from the 1880s, cracked gravestones, and peeling paint . . . all waiting to be used in some future project as a texture.

Figs. 8.31 and **8.32** were inspired by 1970s pub logos. (I couldn't help doing one more beer-related design—at least this one was all text . . .) **Figs. 8.35** through **8.37** were just me experimenting with simple, legible, stamp-style logo ideas. I was particularly happy with the faux color misregistration in **Fig. 8.34**, which was my favorite of the bunch.

In the end, **Fig. 8.33** was enthusiastically accepted as the final design. I delivered vector files to the team and received the balance due on the project. As of this writing, Stout Club has already launched a website and several comics projects, and you can see the logo on all of them.

A NOTE ABOUT DESIGNING TYPE

Few letterers design logos, even fewer design their own typefaces from scratch. I've been designing type for almost twenty years for my website, Blambot.com. In fact, I designed almost every typeface in this book, including this body copy font! It's called Budrick BB.

Typography is a *massive* subject. I wrestled quite a bit with adding a chapter to this book dedicated to the subject of designing and programming fonts, but a single chapter would never be enough. If I were to include in-depth details on every step involved in type design, it would take up more than a chapter . . . in fact, it would probably be longer than this *book*. Since I can't do the topic the justice it deserves here, I have decided to briefly touch on my process for you instead. If you are truly interested, you can venture down the rabbit hole of typography on your own.

My sources of inspiration range from old comics, wine labels at the liquor store, old paperback novel covers, vintage music posters, and everything in between. But to be perfectly honest, most of the time it's a matter of necessity. I'll be lettering a comic book or designing a logo and realize I need a certain style of font that I haven't created yet.

I start more organic type designs with either hand lettered samples scanned from art I've drawn in ink, or digitally hand lettered ideas lettered in Photoshop with my tablet. Angular, inorganic designs are usually built directly in Illustrator using the Pen Tool and various shape tools.

Organic designs get traced "by hand" with the Pen Tool—point-by-point—to convert them into vectors (I hardly ever use auto-trace for font designs unless the font is extremely textured, rendering point-by-point tracing far too laborious to be feasible).

My initial design process in Illustrator can take days to months depending on how satisfied I am with the work. When I have all or almost all of the characters designed, I copy them into Fontlab, a program specifically for designing and programming fonts. Other typographers also use a program called Glyphs. Note that you can create type completely within Fontlab or Glyphs. It's just my habit to begin the process in Illustrator.

In Fontlab, work continues. I size, space, kern, correct paths, add hinting, develop the different weights, program auto-ligatures and contextual alternates, and much, *much* more. It's quite a process—particularly kerning, in which I check the interaction between 15,000+ pairs of characters against one another—and it can take anywhere from weeks to months for me to finish an entire typeface. Finally, I save the files in Opentype format (.otf) and run them through some tests in different programs to see how they perform. When they pass inspection, I release them on Blambot.com.

It's a slow process, but one that's deeply rewarding when you finally install fonts that are your own unique creation . . . and see others enjoying them as well.

Before we move on, I thought I'd offer a gallery of logos and type designs that I've created over the years. These represent various subjects, methods, and even media—for instance, *Middlewest* and *The Me You Love in the Dark* were hand lettered. *Rivenshield* was for an RPG campaign world, and Comic Book Lettering is an Art was a t-shirt design.

PEANUTS™

middlewest™

PFifER & FRiENDS™

RIVENSHIELD™

The ME YOU LOVE in the DARK™

THE BERSERKER'S DAUGHTER™

FROM PROOFS TO FINALS

WHEN THE LETTERING IS FINISHED

An often overlooked part of the letterer's job is the delivery of files once the creative aspect of our task is finished. The book is lettered, and it's time to present your work to the publisher. This is a multi-step process, and there are commonly accepted practices regarding file type and delivery.

The basic process goes like this: the letterer creates .pdf proofs of the entire book and uploads them to the publisher's server for review by the editor and/or proofreaders (and potentially the writer and artist as well). Soon, the editor will send back a marked-up version of the proof with everyone's compiled corrections (or "correx" for short) for the letterer.

When the corrections have been made to the Illustrator lettering files, a new proof is made and sent to the publisher. The process is repeated (hopefully only once or twice), until the editor gives the okay for final files to be created. Based on the publisher's preferences, the letterer turns the Illustrator files into either .eps files of *just* the lettering, or—if the letterer is being paid extra to prepare print-ready files—high-res flattened .tifs of each page, an InDesign file of the pages, or a print-ready .pdf made from an InDesign file.

When a letterer uploads the final files to the publisher's server, the letterer should also submit their invoice or voucher for payment.

LIVE VS. OUTLINED TYPEFACES

Before we get into the substance of this chapter, I want to address an important topic: you *should never* deliver files to a publisher containing live typefaces—and a publisher should not require you to provide copies of the typefaces you used to letter a book unless they already own *their own* licenses for those typefaces (kind of making it a moot point). Handing over typeface files to a third party may place you in violation of the typographer's End User License Agreement (EULA)—the agreement you entered into when you purchased a license for each of the typefaces.

The most common reason for a publisher to ask you for files containing live typefaces is so they can circumvent you during the corrections phase—someone else (who may not be skilled as you) may be altering your work. You should be very wary of this. While small corrections are inevitably going to be done by the publisher's production department at the eleventh hour, you should make it a point to request that *you* want to handle your own corrections. It's your name in the credits after all.

The solution to all this is simple: you'll use Select All and Convert To Outlines to turn all live text to vectors on files before delivery—you can even turn it into an Illustrator Action to execute the process with a single F-key. I'll let you know when to Convert to Outlines as we move through the following topics.

PROOFS

Adobe Acrobat .pdfs are the accepted file format for sending low-resolution samples of your work to your editor for review. Your goal is to provide a single document that contains all the pages you lettered in a particular book. It's important to note that letterers each have their own preferred way to generate proofs—mostly tailored to their lettering template sizes. Without getting bogged down in minutia here, keep in mind that these instructions are planned out for the templates detailed in this book.

PROOFING WITH ILLUSTRATOR AND ACROBAT

Some of you may be able to combine Illustrator files directly in Adobe Acrobat to make proofs. It seems like with recent updates, I lost the ability to do so without going through a process that was too elaborate for my workflow. Though complicated—and not my recommended method—the following approach should be possible for nearly everyone.

In Illustrator, open each document containing a page you've lettered. Make sure any layer of your template with live text is unlocked in the Layers window (Window > Layers) and then Select All (Command + A) and Convert to Outlines (Shift + Command + O). This will turn all live text into outlines. Then Save As (Shift + Command + S).

This will bring up the Save As window. At the bottom, in the Format field, select Adobe PDF. **(Fig. 9.1)**

The Save Adobe PDF window will pop up. For proofs, you want to keep the file sizes small—there's no need to have high-res art in these—so at the top of the window, in the Adobe PDF Preset field, choose [Smallest File Size]. When you're done, click Save PDF. **(Fig. 9.2)**

That's one page saved as a proof. Make sure you never accidentally overwrite your original; if you do, all your live text will no longer be editable in case of corrections!

You'll have to repeat this process for each page (which is a hassle, I know, that's why I prefer using the upcoming InDesign method).

Fig. 9.1

Fig. 9.2

Once you have all those pages saved as individual .pdf files, you'll have to compile them into a single document in Adobe Acrobat. Open Acrobat, and click on Tools in the top left corner. **(Fig. 9.3)**

In the Tools window, select Combine Files from the Create & Edit menu. **(Fig. 9.4)**

Click Add Files and navigate to wherever you stored all those individual .pdfs. **(Fig. 9.5)** Add them all.

Click Combine, save your new .pdf, and you're done.

You may remember the aside in Chapter Three called *Multi-Artboard Templates,* where savvy Illustrator users might choose to have every page of a comic in a single Illustrator document. While I find there are drawbacks, the big perk to the approach is this step of making .pdfs (and .eps files later on). Since every page is in a single document, you'd only have to run this process once instead of opening each page and repeating the steps for each.

That said, I still choose to use a single artboard, so let's move on to my preferred method of generating proofs . . .

Fig. 9.3

Fig. 9.4

Fig. 9.5

PROOFING WITH INDESIGN

By making a multipage InDesign document specifically for proofing and populating it with all the Illustrator lettering files of a particular book, you can turn out proofs for an entire project without much fuss. The best part about this approach is that your InDesign document will update itself if you make any changes to the .ai files it contains.

Imagine you've had to make several rounds of corrections to your Illustrator files . . . to produce an updated proof, you simply make the corrections to the individual Illustrator files, open the InDesign document you've made for proofs, and you'll be prompted with a message that essentially says, "Hey, these Illustrator files seem to have changed, do you want to update them here?" Click Update Modified Links, and you're all set. You can then export a .pdf of the whole revised book in one fell swoop.

Creation of this InDesign document should take you a few minutes at most.

In this example, I'm going to use pages from a book I've already lettered, *The Me You Love in the Dark* #3 by Skottie Young, Jorge Corona, Jean-Francois Beaulieu, and myself.

Open InDesign and use the keyboard shortcut Command + N to bring up the New Document window. **(Fig. 9.6)**

Fig. 9.6

Notice the column on the right. Set up the Width and Height based on the full bleed size (6.875" x 10.4375") that we talked about extensively in Chapter Three. For the number of pages, I subtract a page for every double-page spread that appears in the issue. In this case, there is one spread, so 20-1=19. Facing Pages should be un-checked. You shouldn't really have to worry about the other fields at this point since this document is just for proofing, not for print. What you see in the example is fine.

Click Create, and you'll end up with a blank nineteen-page document. Make sure the Pages window is open (Window > Pages). Here it is on the far right, showing icons of all the pages. **(Fig. 9.7)**

Fig. 9.7

To drop in all your Illustrator documents, use keyboard shortcut Command + D to Place. Navigate to the folder where you've saved your Illustrator files, select them all, and click Open. **(Fig. 9.8)**

Fig. 9.8

Your cursor will turn into a little thumbnail of the Illustrator files you're placing. Click the top left corner of page one of the document to place the first Illustrator file. You don't have to be exact, just click that top left corner. InDesign will understand your intent and align the file to the exact corner. **(Fig. 9.9)**

The Me You Love in the Dark courtesy of Skottie Young and Jorge Corona.

Fig. 9.9

The Illustrator file will appear on page one, and your cursor will change to a thumbnail of the next Illustrator file. Scroll down to the second page of the InDesign document and repeat the process. Do this until all twenty pages are placed.

What if you have a double-page spread? Place it as normal, and finish placing all the pages of the book. When they're all placed, scroll back to the double-page spread, click on it in the Pages window, and at the very bottom of the window, you'll see three small icons. The first one is Edit Page Size. **(Fig. 9.10)**

Fig. 9.10

This will open a flyout menu; click on Custom at the bottom of the list to bring up the Custom Page Size window. Change the Width field to 13.5" and click OK. **(Fig. 9.11)**

You'll have to slide the double-page spread Illustrator file over to the left of the new, wider page area.

Not to get too far into the weeds on the topic of making room for double-page spreads . . . but if you're already an InDesign user, you may be wondering why I'm not just dragging a blank InDesign page beside another page to make space for a double-page spread. (Try it out by right-clicking on a page in the Pages window, uncheck Allow Doc Pages to Shuffle, then you can drag pages—but make sure you Export As: Spreads

Fig. 9.11

when you export your .pdf proof.) This works if you're using the Alternate Template Setup in Chapter Three, or if you create your blank InDesign document at your *trim* size and set the bleed measurements in the Bleed fields. But for the default lettering template detailed in this book, doing this will obscure part of your title block since it falls within the bleed area. That's why I just modify the size of blank pages that contain double-page spreads. It's virtually the same amount of work.

To continue . . . you can now export a .pdf of the whole book by bringing up the Export window (Command + E), changing Format (in the center there, towards the bottom) to Adobe PDF (Print), and clicking Save. **(Fig. 9.12)**

This brings up another window, Export Adobe PDF. As I mentioned earlier, selecting [Smallest File Size] is your best bet for a smaller file. Click Export, and you're done! **(Fig. 9.13)**

Fig. 9.12

Fig. 9.13

Here's how that .pdf looks when viewed in Adobe Acrobat. **(Fig. 9.14)** You can simply scroll through all the pages of the book to check the results.

After you send this .pdf file to your editor, there will inevitably be corrections that need to be made in your original Illustrator files. After you make those changes, just open up the InDesign proofing file, and you'll get prompted with the Issues with Links window. Just click Update Modified Links and the changes you made to any of the Illustrator files contained therein will update in the InDesign file! Finally, save a new .pdf of the revised comic.

In **Fig. 9.15**, I've changed one Illustrator document, and when I open the InDesign file, it shows that one Modified Link needs to be updated.

Fig. 9.14

Fig. 9.15

NAME-CHECKING

Sometimes, for clarity, you'll get a correction note from an editor to "name-check" a character in a bit of text. This means you should add the name of the person being addressed instead of a pronoun that might be too ambiguous in the scene. Some publishers also like to emphasize all names appearing in dialogue and captions as well.

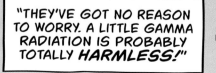
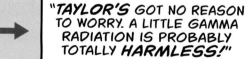

CORRECTIONS

It's very rare that you'll turn in lettering on a project and not have *any* corrections. Of the many books I letter in a year, it happens once or twice. Most of the time, there will be some small changes. Corrections are any spelling, plot, or grammar issues that the editor or writer wants changed in the lettering before final files are turned in. Missing commas, misspelled words, and a sentence or two that need to be rephrased are all typical. A standard correction pass on an entire book usually takes less than an hour. Expect two or occasionally three passes on a typical twenty- to twenty-two-page project.

Note that corrections *do not* mean rewriting the comic after it's been lettered . . . or even rewriting the dialogue of a whole page. A script should be finalized as much as possible before it is ever sent to you for lettering. Since the normal amount of corrections I mentioned above are included in your page rate, extra pay may *not* be offered to you when massive changes need to be made after lettering. Just how much revision goes beyond standard "corrections" is debatable. It's up to you and your editor to address this when the amount of rewriting becomes unacceptable. Speak up when you are concerned. It's your time and your page rate on the line after all. Do not be afraid to ask.

As I mentioned briefly before, I recommend that you make it known to your editor that you want to perform any corrections yourself. Occasionally, to save time, a publisher will circumvent you and have their production department make changes to your lettering. While I think a good production department is worth their weight in gold—they've saved my butt more than once—I have seen too many poorly made changes to my lettering end up in print. It's unacceptable to have poorly executed lettering changes in a book when it's your name listed in the credits as letterer. Discuss with your editor your willingness to do all corrections before a project gets underway, and commit to speedy revisions when needed. You will be expected to turn around corrected proofs quickly—within a day or two on weekdays.

FINAL FILES

When you are informed that no more corrections need to be made, it's time to generate final files for the publisher. Some publishers prefer you to deliver the lettering *only,* especially if you were working over low-res art. Their production department will handle the merging of lettering with the high-resolution art. Other publishers expect print-ready files, including the high-resolution art. It's good policy to ask what they prefer before lettering begins.

Another question that you may want to ask a publisher is if the work will eventually be translated into other languages. It's typical for translations to be tasked out to letterers who specialize in that job. Some methods of creating final files are less "translation-friendly" than others. For instance, since .tifs are flattened pixel-based files, the letterer who will be translating that book will have to clean out all the dialogue manually in Photoshop before re-lettering the book. Methods that leave the lettering vectorized (like .eps files), or on their own layer (like InDesign files), save time and work for that letterer down the road.

Let's work through some typical final file scenarios.

DELIVERING LETTERING AS EPS FILES

Most of the time, I deliver .eps files of the pages I've lettered. These contain *just* the lettering, balloons, captions, sound effects, etc. with the Art and Title Block layers of the lettering template removed. Delivering final files in this way is included in your page rate. The letterer receives no extra compensation for making .eps files.

Before we start, I want to mention that while I am giving you a step-by-step breakdown of the process of creating an .eps file, know that this process can be recorded as Illustrator Actions tied to F-keys, *greatly* speeding up the process. My old process for generating .eps files was just three F-keys. My current process distills all this down to just *one!*

Let's use a page from *Umbrella Academy: Hotel Oblivion* #7 by Gerard Way, Gabriel Bá, Nick Filardi, and myself as an example of creating .eps files. Here's page eighteen. **(Fig. 9.16)** Remember early on when I told you that letterers often work over inks? This is one of those times. (I took a guess about the eventual color palette of the page in order to add color to that "BOOM"—something you'll be doing often.) Note that the inks look washed out because the Art layer in our template is set to "dim" the art, helping us to better see our lettering while we work.

The Umbrella Academy: Hotel Oblivion courtesy of Gerard Way and Gabriel Bá.

Fig. 9.16

This is a good time to check that your K:100 blacks are properly set to overprint. You've probably *already* double-checked this along the way, but it never hurts to triple-check.

First, we need to make sure none of the fonts we used in the document will be live or editable in the final .eps file. Make sure the only layers in your template that are locked are the Art layer and potentially the Title Block, or Bounding layer. Use the keyboard shortcut for Select All (Command + A) and then go to Type > Create Outlines.

You'll see all the live text in your document change to vectors. **(Fig. 9.17)**

Fig. 9.17

Next, in your Layers window (Window > Layers), select the Title Block and Art layers and delete them with the little trash can icon in the bottom right corner of the window. **(Figs. 9.18** and **9.19)**

Fig. 9.18

Fig. 9.19

You're left with a rather sparse-looking Illustrator file that contains just the remaining layers of lettering. **(Fig. 9.20)**

Fig. 9.20

All that's left to do is save this as an .eps file. On your keyboard, use shortcut Shift + Command + S to bring up the Save As window. I recommend you make a folder just to "catch" your EPS files, as you see in **Fig. 9.21.** Change Format to Illustrator EPS (.eps), then click Save.

Repeat this process to make .eps files for each page of the issue. You can then upload this folder to your publisher's server, and you're done!

Fig. 9.21

PERFORMING PRE-PRESS SERVICES

If you're expected to deliver print-ready files of the lettering married to the art, you'll want to know you'll be completing this task *before* you start lettering anything. Not only is this a service letterers generally charge a small extra fee to complete, but you can save some time if you request the fully colored, high-resolution art before you start lettering. High-resolution art would be 400-600ppi (low-resolution would be around 120-300ppi—I wouldn't letter on anything lower than that). If you letter over the high-res art right from the start, you won't have to deal with swapping low-res for high-res later on when you need it.

When you get the high-res art, open up the pages in Photoshop and double-check that they are standard western dimensions (6.875" x 10.4375"). You can resize or trim the page dimensions very slightly as long as you make it known to the editor, have experience doing this, and are sure you're not making mistakes. Also check that the pages are high enough resolution for print. If the resolution is too low, you should *not* upscale it. It's impossible to add more resolution . . . you can only add more *pixels;* the image's poor quality will remain. You can scale raster quality down, but never up. In this instance, contact the editor and request proper-resolution art files for print.

Once you've got proper art, go ahead and letter the book. After corrections and once the editor gives the go-ahead, it's time to make final printable files. You can either create an InDesign document of the lettering married to the high-resolution art, a high-quality .pdf, or flattened .tifs.

COVER CREDIT FOR LETTERERS

Up until recently, it's been pretty rare that the letterer or colorist has their name listed on the cover of a comic along with the writer and artist. As this is largely a marketing technique, for years the argument has been, "no one buys a comic for the colorist or the letterer." Which may be true for the most part. It's getting more common for colorists to have their names listed on the cover, since more than ever, they make a huge contribution to the art. But it's still fairly rare for letterers.

I think what progress letterers have made on this topic is two-fold. First, people are realizing that the entire creative team (and yes, the letterer *is* part of the creative team) is responsible for the comic book being a polished final product. Second, the internet has made lettering far more visible as an artform than it used to be.

PRE-PRESS WITH INDESIGN

To compile all the interior pages in an InDesign document, you'll first want to make .eps files of just the lettering, as we covered earlier. I like to have the .eps files saved within their own folder. The same goes for the high-res artwork.

Open InDesign and use Command + N to bring up the New Document window. **(Fig. 9.22)**

On the right, in the Width and Height fields, you'll want to input your *trim dimensions.* In this case, our standard American trim dimensions are 6.625" x 10.1875", as we covered earlier. The Pages field should contain the number of pages of your book, *minus one* for every double-page spread. I'm using *I Hate Fairyland* #20 by Skottie Young, Jean-Francois Beaulieu, and myself. While this issue has twenty-two pages, it has *three* double-page spreads. Thereforet, 22-3=19 pages.

I prefer to uncheck the Facing Pages box, but use whichever you'd like.

If you scroll down a bit, you'll come to the Bleed and Slug info. In the Bleed section, you want to make sure all four fields contain an eighth of an inch bleed, or .125". Note that this measurement added to our trim measurements brings us up to the American standard 6.875" x 10.4375" full bleed size.

Fig. 9.22

In **Fig. 9.23** you can see the newly created blank document. Each page has a thin red line around it indicating the full bleed.

Fig. 9.23

Now is also a good time to use Save As (Shift + Command + S) to save the document alongside the folders that contain the .eps and art files.

Use Place (Command + D) to open the Place window. Navigate to the folder containing the high-res art for the book. Select all the pages, and click Open. In a second, you'll see your cursor change into a little thumbnail of page one. Position the cursor as close as you can to the top left corner of the bleed line and then click. **(Fig. 9.24)** Don't struggle to click perfectly on that corner; InDesign will know what you're trying to do, and the image will snap to the corner. The art will appear, and as long as the sizes match, it will perfectly fit to your page. **(Fig. 9.25)**

Fig. 9.24

I Hate Fairyland courtesy of Skottie Young.

Fig. 9.25

Continue down, dropping page after page of art onto each blank page of the InDesign document, until they're all placed.

You'll have to modify the page size of any page that contains a double-page spread. In the Pages window (Window > Pages), scroll to that page, select the small thumbnail, and at the bottom of that window, click the Edit Page Size button. It looks like two sheets of paper with folded corners. **(Fig. 9.26)** When you click it, you'll get a flyout menu with some page size options. All the way at the bottom, click on Custom. This brings up the Custom Page Size window. In the Width field, change the value to 13.25 in. **(Fig. 9.27)**

Fig. 9.26

Fig. 9.27

You'll see the page with your double-page spread change size. Select the art and slide it to the top left corner of the page so it lines up perfectly. **(Fig. 9.28)**

Fig. 9.28

Open the Layers window (Window > Layers) and you'll see that by default you've been working on Layer 1. Let's create a new layer for the .eps files we're about to drop in. Use the Create New Layer button to add Layer 2 on top of Layer 1, and make sure you're on that layer before we proceed. **(Fig. 9.29)** You could rename these layers if you wanted to (double-click on them), but there are only going to be two layers to keep track of, so . . .

Fig. 9.29

Scroll up to your first page in the main window, and use Place (Command + D) once again. In the Place window, navigate to the folder where you saved all your .eps files. Select them all and click Open. You'll see your cursor turn into a thumbnail image of the first .eps file. You can click on the top left corner of each page to drop the .eps files on top of their corresponding art. **(Fig. 9.30)**

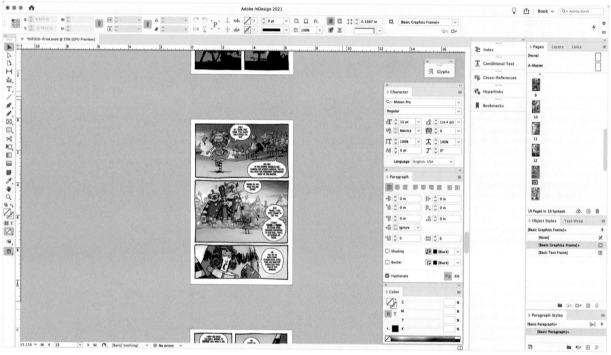

Fig. 9.30

Note that if you included that invisible rectangle in your lettering template all the way back in Chapter Three, these .eps files will perfectly line up with the art. There will be no need to manually adjust the lettering to fit where it should be on each page.

As long as there are no overprint problems that you need to go back to your Illustrator files to solve, save your InDesign file again and you're done! Note that if you send this .indd file to a publisher, you will need to include the folders of the art and .eps files. The easiest way to do this is to use File > Package to collect all linked materials (including live fonts—but you shouldn't have any of those in your .eps files).

Alternatively, you can make a print-ready .pdf file to send to the publisher. In your finished InDesign file, use Export (Command + E) to bring up the Export window. In the Export window, change the Format to Adobe PDF (Print) and click Save. **(Fig. 9.31)**

This will bring up the Export Adobe PDF window. Change the Adobe PDF Preset to [Press Quality]. **(Fig. 9.32)** This is a pretty universal preset for most commercial printers, with one exception. By default it clips pages at the trim size and ignores your bleed measurement. To remedy this, switch to Marks and Bleed in the left-hand menu. Under Bleed and Slug, check Use Document Bleed Settings. After that, you can click Export to finish up. **(Fig. 9.33)**

Fig. 9.31

Fig. 9.32

Fig. 9.33

CROSSTRAINING

I firmly believe that everyone working in comics should try everyone else's job at least once. Try writing, drawing, coloring, editing, inking—try it *all!* You don't have to be good at it, you just have to understand it in a hands-on way. You'll know (at least in a general way) what's involved in flatting colored art, the challenge of laying out panels, trimming dialogue to make it stronger and clearer, etc. Communication among creative teams becomes more concise and productive, and everyone ends up appreciating each other's jobs on a level that they perhaps hadn't before.

PRE-PRESS AS TIFF FILES

Delivering .tifs of the lettering flattened down onto the art is the easiest of all the options, although it means someone at the publisher is probably just going to use these to make an InDesign file. You can do it right from within your Illustrator documents. For this example, I'm going to use a page from *Middlewest* #16 by Skottie Young, Jorge Corona, Jean-Francois Beaulieu, and myself. **Fig. 9.34** shows page ten lettered in my template . . .

Middlewest courtesy of Skottie Young and Jorge Corona.

Fig. 9.34

As you know, the art looks washed out because we set our lettering template's Art layer to "dim" the image to 30% in order to better view our lettering. Don't worry, this won't affect the output of final files. Illustrator ignores this during export.

As always, double-check that your K:100 blacks are set to overprint, then in your Layers window (Window > Layers) delete the Title Block layer by selecting it and clicking the trash can icon in the bottom right corner. **(Figs. 9.35 and 9.36)** You don't want your title block printed in the comic!

You don't have to worry about converting the live text to outlines in this scenario. Everything is about to be flattened down into a single layer .tif file. The text will be rasterized in the process.

Fig. 9.35

Fig. 9.36

Use keyboard shortcut Command + E to open the Export window. I recommend you make a folder specifically for final files, as I've done here. Change Format to TIFF (.tif) and click Export. **(Fig. 9.37)**

This brings up the TIFF Options window. Color Model should be CMYK, and the resolution should match the ppi of the high-resolution art (in this case, 400ppi). Another important note is to *make sure* LZW Compression is checked. It saves a tremendous amount of file size, without any perceptible downside. Click OK to finish the export. **(Fig. 9.38)**

Fig. 9.37

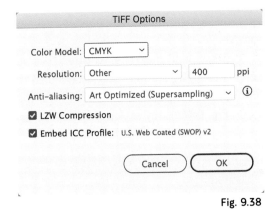

Fig. 9.38

You'll see a .tif of the page appear in the folder you made for final files.

Close the Illustrator file without saving. You don't want your original file altered in case you have to come back to it at some future point.

You can repeat this process on the rest of the pages to finish up.

I recommend that as one final quality control check, you open your new .tifs in Photoshop just to make sure everything processed properly. This is also an excellent way to check if your overprints are correct, particularly with sound effects. Non-black color fills that have been mistakenly set to overprint will look very wrong, as if the otherwise bright and clear color fills were muddy and dark. On this page, note that I actually have a black sound effect, the "TZZAAAAK" in panel three. While the K:100 black should be set to overprint, there's a bright cyan duplicate of it, behind and slightly offset, that should not.

Here's a look at how that .tif turned out. **(Fig. 9.39)**

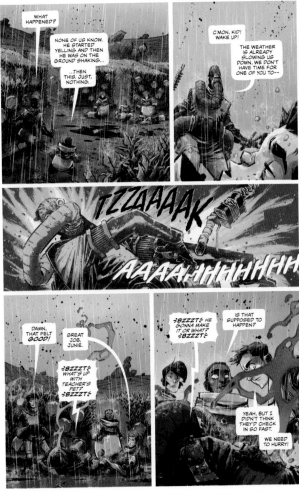

Fig. 9.39

KEEPING TRACK OF YOUR PROJECTS

As we end the chapter, I'd like to take another minute to address a couple of important bookkeeping duties you'll be responsible for as a freelance letterer. The first is tracking your work. Being organized is extremely important. Knowing what stages you're on for multiple projects will go a long way to making your day go more smoothly. At a glance you'll be able to tell what's pending and what you've been paid for.

This completely depends on your ability to stay on top of this information as it changes. I suggest you make a spreadsheet, or go old-school like I have and make a form like this in Illustrator. I print and keep blank copies ready for use.

You'll need these fields: title, issue number, page rate, number of pages, total fee for the project, the editor's name or initials, the date you received all the files you required to start working, the date you delivered proofs to the editor, the date you delivered final files, the invoice number, and the date your were paid.

Fig. 9.40 is my actual project tracker . . . with ficticious information, of course.

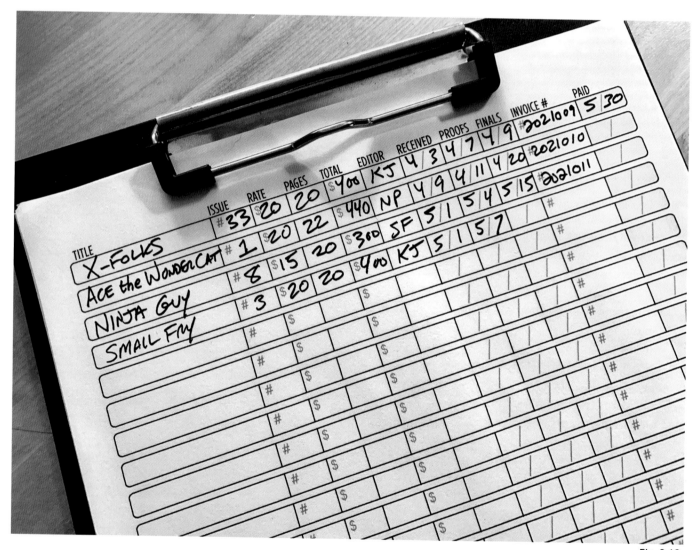

TITLE	ISSUE	RATE	PAGES	TOTAL	EDITOR	RECEIVED	PROOFS	FINALS	INVOICE #	PAID
X-FOLKS	#33	$20	20	$400	KJ	4 3	4 7	4 9	#2021009	5 30
ACE the WONDERCAT	#1	$20	22	$440	NP	4 9	4 11	4 20	#2021010	
NINJA GUY	#8	$15	20	$300	SF	5 1	5 4	5 15	#2021011	
SMALL FRY	#3	$20	20	$400	KJ	5 1	5 7		#	

Fig. 9.40

INVOICING FOR COMPLETED PROJECTS

When you've sent in final files for a project, it's time to create and email your invoice for payment. You need to include your name, business name (if any), contact info, bank transfer information (optional, if that's how you'll be paid), the date, an invoice number (something sequential that you can easily update for each invoice—I like to use the four-digit year followed by numbers counting up from 001), a breakdown of the services performed, the prices for each, and the grand total. The invoice itself should be easy to understand, so don't get too fancy. You can use a word processing program, a spreadsheet, or even Illustrator (potentially saving each invoice as a .pdf) to make a template that you can use for each new invoice.

Also, make sure you have an idea of when the publisher typically pays out. Every two weeks? Thirty days?

I'd also like to mention that many people seem to find invoicing . . . *uncomfortable.* I want to remind you that there's nothing to be anxious about. You worked very hard—not just on this book, but think of all the time you devoted to learning and improving the very special set of skills that allow you to perform this job. You *earned* this pay, and the publisher is expecting your invoice. This is not a handout. Deliver that invoice confidently! You like to eat food and live indoors, right? Right! **Fig. 9.41** shows a dummy invoice for your reference.

I'm clearly not an accountant, and you probably aren't either, so I highly recommend you hire a qualified accountant, especially come tax time.

If you are considered "work-for-hire" and not an employee of a publisher, the payments they send you probably have no taxes taken out of them. You are responsible for paying the taxes on this income. American freelancers may be considered self-employed, and therefore have to submit quarterly estimated tax payments.

Consider keeping a spreadsheet of your finances so you can estimate how much money you'll make in a year and how much you need to set aside for taxes. US-based publishers will send you 1099s with definitive totals—at the *end* of the tax year.

FILIPE THE LETTERER
INVOICE FOR LETTERING SERVICES

FOR:
Spiffy Comics Publisher
1234 Notareal Street
New York, NY, 10022
Attention: Accounts Payable

By:
Filipe A. Fakename
PO BOX 56789
Woonsocket, RI 02895
filipetheletterer@totallyfakemail.com
401-555-5555

Bank Transfer Info:
Artificial Bank
Routing: 00000000
Account: 00000000

Invoice Date: 4/15/2021
Invoice # 2021009

QTY.	Description	Price Each	Amount
22	Lettering - Ninja Cats #2	$15.00	$330.00
22	Pre-press - Ninja Cats #2	$5.00	$110.00

TOTAL PAYMENT DUE: $440.00

Fig. 9.41

PUTTING IT ALL TOGETHER

It's one thing to provide instruction broken down into very specific categories—it's quite another to see how all those factors come into play while lettering real comic book pages. Not everything you've read in this book will be useful for *every* page that will come across your desk, but all of it *will* be useful at some point. Eventually, you won't have to flip through these pages to find the reference that's relevant to a problem you've encountered—you'll have internalized these things, and you'll just pull it out of your "bag of tricks," so to speak. There is always frustration at the start of a new endeavor, but trust me, after enough diligent practice, this will all become the cerebral equivalent of muscle memory.

I thought the best way to wrap up our journey through these techniques is to take you through my step-by-step process for lettering a page. Even though we're going to focus on sequential steps one at a time, the process happens *very* quickly when I'm lettering in my studio. I usually finish a page in fifteen to twenty minutes from the time I place the art in my template to the time I hit Save for the last time and move on to the next page. I like to finish a twenty-two-page comic in six to seven hours of total work time. That may seem impossible for you right now, but you'll get there if you keep at it. I promise.

STEP-BY-STEP

I like to flip through the entire script of a comic before I start lettering. This is mostly to spot anything that needs to be adjusted before I start lettering (double dashes instead of Em dashes, making sure smart quotes are used instead of straight quotes, etc.) I use Word's Find > Replace to correct them. For this example, I'll be using *Umbrella Academy: Hotel Oblivion* #5, page 20 by Gerard Way, Gabriel Bá, Nick Filardi, and myself. Gerard's scripts are always pretty tight. Here's the well-formatted page on which we'll focus:

Page 20

Panel 1: EST-EXT-Oblivion Planet: A nice establishing shot of both the Hotel Oblivion and the Minerva parked out front. The Perseus Televator is also outside in front of the hotel but the doors are now closed. We only see a couple of Zoo's Techs standing outside. The UA boys and Zoo crew are inside.

1/SPACEBOY (off panel):	Empty!
2/CAPTION:	The Hotel Oblivion.
3/SFX:	Boom boom boom

Panel 2: INT-Hotel—Lobby: Space, Kraken, and Zoo are in the lobby. Zoo strolls around very impressed with the building. Spaceboy punches a wall repeatedly. Kraken is struggling with the revolving doors, which won't budge. Away from them, we see some of the faceless Bellhops watching them, standing.

4/SFX:	Boom boom boom
5/ZOO:	<u>Apparently,</u> Spaceboy.

| 6/ZOO: | From what I can gather from your Father's notes, this <u>pocket dimension</u> seems to be the place where Hargreeves kept all your most <u>strange</u> and <u>violent</u> foes. |
| 7/KRAKEN: | And If nobody's <u>here</u>--and that <u>Televator</u> is parked outside-- |

Panel 3: Over one of the Bellhops who flinches as Spaceboy punches the wall, knocking out a huge chunk of it. He is pissed.

| 8/SPACEBOY: | They got <u>out</u>, and <u>we're</u> trapped in here! |
| 9/SFX: | Boom |

Panel 4: Spaceboy stands, defeated, Zoo, in the foreground, points at the hole in the wall that seems to be self-repairing. Some kind of funky sci-fi magic effect.

| 10/SPACEBOY: | He kept so many secrets . . . so many things from us. |
| 11/ZOO: | There it is again . . . |

Panel 5: The wall is almost done fully repairing, or is fully repaired. Kraken has walked over to them.

| 12/ZOO: | The Walls <u>self-heal</u> major damage! |
| 13/KRAKEN: | Then how did <u>they</u> get out? |

Panel 6: A faceless Bellhop, hand up holding a key, walks past Dr Zoo toward the revolving doors. Dr. Zoo does a double take, reacting to the Bellhop.

| 14/ZOO: | I'm not sure . . . |

Over on the right is the beautiful line art by artist Gabriel Bá that I'll be lettering. **(Fig. 10.1)** Note that on this series, I typically don't have access to the colors while I letter. (As I mentioned before, this is how the process usually works on most projects—the colorist and letterer are usually doing their jobs simultaneously.)

ATTENDING CONVENTIONS

I have exhibited at comic book conventions both big and small. I've also purchased a pass and walked around like any other attendee. If your goal is to make connections and look for lettering work, each option has its perks and drawbacks.

Exhibiting at a con means you've paid for either a booth (more expensive) or a table (less expensive). Expect to have some signage printed beforehand so that your space is attractive and easily spotted in a crowded hall. Since you will be listed in the convention guide, you will have your own "address" on the con floor and people will easily be able to find you. Purchasing space usually includes a couple of Exhibitor badges that let you go in early and stay late, and your booth space is great place to sit and store your stuff. The downside is that you will be stuck behind your table for the majority of the con. You may not be able to see the sights, attend panels, go shopping, or pop out to meet friends outside the convention. Also, it's *expensive.* You're taking a gamble that the money you spend to exhibit will be made back in future work contacts made at the convention.

Visiting a convention as an attendee—or what I like to call, "free range"—means you'll be able to stop by the booths of all the publishers and creators who may be looking for letterers for their projects, you can schedule critiques with editors, and you can come and go as you please. Attending is also far cheaper, and you can spend time browsing around as a fan. The downside is that fewer people will know where to find you, you'll have to carry around any promotional materials you brought with you (a portfolio, business cards, stickers, etc.), and you'll also be on your feet all day in a very—VERY—crowded building.

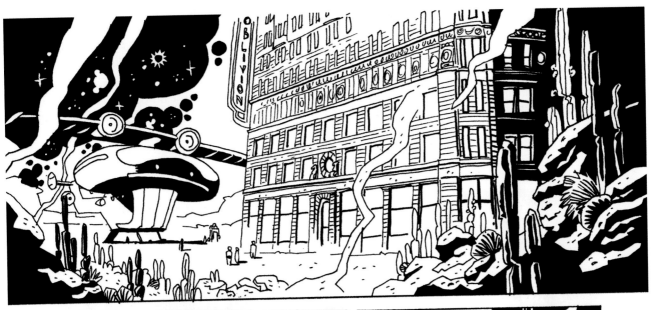

Umbrella Academy: Hotel Oblivion #5 courtesy of Gerard Way and Gabriel Bá.

Fig. 10.1

I make two decisions at this point. Notice that in Panel 1, there is dialogue before the location/time caption. This means I probably won't be able to place the caption in that nice negative space in the top left corner of the art. The other decision I make is that the repeated BOOM sound effects could overwhelm the conversation going on . . . I want to make them obvious, but not obtrusive, as that doesn't seem to be Gerard's intent.

Speaking of placement, I typically receive placement suggestions from the editor on this series . . . they look something like **Fig. 10.2.** Most of the time, the suggestions are solid, but if I see a way to improve readability, I use my own judgment.

Fig. 10.2

The editor's placements confirm my supposition about Panel 1. And now I can see that the available space for lettering in the middle panels may end up being tight.

Time to start lettering.

For each project, I have a lettering template saved with all the assets (balloons, typefaces, caption styles, etc.) for the style guide I've designed for that series. I open my *Umbrella Academy* template, place the art on the Art layer, and lock it. You'll remember that the Art layer in our lettering template is set to "dim" the inks to 30% so that we can better see our lettering as we work.

Fig. 10.3

The placements are pretty close to how I think I'll lay out the lettering, so I'll start by copying/pasting my Area Type objects where I plan on placing the dialogue text. **(Fig. 10.4)** These Area Type objects are pre-loaded with the custom typeface I made for Gerard Way. They are also set at the point and leading size that I've predetermined, and are already filled with K:100 black, set to overprint.

I use butted balloon Area Type objects for any balloons that I think might butt against a panel border, and elliptical Area Type objects for any balloons that will probably float. You'll notice the text in the Area Type objects is just nonsense placeholder text.

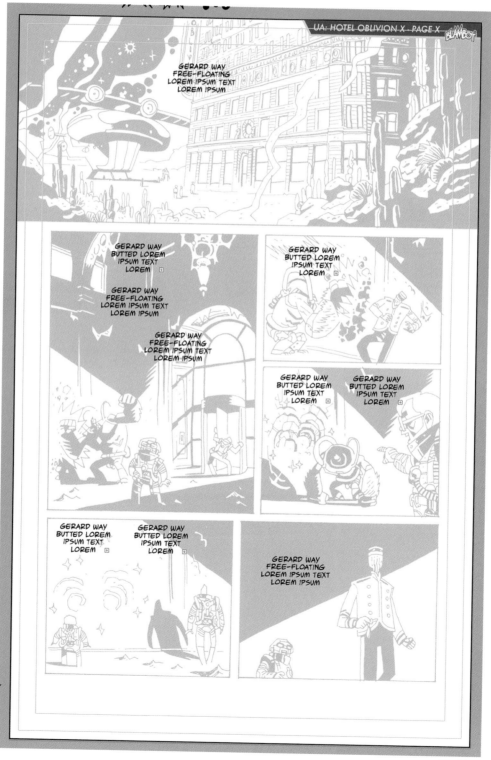

Fig. 10.4

Next, I address each one of those Area Type objects, flipping back and forth between the script and the corresponding panel as I copy/paste each line of dialogue into its Area Type object. I format each word that needs to be bold italic using the Character Styles window, then adjust the size of the Area Type object to fit all the text in a pleasing ovoid shape. I also make sure each butted Area Type object is appropriately spaced away from the panel borders. The goal is to get all this text *exactly* where it will end up without any more nudging or reshaping during the ballooning step. While I'm at it, I add the location/time caption text in Panel 1. When I'm happy, I lock the Lettering layer in the Layers window so I can't accidentally move anything on that layer during the ballooning process. **(Fig. 10.5)**

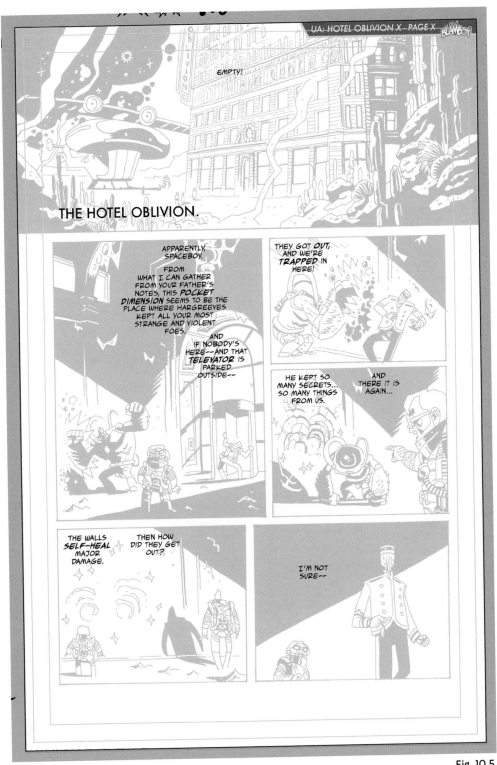

Fig. 10.5

Switching to the Balloons layer of the template, I turn my attention to the collection of balloons that I have saved on the left side of the artboard (you can flip back to **Fig. 10.3** to see those). For the style guide of this project, I designed some manga-inspired balloons. They have soft angles and corners instead of an elliptical shape.

I choose balloons for each completed Area Type object, based on the shapes of the Area Type object text, and copy/paste the balloons roughly where I'll need to fit them. **(Fig. 10.6)**

Fig. 10.6

I address each balloon in order, and resize and reshape them to fit comfortably around each Area Type object. At this point, I'll know if I have to unlock and move any of the Area Type objects on the Lettering layer. It's possible that some need to be nudged closer or farther away from panel borders. I unlock, adjust as needed, and relock the layer before moving on to the next balloon. I create each tail with the Pen Tool and unite it to its balloon as I go. Note that in Panel 1 we have a tail ending in a squink. I custom created that on the fly with the Pen Tool. Next, the balloons that butt against panel borders get trimmed with clipping masks. **(Fig. 10.7)**

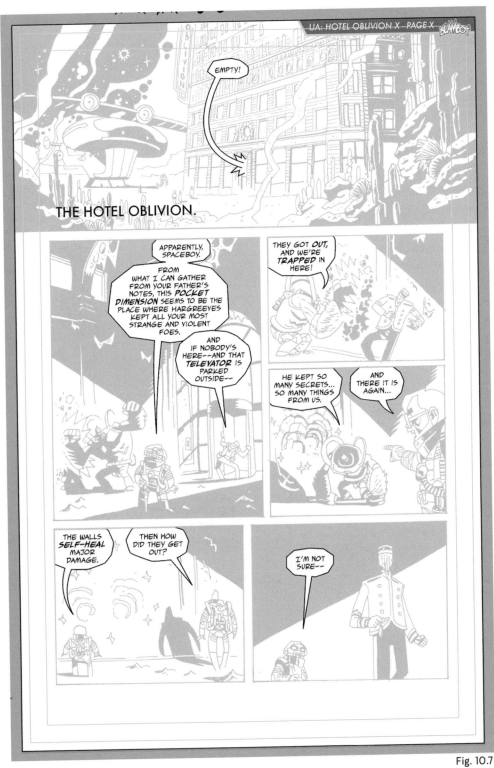

Fig. 10.7

The balloons are already set up with the correct stroke weight (.75) and color (K:100 black) for this series, so I don't need to change those settings.

Also, you can see that I didn't add a caption box or any other treatment to the location/time caption. On this series, it's part of the style guide to simply float these over the art. The colorist (or sometimes the publisher's production department) makes sure that the color of the caption text stands out against the artwork.

As I mentioned in previous chapters, instead of sifting through menus, I have Illustrator Actions linked to F-keys for almost every step of the balloon-making process: clipping masks, uniting tails, creating balloon connectors—this greatly speeds up the process and lets me focus on the more creative decisions.

Finally, it's time for the sound effects. Spaceboy is pounding on the walls of the hotel—I want these to be beefy, slightly distressed, and easy to read . . . but I don't want them to overpower the conversation. There may be times when sound effects *should* overpower a conversation, but from context, I don't think this is one of those times.

I choose a font that I created called Crypt Creep BB. While it wasn't really designed for sound effects, I think it works well for this scenario.

Since the sound effect repeats, and I don't want them all to appear identical, I make a couple of versions where the *O*s shift one way or the other. I spread the BOOMs around where needed in Panels 1, 2, and 3, resize and rotate them, and add an offset path to each. Note that as the BOOMs progress through the panels, they get bigger and bigger, suggesting increasing intensity. **(Fig. 10.8)**

In Panel 2, I make the conscious choice to put the sound effects on the Beneath Balloons layer of my template and partially obscure them behind balloons. **(Fig. 10.9)** In Panel 3, I trim the BOOM to the top and right panel borders with simple clipping masks. **(Fig. 10.10)**

Since I'm lettering over inks and I don't have access to the color palette of the finalized art, I leave the sound effects, titles, etc. without colors. The publisher or colorist will address this later on.

Fig. 10.8

Fig. 10.9

Fig. 10.10

I give the whole page a final look, trying to spot errors or tangents, then I double-check overprints. I ask myself if there are any changes to the placements that could improve readability. When I'm satisfied, I select everything outside my artboard and delete any leftover lettering assets (which is another process accomplished with the single click of an Action linked to an F-key). I change the title block to reflect the issue and page number and save the page in the appropriate folder in my work file. **(Fig. 10.11)** It's time to move on to the next page!

Later, I make proofs. After my editor sends corrections, I make .eps final files of just the lettering, upload them to the server, and invoice for my work . . . another issue finished!

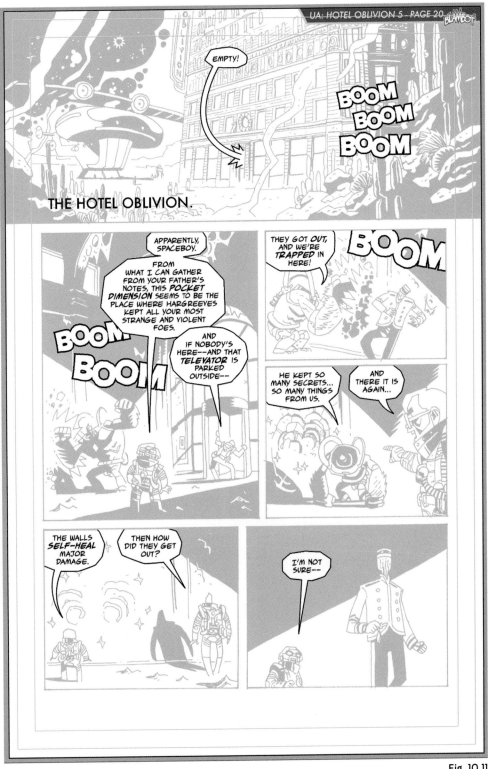

Fig. 10.11

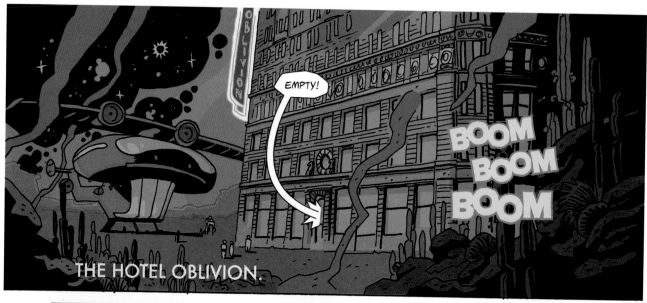

THE HOTEL OBLIVION.

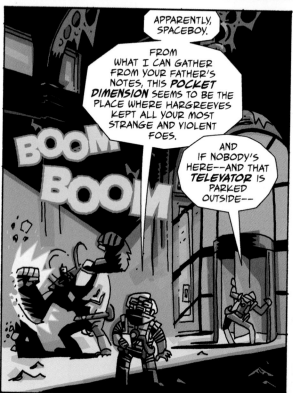

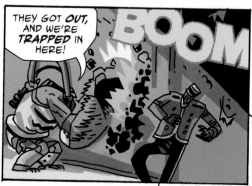

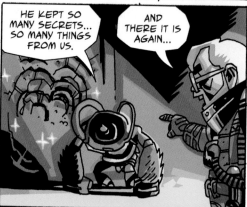

Umbrella Academy: Hotel Oblivion #5 courtesy of Gerard Way and Gabriel Bá.

Fig. 10.12

OVERLAPPING AND UNDERLAPPING BALLOONS

Virtually every comic book that you letter will contain conversations between characters. Due to the volume of dialogue or space constraints within the artwork, you will have to overlap or underlap balloons . . . but how to choose? Sometimes a publisher may have a set "house style." Other times it's the letterer's or editor's preference. Whichever option you go with, I suggest that you be consistent across all the issues of a series.

I think it's worth mentioning that in most cases (and given enough space), I try not to overlap/underlap every balloon in a conversation—just the replies that feel like they should come sooner than others. This whole technique can be considered a visual representation of the rhythm of the conversation.

Some editors I've worked with who have particular lettering preferences like to order balloons whicheverway they think looks best based on the composition of the panel. They may even specifically indicate this in their balloon placements.

Overlapping

I like to think of this option like dealing cards in a card game. The first balloon is laid down, and every other balloon overlaps its predecessor as the conversation continues. Overlapping is particularly effective and more consistent when one character interrupts another. I tend to default to this approach when I'm lettering, but when it seems appropriate, I lean towards the Foreground/Background option below.

Underlapping

This is a traditional house style amongst Marvel letterers. This approach has the first balloon at the "top of the stack" and every other balloon underlapping its predecessor as the conversation continues.

Foreground/Background

Here, the foreground character always has the top-most balloons. The background character always has the bottom-most balloons. This method helps sell the "depth" of a panel when the speakers are on different planes in the art.

Overlapping balloons

Underlapping balloons

Foreground/Background

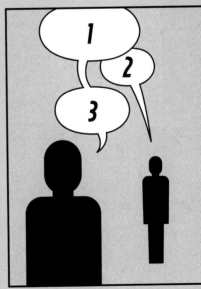

CONCLUSION

The Essential Guide to Comic Book Lettering was originally supposed to be 160 pages. In my heart I think I knew that wasn't going to be enough space for my concept, which was "the most comprehensive book on comic lettering ever written."

By the time I pitched it to Image, I was about halfway through scripting, and I had bumped up the estimate to 200 pages—surely *that* would do it—but there always seemed to be one more bit of esoteric knowledge that had to be included. (The number of sticky note "reminders" stuck to my computer monitors reached truly ridiculous proportions.) Suffice it to say, the book you just read is 256 pages . . . and I *still* have the nagging feeling that there are a few more things I forgot to include.

You see, I want you to be *prepared*. Not just for the technical aspects of the job, or even the traditions passed down from letterer to letterer . . . but all of it: the lifestyle, the hunt for work, the long hours, the responsibilities, and the passion you'll need to get through it all . . . I want lettering to make you *fulfilled* and *successful*. I want to stand in a comic book shop, take an issue from the shelf, and see some new and interesting lettering by a talented up-and-coming letterer. Because by teaching you, you're teaching *me*, too. We all continue to grow in our art by doing good work and inspiring one another.

I hope you see that lettering shouldn't be considered an afterthought, or some laborious final step of production. Our primary tools may have changed from ink to pixels over the decades, but that hasn't lessened the craft. We are still designers, and the work we do is only limited by our own creativity. If you commit to being a student of lettering, it'll show in your work regardless of the tools you use, and with time and practice, the jobs will roll in.

I want to believe that when this book finally goes up on your shelf, it'll be dog-eared, scrawled with notes, and well-loved. For those of you reading an ebook version, I suppose you can't really wear out a digital edition—but I still hope you'll try. This book is a tool, after all—a resource to help you when you need to design a radio balloon, you've forgotten the difference between an ellipsis and a double dash, or you're just having a bad day and need some inspiration to get your mojo flowing again. We all have days when nothing we do seems good enough, or we're overwhelmed and spiraling out of control. When that happens, my wife likes to remind me that my *worst* day working in comics is still better than my *best* day working in any other job.

She's absolutely right . . . and If you love comics as much as I do, I promise that will be true for you, too.

ACKNOWLEDGEMENTS

A very heartfelt thanks to Spencer Cushing, Skottie Young, and Eric Stephenson. All three of whom stepped in at different points along the way and saved this project from certain doom. You would not be reading this book without them.

To Tom Orzechowski, whose legendary work I've been admiring since I was a teenager. To this day, I learn something new every time I open a comic book that Tom has lettered (and you will, too). I couldn't have asked for a better Foreword to this book.

To Taylor Esposito, who was the first letterer (and lettering instructor!) to read an early draft of "The Guide." He provided an invaluable second set of experienced eyes on the project, and I am indebted to him for his selfless effort to help me improve this book.

To Logan DeAngelis, my lifelong pal and master of InDesign. Thanks for always being there for me and answering all of my annoying production questions, brother.

To Mike Allred, who gave me my first professional gig despite my total lack of experience . . . starting me on the path to my dream job.

To Wendy and Richard Pini, whose comics I obsessed over as a kid, and by some twist of luck, ended up working on as an adult—thanks for making me part of the wolfpack.

To Gerard Way and Gabriel Bá, who continue to amaze me with their work and kindness—I love being a part of your team.

To Rafael Albuquerque who surprises me not only with his astonishing art, but his willingness to include me in his projects whenever he can.

To Jorge Corona, whose whimsical, beautifully rendered art is a dream to letter over.

To Evan Dorkin and Jill Thompson, who graciously invited me to contribute to their world of mystical animals. I enjoy each and every issue as both a letterer and a reader.

To Juan Ferreyra and Paul Tobin, who are not only warm and funny people, but are immensely talented—working on projects with either of you is always something I look forward to.

To Paige Braddock at Charles M. Schulz Creative Associates, and Chris Bracco at Peanuts Worldwide, LLC for their kindness and for letting me contribute designs to one of my favorite comic strips of all time.

To the editors who kindly keep me busy year after year, even through a pandemic! To the writers, artists, colorists, and production folks who set the stage for my work and who inspire me to try harder than I did the time before . . . every time.

To Deanna Phelps, Melissa Gifford, and all the folks at Image who helped make this book better than I could have made it by myself.

To my fellow letterers who are quick to share new tips, inspire me, and who support Blambot. There is no finer bunch of smart, funny people with whom I'd rather share a beer after a long day at a comic convention.

To the letterers I've looked up to since I carried around their dog-eared comics in my backpack at school: Todd Klein, Gaspar Saladino, John Workman, Stan Sakai, Sam and Joe Rosen, Janice Chiang, Artie Simek, Bill Oakley, Lois Buhalis, and so many more—many of whom continue to show us *how it's done.*

To my mother who ceaselessly encouraged my pursuit of art, and to my father who was the perfect role model for turning my art into a career.

And finally . . . thank *you.*

Let's make comics.

HEH...HA...HA HAA HA HA HAAA

ABOUT THE AUTHOR

Nate Piekos graduated with a Bachelor of Arts degree in graphic design from Rhode Island College in 1998. As the creator of Blambot.com, his typeface and logo designs can be seen worldwide in comic books, feature films, television, advertising across all media, and nearly every kind of product packaging. He's the recipient of numerous awards, including the 2010 Rhode Island College Alumni Honor Roll Award for Success in the Field of Design, the 2010 Eagle Award for Best Letterer, and the 2020 Ringo Award for Best Letterer. Nate continues to work on some of the most high-profile projects for virtually every major publisher in the comic book industry, including Image Comics, Dark Horse Comics, DC Comics, and Marvel Comics. Outside the studio, Nate likes to cook, is a guitarist, plays tabletop RPGs, and loves a good horror novel. He's married to his college sweetheart, and together they live in the woods of Rhode Island with their faithful companion, Ace the Wonder Cat.

You can follow Nate on social media at . . .

Twitter:
@blambot

Instagram:
@natepiekos

Facebook:
blambot

For more tips, typefaces, and design by Nate Piekos, visit . . .

blambot.com